SEEING SCIENCE

T0091971

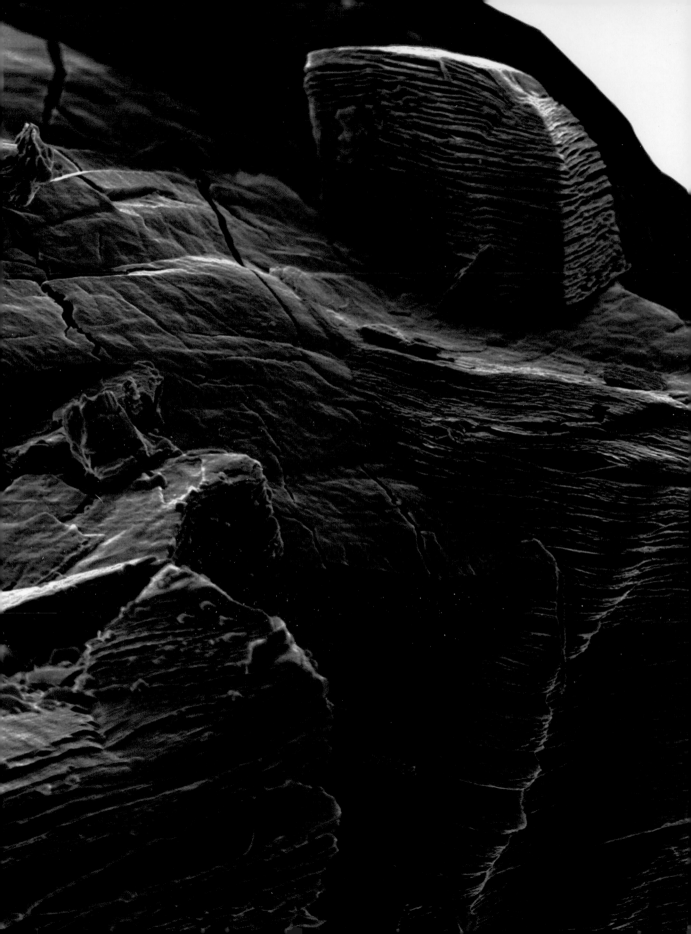

SEEING SCIENCE

The Art of Making the Invisible Visible

Jack Challoner

The MIT Press | Cambridge, Massachusetts

Cover:
False-Color SEM of a
Human Natural Killer Cell
National Institute of Allergy
and Infectious Diseases
(NIAID), 2016
See page 42.

Title page:
Scanning Electron Micrograph
of Titanium Carbide
Babak Anasori, Drexel
University, 2011
The image on the previous pages
won the People's Choice Award
in the 2011 National Science
Foundation's Visualization
Challenge. Entitled "The Cliff of
the Two-Dimensional World,"
this remarkable image is an
extremely close-up view of a
crystal of titanium carbide from
which ultrathin layers have been
eroded, leaving the cliff-like form
you can see. Note that the image
has been colored for effect; a
scanning electron microscope
does not detect color.

Text copyright © Jack Challoner
Design and layout copyright © Quarto Publishing plc
MIT Press edition, 2022

All rights reserved.

The MIT Press
Massachusetts Institute of Technology
Cambridge, Massachusetts 02142
http://mitpress.mit.edu

This book was conceived, designed and produced by
Quintessence Editions
An imprint of The Quarto Group
The Old Brewery
6 Blundell Street
London N7 9BH

Senior Commissioning Editor: Eszter Karpati
Editor: Emma Harverson
Design (text): www.gradedesign.com
Art Director: Gemma Wilson
Picture Research: Sarah Bell
Associate Publisher: Eszter Karpati
Publisher: Lorraine Dickey

978-0-262-54435-1

Library of Congress Control Number: 2021948616

Printed in China

10 9 8 7 6 5 4 3 2 1

Contents

Introduction: The Importance of Seeing

Leonardo da Vinci once wrote:

"If you, poet, had to represent a murderous battle, you would have to describe the air obscured and darkened by fumes from frightful and deadly engines, mixed with clouds of dust polluting the atmosphere, and the panicky flight of wretches fearful of horrible death. In that case the painter will be your superior, because your pen will be worn out before you can fully describe what the painter can demonstrate forthwith by the aid of his science, and your tongue will be parched with thirst and your body overcome by sleep and hunger before you can describe with words what a painter is able to show you in an instant."[1]

In 1911, the editor of the *New York Evening Journal*, Arthur Brisbane, voiced the same sentiment, albeit more concisely, when addressing a gathering of advertisers: "Use a picture. It's worth a thousand words."[2] Today, we are all familiar with that phrase—and we are also beset with advertisers' images, which enter our brains and help shape our desires more successfully and with more immediacy than words alone could do.

Perhaps one reason that images have such power is the fact that the information they contain is delivered "in parallel"—all at the same time. Words, on the other hand, whether spoken or written, need to be delivered and consumed in series, one after the other, if they are to make any sense. An image can contain many details—for example, colors, shapes, objects at different distances, collections of objects, facial expressions and body postures, a sense of place, and movement. Our brains allow us to interpret all of this incredibly quickly. In a 2014 experiment, volunteers were able to identify the subjects of images flashed before their eyes for as little as 13 milliseconds.[3] Pictures are also committed to memory more readily than corresponding words—the so-called picture superiority effect.

Images are so efficient and powerful, and consume so much of the brain's power, that vision is generally regarded as the dominant sense (although some researchers have suggested that other senses might be dominant in certain cultures).[4] Our incredible visual abilities probably evolved because they helped our ancestors survive. Research has shown that in primates (an order of which our species is a member), variation in brain size is associated with visual specialization.[5] The ability to take in a whole scene quickly would have helped our ancestors find food, negotiate

Artwork of Brain and Eye Anatomy
Springer Medizin, date unknown
This schematic diagram illustrates the basic anatomy of our sense of sight, from a viewpoint beneath the brain. Images fall on the retina at the back of each eye, and light-sensitive cells there produce nerve impulses. Some basic image processing actually occurs in the retina—particularly the recognition of lines and edges. Each eye sends the equivalent of about nine megabits per second along the optic nerves (bright yellow). Some of the neurones in the optic nerves cross over at the optic chasm, so that information on the left side of the visual field arrives at the right side of the brain—and vice versa. Eventually, the impulses arrive, and are processed, at the visual cortex (highlighted red), which also receives information from long-term memory, the associational cortex, and the processing areas in the frontal cortex.[6]

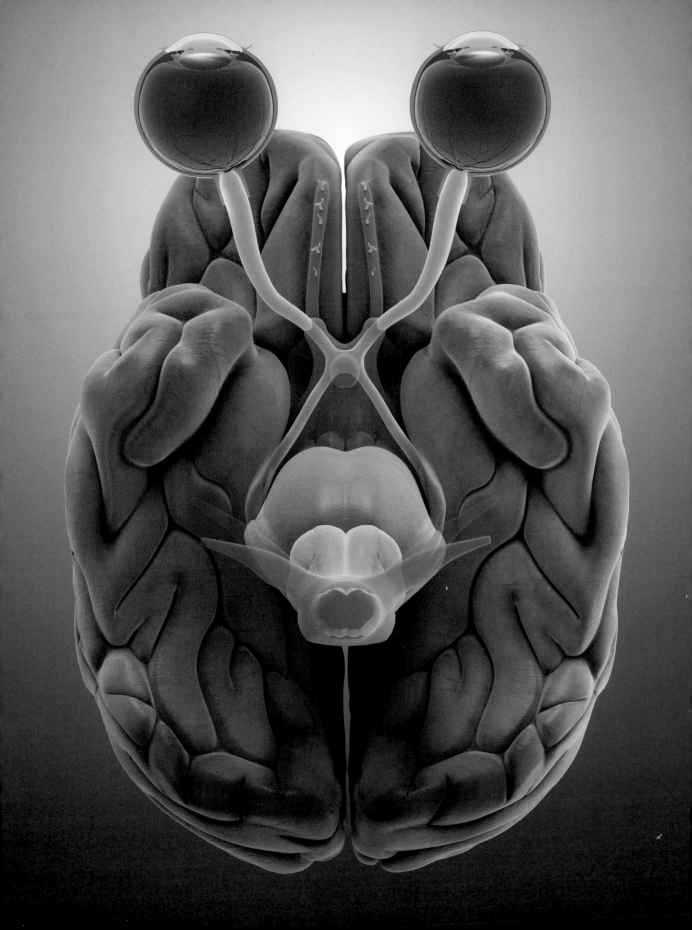

the landscape (including planning ahead)—and, of course, be alert to potential threats. We can only taste and touch what is in our immediate vicinity; smell only what is nearby and upwind; and hear things that are loud or nearby; but in the right conditions, we can see for miles.

Just as images have particular power in advertising, so it is in science. Offering more than 160 examples, this book is an investigation of the importance and the use of images in science. All that these images are trying to "sell" is knowledge, and in this respect they can serve many different purposes. They can, for example, show invisible things, making them more accessible and understandable. This is important, because, as architect, inventor, and futurist Buckminster Fuller put it: "99.9 percent of reality is not apprehendable to the human senses."[7] Creating images of things that are not normally visible to us necessarily involves technologies that can make such things visible in the first place—microscopes, telescopes, and infrared and high-speed cameras, for example. Such technologies, and the images they produce, are the subject of chapter 1.

A vital part of almost all scientific endeavors is the collection of data. In most cases, this data comes in the form of numbers, which, on their own, have little meaning. Graphs and other constructions allow scientists to visualize trends in their data, making them accessible with the same immediacy and clarity as an advertisement. Chapter 2 is a celebration of the use of data visualization, and investigates the use of images to represent the information and knowledge that science produces.

Sometimes the data that scientists produce come from mathematical models. This is particularly useful in situations where an experiment cannot be performed, but where hypotheses still need to tested—in astrophysics, for example. The visual outputs of mathematical models, especially when produced by simulations run on supercomputers, are the subject of chapter 3.

Chapter 4 explores the role played by artists in science. Some artists may collaborate with scientists to create scenes that sum up the accumulated knowledge about a subject that cannot be seen with our own eyes—scenes from the distant past or objects in deep space, for example. Beyond such artists' impressions, artistic creations can also help in the communication of scientific knowledge to a wider audience, making complex subjects more accessible. Some artists will express scientific ideas more abstractly, evoking feelings about what science has discovered.

Of course, each image tells a story but, in almost all cases, that story only becomes available when some explanatory words provide context. Even Arthur Brisbane, quoted above, suggested that advertisers should "use a picture with five words." And so, each image in this book is accompanied by a caption providing information about the provenance of the image and explaining what the image depicts. You will also find references to scientific papers and other resources, which provide additional information for the extra-curious reader.

Artist's Impression of the Universe

Pablo Carlos Budassi, 2012

This remarkable image represents the entire universe, on a logarithmic scale, across time and space, with the solar system at the present time at the center and the energetic plasma created at the beginning of time at the outside edge. It sums up what this book is about: it features things that human eyes cannot see (chapter 1), is based on real data (chapter 2), is a mathematical model, since it is reconstructed on a logarithmic scale (chapter 3), and was created by an artist (chapter 4).

We live among unseen patterns of delicate beauty and exquisite chaos that exist on every scale. We bathe in invisible radiation and particles and we are suffused by shifting fields that permeate all of space. Our very cells are intricate molecular machines, too small to see, and the story of our origins stretches back through an unimaginable length of time. The only way to make any sense of the things that science has discovered is to picture them in our minds—or better still, in front of our eyes.

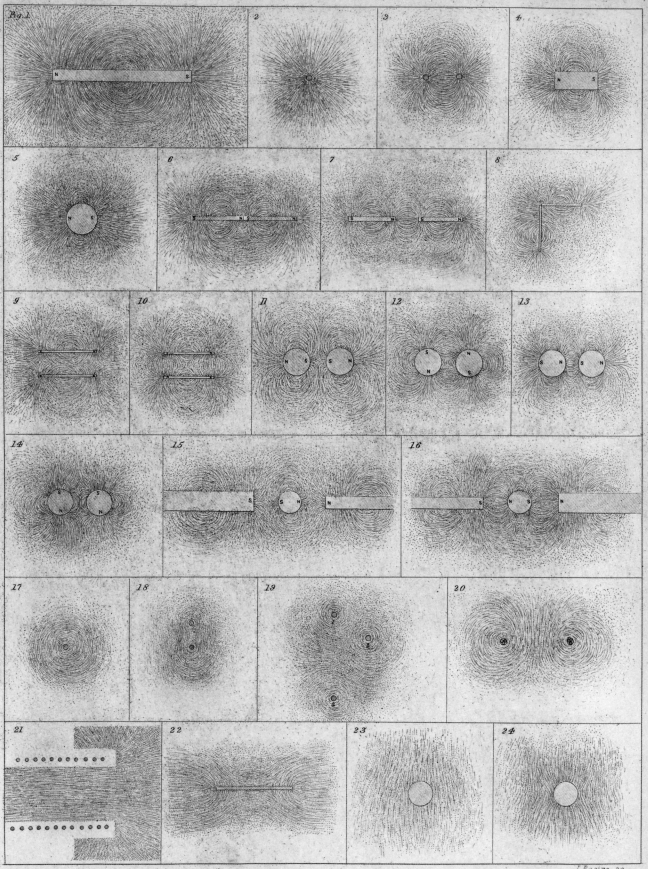

J. Basire sc.

1: Making the Invisible Visible

There is much more to reality than meets the eye. The air around you is teeming with microscopic dust particles and water droplets, and is itself composed of countless atoms and molecules, most of which are traveling faster than a jet airplane; radiation beyond the visible spectrum is coursing by at the speed of light; extraterrestrial particles are passing right through your body more easily than a searing hot knife glides through butter; electric and magnetic fields fill every part of space; and all around you, myriad processes are happening too fast for you to perceive them, or too slowly to be noticed. This chapter demonstrates some of the ways in which scientific instruments and other technologies make the invisible visible.

Drawings of Magnetic Fields
Michael Faraday, 1852
These drawings by the physicist and chemist Michael Faraday (published in *Transactions of the Royal Society*, 1852) show patterns of iron filings that highlight the invisible force fields around magnets. Faraday was an experimenter and a theorist, and relied upon visual thinking to move from one discipline to the other.[1] It was Faraday who coined the term "field," after experimenting with electricity and magnetism for more than thirty years.

Microscopes and Telescopes

Limitations of the human eye

Human eyes are remarkable, but they have three key limitations that render much of the world around us invisible. The first is that eyes are, by definition, only sensitive to visible light (a tiny part of the electromagnetic spectrum; see page 48). The second is that they can only detect light above a certain level of brightness: some things are too dim for eyes to see. For example, a total of only about six thousand stars are visible to the naked eye—even on the darkest and clearest of nights—although many, many dimmer stars are present. A telescope has an aperture larger than the pupil of the eye, and so has greater light-gathering capability. In 1610, Galileo Galilei was able to see "a host of other stars, which escape the unassisted sight, so numerous as to be almost beyond belief" (see page 19).

The third limitation of the human eye involves "acuity," the ability to resolve detail. This means that very small things, or things of whatever size that are very far away, are invisible. One cause of this limitation is diffraction—the way in which light spreads out as a result of its wave nature. Light passing through the pupil of the eye spreads out from the pupil's edge, just as water waves spread out when they pass through a gap in a harbor wall. As a result, when it falls on the retina (the light-sensitive surface at the back of the eye), the light from any point of an object forms a small, blurred disk (called an Airy disk, after nineteenth-century astronomer George Biddell Airy) rather than a sharp point. In the retinal image, the Airy disks of any two points that are very close together will merge, and those two points cannot then be resolved.

Visual acuity also depends on the density of the light-sensitive cells that populate the retina—just as the resolving power of a digital camera depends upon the number of light-sensitive elements in its image sensor. The total number of light-sensitive cells in the retina is close to 100 million. The visual acuity of the human eye is highest where the cell density is highest, in a small region called the fovea. At the center of the fovea, there are more than 150,000 cells per square millimeter[2] (this works out at nearly 100 million cells per square inch, although the area of the fovea is much smaller than 1 square inch).

Visual acuity

Visual acuity varies from person to person (and with age), and its determination is the main objective of the standard eye test (called the Snellen test, after nineteenth-century optometrist Herman Snellen). Normal eyesight is often defined as "20/20" vision ("6/6 vision" in metric units). The first number is the distance to the eye chart during the Snellen test (20 feet, which is about 6 meters). The second number is the distance at which an individual needs to sit, to see details a person with normal acuity could see. No surprise, then, that for a person with normal acuity, this number is also

20 (or 6). Individuals with the highest recorded visual acuity of 20/8 (6/2.4) can see letters during the test (from 20 feet) that people with normal acuity would only just make out if they sat 8 feet (2.4 meters) from the chart. Such eagle-eyed viewers are able to resolve objects at 0.4 arc minute apart ($\frac{1}{150}$th of a degree). This is the angle made by the width of a human hair held at arm's length. The resolving power of people with normal acuity is about 1 arc minute ($\frac{1}{60}$th of a degree).

Magnifying the image

These limitations on the perception of fine detail can be overcome by increasing the size of the image on the retina. Bring a small object much closer to the eye, and the image it forms on the retina is much bigger. As a result, even the finest details of the image will cover more light-sensitive cells, and diffraction will no longer be a problem. There is a limit to this, too: in order to see very small objects, you would need to bring them so close to the eye that you would never be able to focus on them. And so, objects smaller than about 0.06 millimeters (about 2 one-thousandths of an inch) will always remain invisible to the unaided eye.

Microscopes form magnified images of small objects, and telescopes, distant objects. The eyepiece lens presents that magnified image for the eye to view, and the resulting image on the retina is much larger than it would be if the unaided eye gazed at the same object. This is how microscopes and telescopes have enabled humans to perceive things that are too small or too far away to see unaided. The microscope and the telescope were both invented in the last decade of the sixteenth century and, unsurprisingly, both played key roles in the rise of science during the following decades and centuries.

A pioneering microscopist, Antonie van Leeuwenhoek was the first person ever to see bacteria. He built his own microscopes, each with a single powerful lens. His instruments produced much higher magnification than those of his contemporaries, and it would be nearly a hundred years before anyone else observed bacteria again. It was not until the nineteenth century that scientists began to understand the importance of bacteria in disease, and only in the twentieth century did they begin to understand the importance of these invisible single-celled organisms in evolution and ecology. +++

PLATE XXIV

Early Drawings of Spermatozoa
Antonie van Leeuwenhoek, 1677

In 1677, a medical student called Johan Ham told Leeuwenhoek that he had observed "animalcules" in semen.[3] (Animalcules was a word Leeuwenhoek coined to refer to microorganisms.) Leeuwenhoek observed sperm cells in a sample of his own semen, and went on to find sperms in the ejaculate of several other animals. Pictured below are his findings on the sperms of rabbits (figures 1 to 4) and dogs (figures 5 to 8). He was the first person to suggest that fertilization takes place when sperm cells enter egg cells, although he never observed this himself. Leeuwenhoek was one of several microscopists who, in the seventeenth and eighteenth centuries, uncovered an unseen world of the very small. +++

[overleaf]
"Micrographia"
Robert Hooke, 1665

Robert Hooke recorded these illustrations of hairs from the "hairy kidney bean" pod (left) and a bee sting (right) in his 1665 best-selling book *Micrographia: or Some Physiological Descriptions of Minute Bodies Made by Magnifying Glasses. With Observations and Inquiries Thereupon.* Hooke was another pioneer of microscopy, and a contemporary of Leeuwenhoek. In the preface to his book, he wrote that he had discovered a "new visible World," and that his work represented an "inlargement [sic] of the Senses." Note that neither the fine hairs of the bean pod nor the bee's sting are actually invisible; rather, the fine details of them are beyond the resolving power of the naked eye. +++

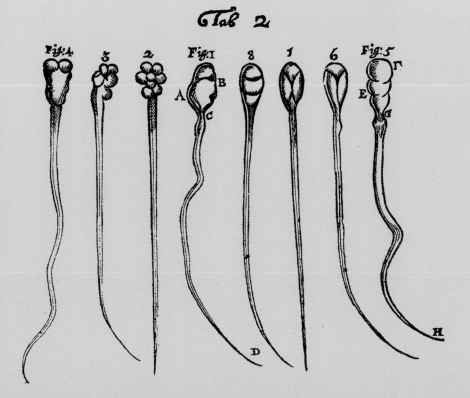

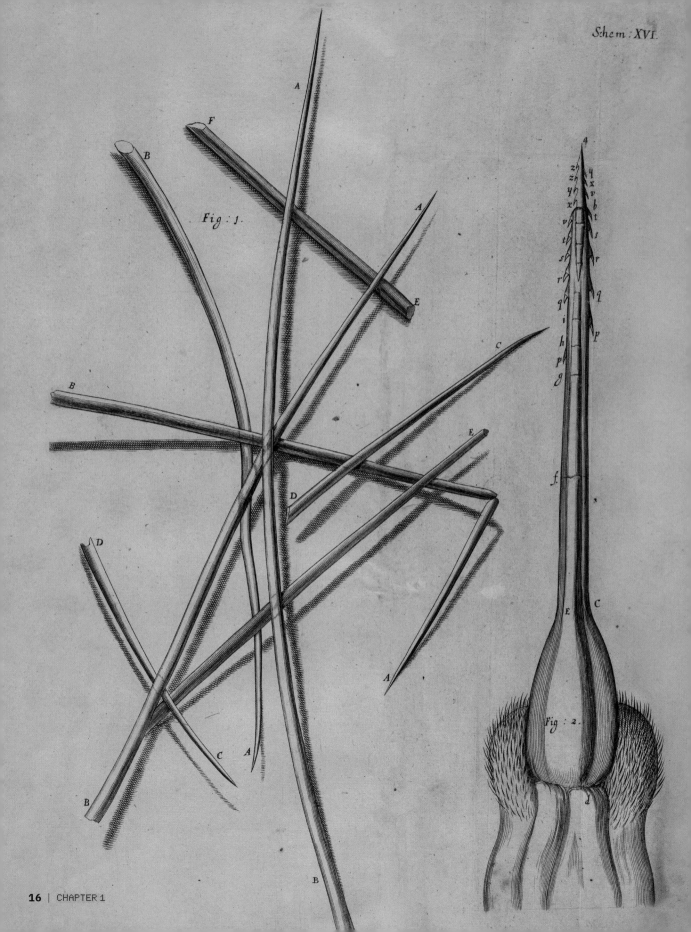

Drawing of Stained Neurone

Santiago Ramón y Cajal, ca. 1890

During the second half of the nineteenth century, microbiologists began using various pigments to "stain" particular cells, or particular parts of cells. Staining brings out contrast, which can be vital when gazing at cells, whose components are often colorless. Camillo Golgi developed a stain in the 1880s that randomly attaches to entire neurones (nerve cells), so that the dense and complex tangle of neurones in the brain can be visualized with clarity. Pioneering neuroscientist Santiago Ramón y Cajal used the Golgi stain method to produce stunning studies of the structure of the brain. +++

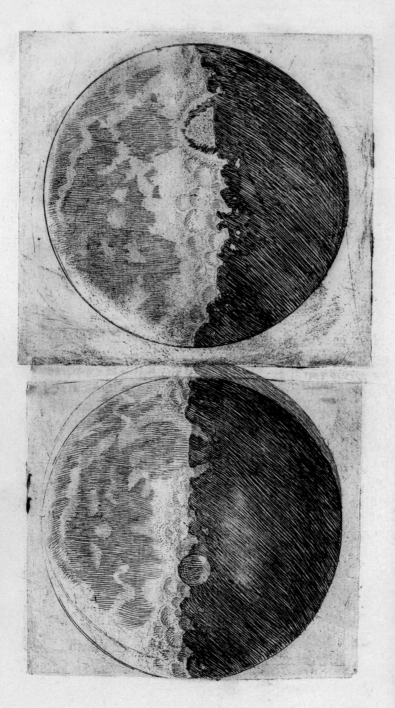

Drawings of the Moon, Showing Craters
Galileo Galilei, 1610

Sometimes, unveiling previously unseen details of something familiar can overthrow long-held assumptions. For example, for hundreds of years, scholars believed the Moon to be a perfect, smooth sphere. When Galileo turned his self-made telescope to the Moon in 1609, he observed rough mountains and craters. He published details of his observations, with his careful drawings, in his 1610 book *Sidereus Nuncius* (*Starry Messenger*). The same book contained drawings of four satellites (moons) in orbit around planet Jupiter, helping to challenge another well-established assumption: that all objects in space are in orbit around Earth.
+++

Drawing of Stars in the Milky Way
Galileo Galilei, 1610

The brightness of stars in the night sky is given as a magnitude: the dimmest stars visible to the naked eye on a clear, dark night are of magnitude 6 (strangely, brighter stars have a lower magnitude). One familiar feature at night is the Milky Way—so called because it appears as a tantalizing nebulous band across the sky. Through his telescope, Galileo could see that, rather than a milky continuum, the Milky Way is teeming with countless individual stars, each too dim for the human eye to perceive. He recorded these observations in his *Sidereus Nuncius*.
+++

Photography and Electron Microscopes

Capturing images

For more than two hundred years after the invention of the telescope and the microscope, scientists were only able to communicate their observations through drawings and the written word. Soon after the invention of photography in the 1820s, however, scientists became able to record their observations directly and faithfully, by attaching cameras to their instruments. The first astrophotographs (photographs of astronomical objects taken through a telescope) were taken in 1840 (see pages 26–33), and the first micrographs (photographs taken through a microscope) around the same time.

Photography brought other advantages: long exposures gather much more light, bringing much dimmer objects into view (see pages 28 and 32); very short exposures or movies with extremely rapid frame rates can capture events that happen much too fast for us to perceive (see pages 34–37); and time-lapse photography can reveal the details of very slow processes (see page 39).

With or without a camera attached, there are limits to the resolving power of optical (light) microscopes, just as there is a limit to what the human eye can resolve (see page 12). Again, it is the wave nature of light that is to blame: it is impossible to capture an image of any object whose size is less than half the wavelength of the light being used to observe it. Visible light has wavelengths ranging from 400–700 nanometers (0.0004–0.0007 millimeters or 0.00002–0.00003 inches), so a microscope, however powerful, cannot produce an image of any object whose size is less than 200 nanometers, even in principle. In recent decades, some ingenious techniques have been developed to push a little beyond this limit, but there are alternatives that can naturally go a lot further—notably, electron microscopes.

Electron microscopes

The electron microscope was invented in the wake of developments in quantum mechanics, which studies the behavior of light and particles on atomic and subatomic scales. One of the key discoveries of quantum mechanics is that tiny objects, such as electrons, behave as waves as well as particles (and, conversely, light behaves as particles as well as waves). In an electron microscope, a beam of electrons illuminates an object and the electrons that pass through or bounce off are detected, so that an image is produced. The wavelength associated with electrons is much smaller than that of visible light, so the limits on resolution for an electron microscope are far smaller than for an optical microscope. As a result, electron microscopes can produce magnifications of up to fifty million times, while optical microscopes are limited to magnifications of up to two thousand times.

Daguerrotype of Human Blood Cells

Alfred Donné and his student Léon Foucault, 1845

Alfred Donné invented photomicroscopy in 1840, when photography itself was very much in its infancy. He published this image in his book, *Cours de Microscopie* (*Lessons in Microscopy*). It was captured using the daguerrotype process, invented in the 1830s by Louis Daguerre, in which silver plates are made light sensitive by exposing them to iodine or bromine fumes. In his introduction to the book, Donné laid out the importance of photography to the field of microscopy: "Before describing what we see, before drawing conclusions from what we observe, we let nature reproduce itself faithfully." +++

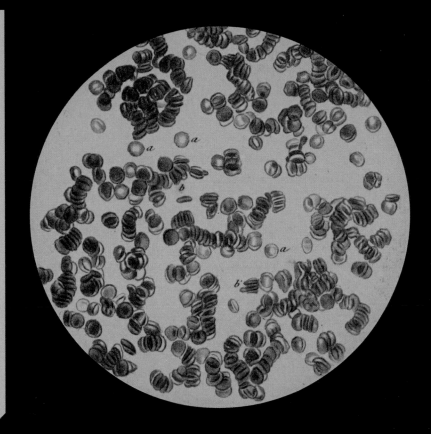

Photograph of Phacodiscus Clypeus

Andreas Drews, 2017

This image shows the radiolarian *Phacodiscus clypeus*, discovered by the naturalist Ernst Haeckel in 1887. Radiolarians are single-celled marine organisms (plankton), protected by an intricate shell made of silica (silicon dioxide). Surprisingly, perhaps, for single-celled organisms, radiolarians are predatory: protrusions extend through the holes in their shells and ingest other single-celled organisms. Radiolarians exist in such huge numbers in the oceans that they play crucial roles in the marine food web, in ecology more generally, in geology, and in the global climate. The depth of field in a microscope is very limited; this photograph is created by combining several photographs, each taken at a slightly different focal plane. +++

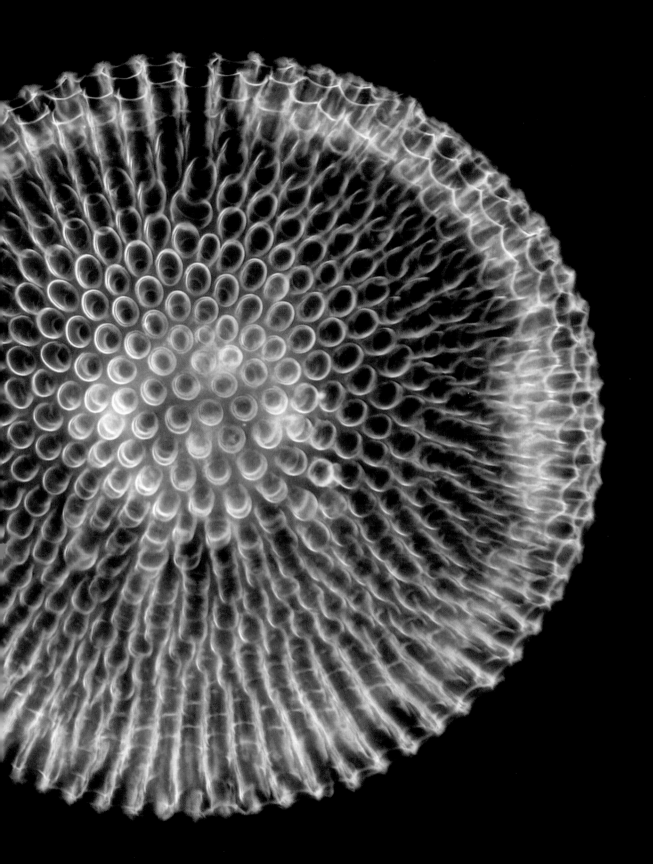

Daguerrotype of the Sun, Showing Sunspots

Léon Foucault and Hippolyte Fizeau, 1845

Sunspots are invisible to the naked eye, though not because they are too dim to be seen (they are bright, but less so than the rest of the Sun's surface). You can see sunspots by projecting an image of the Sun onto a piece of paper, so it is not remarkable that this photograph shows sunspots. What *is* notable, is that this is the first astrophotograph of the Sun ever taken. The photograph was a daguerrotype (see page 21) 12 centimeters (4.7 inches) in diameter. The exposure time was one-sixtieth of a second. +++

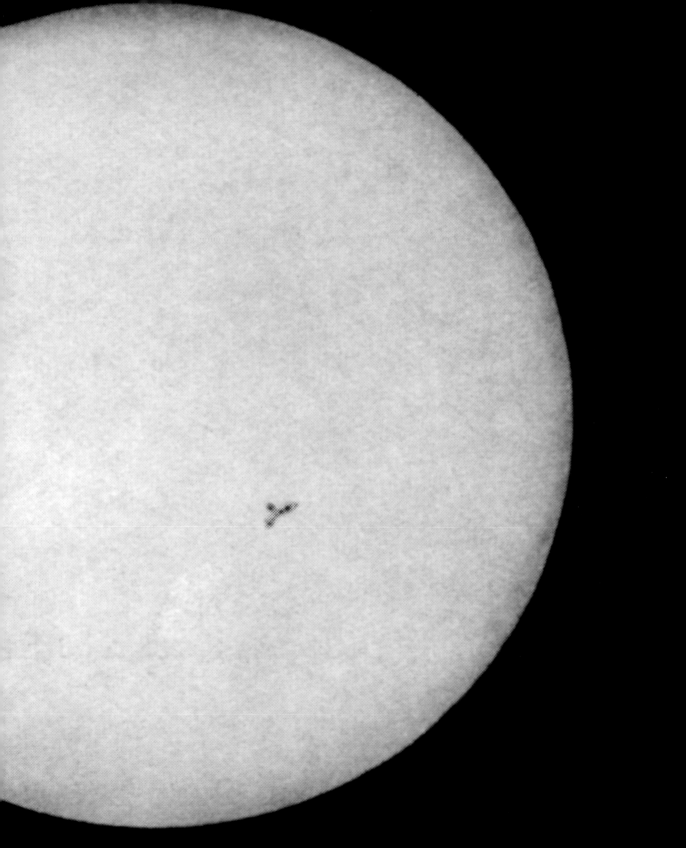

Astrophotograph of the Andromeda Galaxy

Hubble Space Telescope (NASA), 2015

This is just one section of the largest Hubble Space Telescope image ever produced. The full digital image has a file size of 4.3 gigabytes. It shows just part of the Andromeda Galaxy, where millions of individual stars are visible, despite the galaxy being more than two million light-years away. In a press release, NASA compared this to being able to resolve grains of sand in a photograph of a beach. This is more than just a snapshot: it is a mosaic of thousands of individual images, captured on more than four hundred different "pointings." The colors in the image are faithful to what the human eye would see in real life. +++

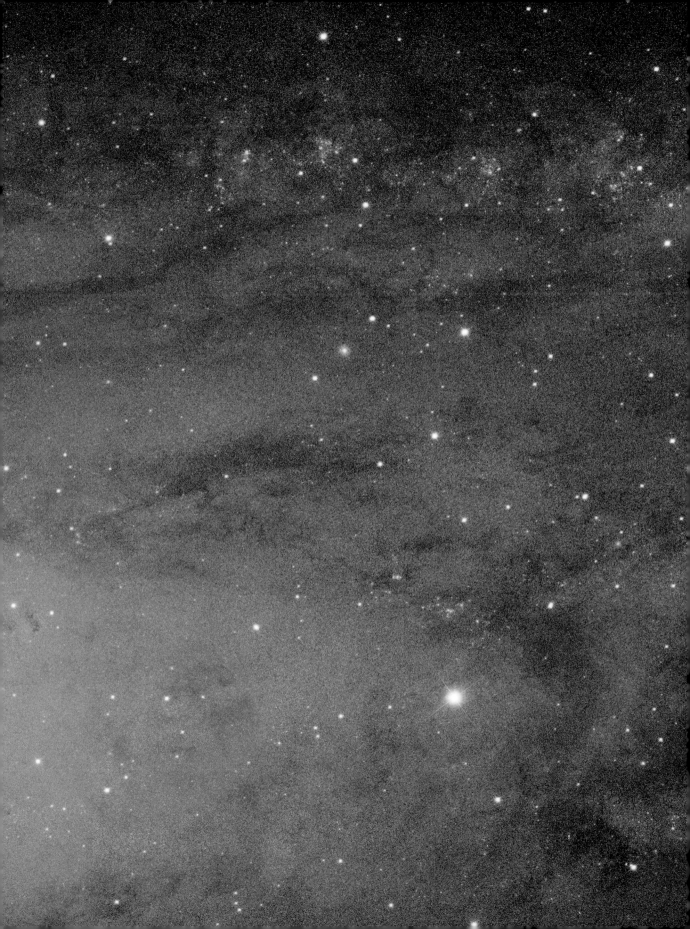

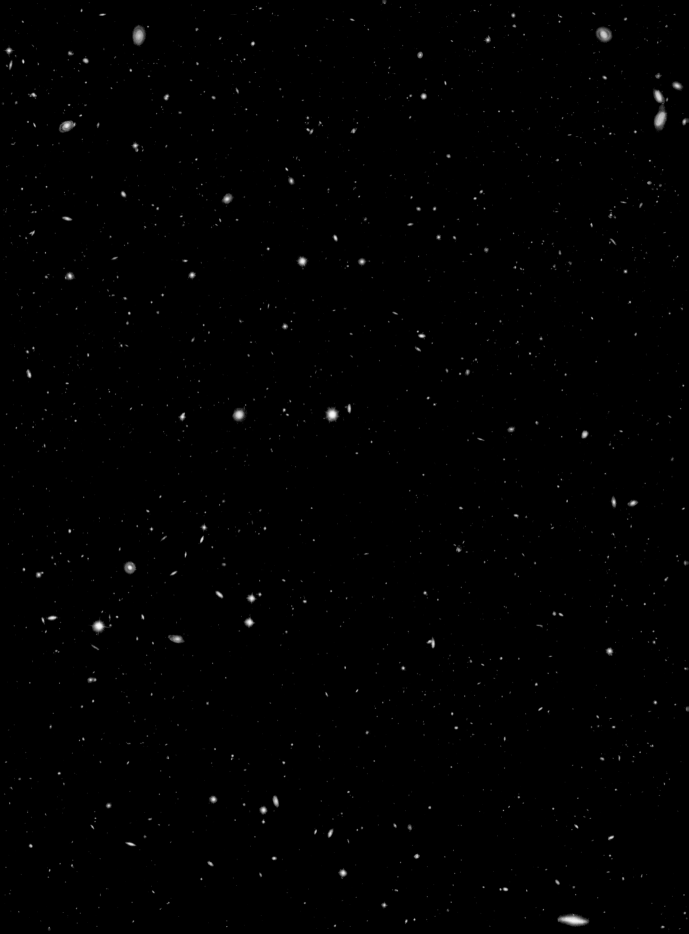

Digital Astrophotograph of Part of the Hubble Legacy Field

Hubble Space Telescope (NASA), 2019

The Hubble Legacy Field is a combination of nearly 7,500 individual exposures amounting to millions of seconds' exposure time. This long-exposure digital astrophotograph is a culmination of work over twenty years that began with the celebrated Hubble Deep Field image (1995). The long exposure time means that very dim objects can be seen: the faintest galaxies here are just one ten-billionth the brightness of what the human eye can see. The field of view is about the same as the width of the full Moon in the sky, yet it captures more than 200,000 individual galaxies. +++

Astrophotograph of the Sun's Photosphere

Daniel K. Inouye Solar Telescope, Haleakalā Observatory (NSO/AURA/NSF), 2020

In this image, features of the Sun's photosphere (visible surface) just 30 kilometers (18 miles) across can be seen. This is equivalent to a marble being visible from a distance of 50 meters (160 feet). The pattern is created by convection: hot plasma (ionized gas; brighter) rises, cools (darker), then falls back down. The brightest parts are where magnetic field lines allow extremely hot plasma to leak out beyond the Sun's outer atmosphere, the corona. This was the first image captured by the ground-based Daniel K. Inouye Solar Telescope. It was captured by gathering light of a precise wavelength, actually just *beyond* the red end of the spectrum—see page 48. +++

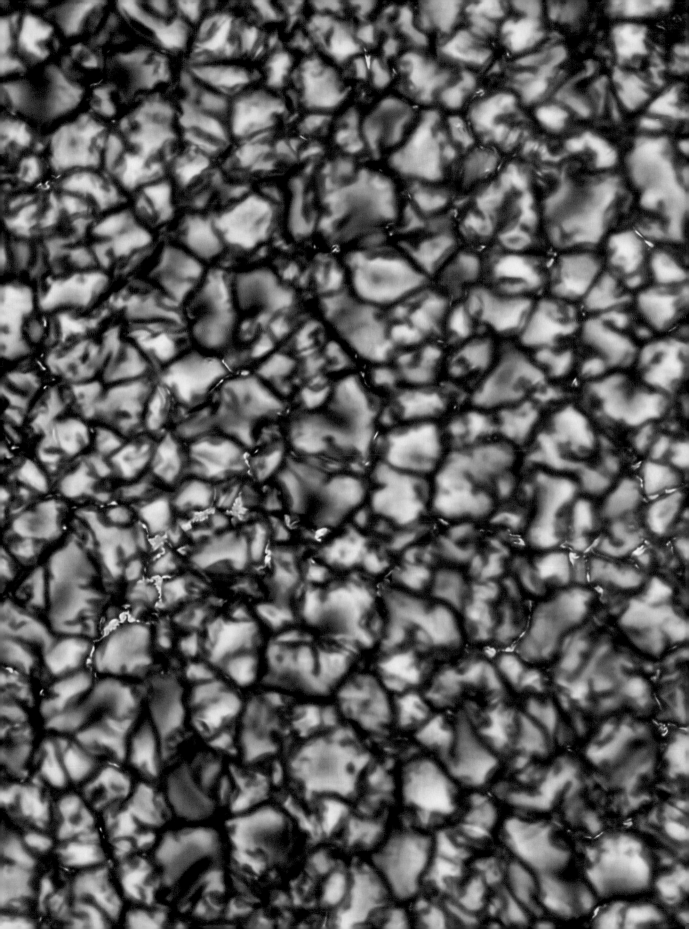

Digital Image of the Dwarf Planet Pluto

New Horizons (NASA), 2018

Here, Pluto is captured by the Multispectral
Visible Imaging Camera (MVIC) aboard
NASA's New Horizons spacecraft. This
recalibrated image, released in 2018, shows
the planet in its "true colors"—very close
to how your eyes would have perceived it
if you had been onboard the spacecraft.
When the image was originally captured, in
July 2015, New Horizons was just 35,500
kilometers (22,000 miles) above Pluto's
surface—near enough to get a very close look.
At that time, the Earth–Pluto distance was
33 astronomical units (thirty-three times the
Earth–Sun distance). That is so far away that
Pluto is tiny and far too dim ever to be seen
by the naked eye, and it never appears as
more than a blurred disk, even using the most
powerful ground-based telescopes. +++

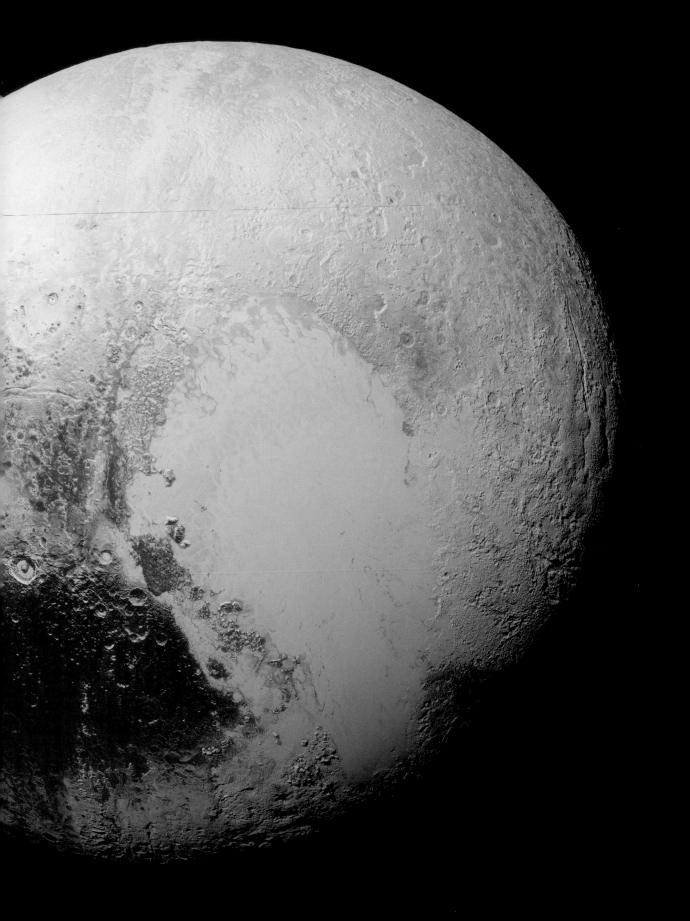

Photographs of Animal Locomotion
Eadweard Muybridge, 1887

Some things occur too rapidly for the eye to see clearly. For example, during the nineteenth century, artists and equestrians had long argued whether all four hooves were off the ground when a horse galloped. In 1878, tycoon Leland Stanford employed photographer Eadweard Muybridge to settle the debate. Muybridge arranged twelve cameras in a line; trip wires activated the cameras' shutters as the horse galloped past. Muybridge went on to conduct hundreds of studies of motion, with humans and other animals; the images shown here are from an 1887 study of a galloping horse. +++

High-Speed Photograph of a Bullet Passing Through a Candle Flame
Harold Edgerton and Kim Vandiver, 1973

Harold "Doc" Edgerton was a pioneer in the field of high-speed photography. From the 1930s onward, he used a range of techniques to capture remarkable images of things the unaided eye would never see. In the 1940s, he developed the Raptronic camera, which could manage exposure times as brief as 1 nanosecond (one-billionth of a second). The image shown here utilizes a technique called Schlieren photography, in which a particular arrangement of mirrors and lenses captures variations of density in the air; exposure time is 1 microsecond (one-millionth of a second). +++

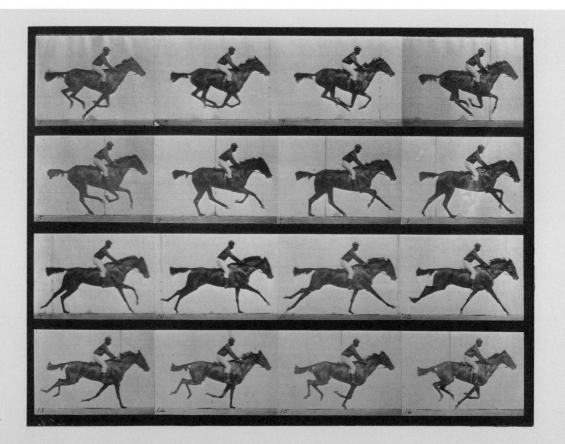

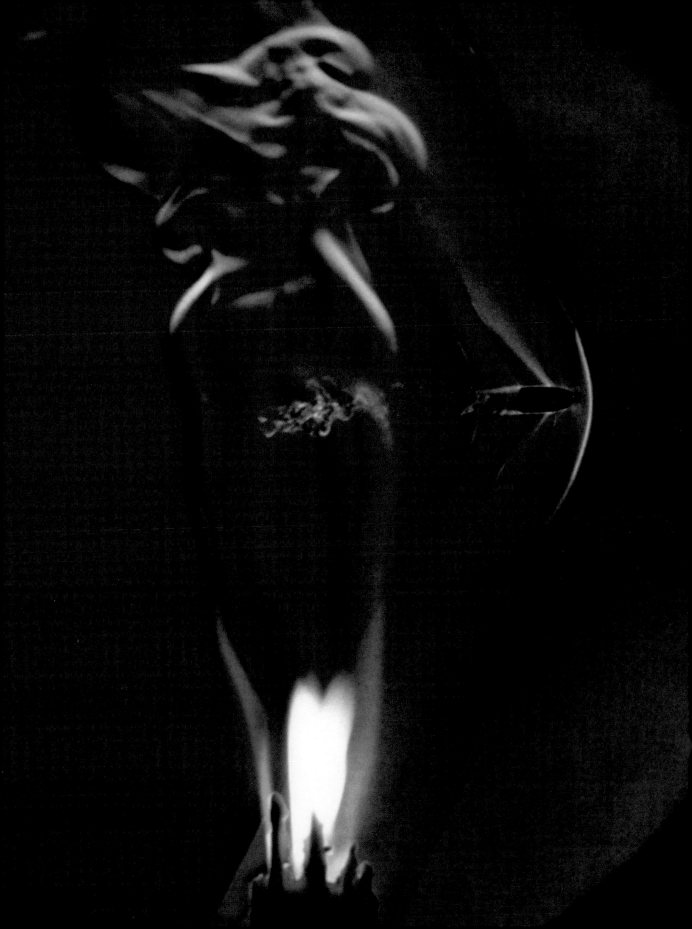

High-Speed Photograph of a Bullet Passing Through an Apple

Harold Edgerton and Kim Vandiver, 1973

Edgerton was a professor at the Massachusetts Institute of Technology (MIT), and he used this iconic photograph in a lecture called "How to Make Applesauce at MIT." In order to take this photograph, the room had to be in complete darkness, so that only the light from the bright flash would illuminate the scene. A microphone captured the sound of the rifle firing the bullet, triggering the flash and the camera; the exposure time was just 0.3 microseconds (300 billionths of a second). Note how the entry and exit points of the bullet are equally explosive. +++

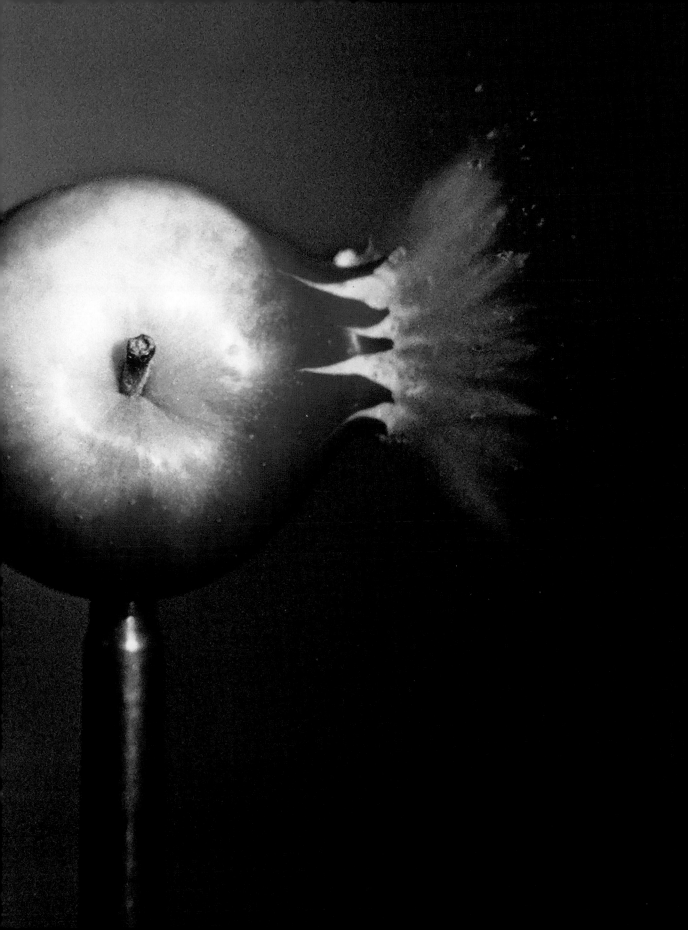

Photographs Leading to the Discovery of Pluto
Clyde Tombaugh, 1930

In 1929, twenty-three-year-old astronomer Clyde Tombaugh began searching the night sky for a planet whose existence had been hypothesized since the discovery of Neptune in 1846. Solar system objects move against the "fixed stars" but, for more distant objects, that movement is far too slow to perceive. Tombaugh used a device called a blink comparator to switch back and forth between photos he took several nights apart in late January 1930. This makes any moving object easy to spot and, on February 18, 1930, Tombaugh made his discovery. The object, first called Planet X, was later named planet Pluto—and then, in 2006, reclassified as a dwarf planet. In the photographs below, Pluto is indicated by the white arrow. +++

Photographs Recording Glacier Loss
Louis H. Pedersen, 1917 (top) and
Bruce F. Molina, 2005 (bottom)

Some things happen too slowly to perceive directly—such as the movement of a mountain glacier as it glides downhill. The change in mass of a glacier is even less perceptible. Glaciers are always losing and gaining mass, but global climate change is resulting in a dramatic overall loss of mass in the world's glaciers. This can easily be seen by comparing photographs of glaciers taken decades apart from the exact same spot. In this example, the images are of Pedersen's Glacier, in Alaska's Kenai Mountains. +++

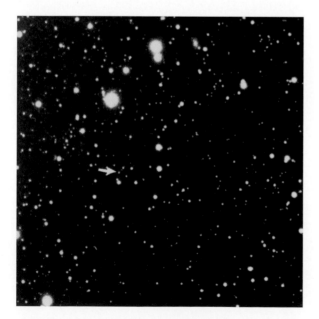

January 23, 1930

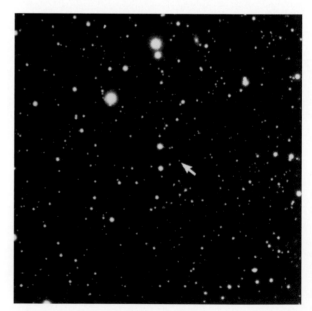

January 29, 1930

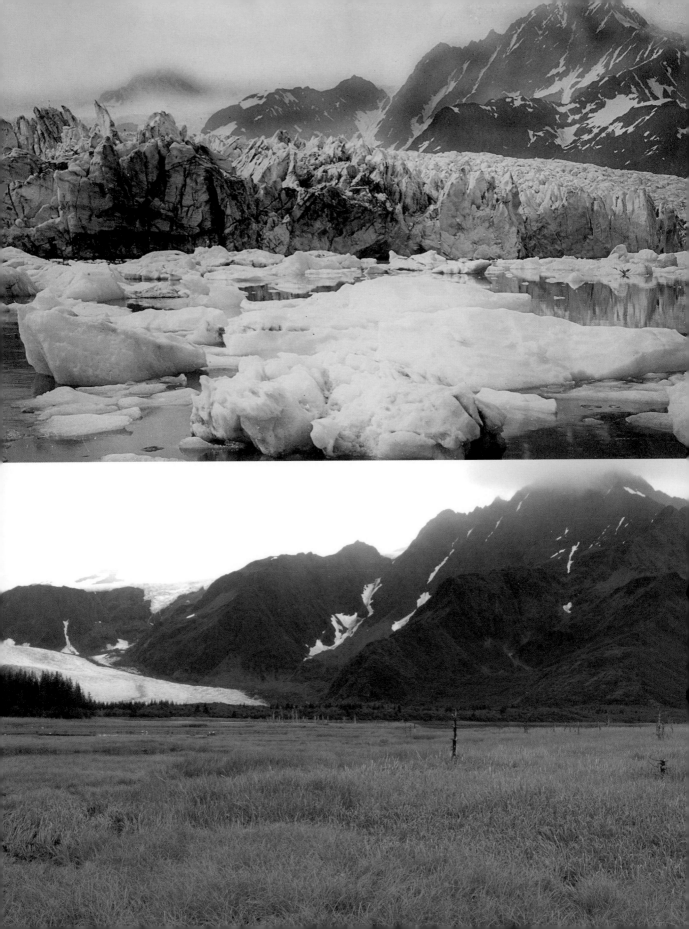

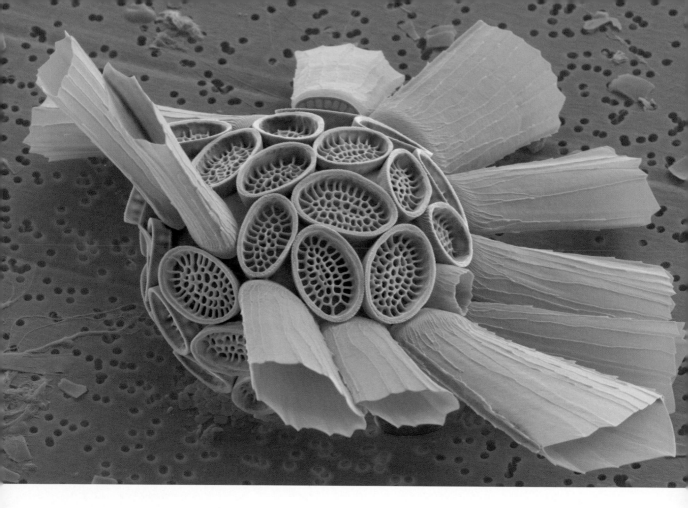

Scanning Electron Micrograph (SEM) of Scyphosphaera porosa
Jeremy Young, 2008

Scyphosphaera porosa is a coccolithophore, a single-celled marine organism that secretes calcium-rich minerals to build a protective shell. Coccolithophores are typically around 0.02 millimeters (20 microns, just less than one-thousandth of an inch) in diameter. While this means they are visible under an optical microscope (though not to the naked eye), the level of detail present in this image is only achievable with the resolution afforded by an electron microscope because the wavelength of an electron is so much shorter than that of visible light (see page 20). Since they are constructed from reflected or transmitted electrons, electron micrographs have no color. The colors are added to help the human eye make sense of an image. +++

False-Color SEM of Novel Coronavirus SARS-CoV-2
National Institute of Allergy and Infectious Diseases (NIAID), 2021

These virus particles (virions; colored yellow) were located on a host cell (colored green) in a sample given by a patient with COVID-19, the disease caused by this virus. The diminutive size of these virus particles—about 0.1 microns, or one ten-thousandth of a millimeter (four-millionths of an inch)—means that without electron microscopes, we would never be able to see the cause of the worldwide pandemic that took hold in 2020, claiming millions of lives. +++

False-Color SEM of a Human Natural Killer Cell

National Institute of Allergy and Infectious Diseases (NIAID), 2016

Discovered in the 1960s, natural killer cells are a crucial part of the body's immune system. They are one of several lymphocytes—white blood cells found in the lymphatic system. Natural killer cells work in a similar way to other lymphocytes, killing infected cells, cancer cells, pathogenic bacteria, and even the body's own cells that have become old, by sophisticated chemical attack. Too small to see even in this high-magnification SEM, are the receptors that make natural killer cells able to identify infected cells, and to differentiate those cells from healthy ones. These receptors are protein molecules embedded in a cell's membrane. +++

False-Color Transmission Electron Micrograph (TEM) of Influenza

Centers for Disease Control and Prevention,
Division of Viral and Rickettsial Diseases,
2009

In this TEM of a subtype H1N1 virus particle,
you can see the prominent spike proteins
that enable the particle to enter host cells.
Inside a scanning electron microscope, the
electrons that make the image are scattered
off the surface of the sample as it is scanned
by an electron beam (the sample often has
to be coated with a thin layer of gold to make
it reflective). Inside a transmission electron
microscope, however, electrons accelerated
and focused by electric and magnetic fields
pass through a thin sample. As here, the
resulting image is a kind of shadow picture,
each point of which represents how easily
electrons pass through at that point. +++

IN FOCUS:
Dust From Outer Space

A shooting star, or meteor, streaking silently across the sky is a wondrous sight. The bright light a meteor emits is the incandescent glow of a meteoroid (rock from space) heating up as it enters Earth's atmosphere at high speed. There are countless meteoroids in orbit around the Sun. They are, by definition, much smaller than planets, dwarf planets, and asteroids, and they come in a range of sizes from about 1 meter (1 yard) across down to tiny specks as small as 0.3 millimeters (0.012 inches).

Any meteoroid that survives its journey and makes it through Earth's atmosphere is then called a meteorite. Though extremely rare, the largest meteorites, whose entry to the atmosphere causes an intensely bright fireball, can cause significant damage. Smaller meteorites that one could hold in the palm of a hand are more common, but finding one is still unusual. The very smallest cosmic rocks are sometimes called micrometeoroids—any of these that make it through Earth's atmosphere are called micrometeorites.

Most micrometeorites (and most meteorites generally) that make it to Earth's surface land in the oceans, since the oceans cover two-thirds of the planet's surface. And most of those that fall on land end up in wilderness. Some, however, end up on roofs, in gardens, in puddles— places where anyone could find them. Study of micrometeorites using powerful optical microscopes or electron microscopes brings out stunning details of these tiny cosmic objects that would otherwise remain unseen.

In recent years, micrometeorite hunting has become a popular hobby, especially in urban areas, where cosmic dust can accumulate on large, flat roofs or be washed from sloping roofs into gutters. One person who has devoted more time than most to developing and popularizing the search, and to the serious study of micrometeorites, is gypsy-jazz-guitarist-turned-scientist Jon Larsen. His 2017 book *In Search of Stardust: Amazing Micrometeorites and Their Terrestrial Imposters*

False-Colored SEM of a Micrometeorite
Ted Kinsman, 2018
This micrometeorite is 0.3 millimeters (twelve-thousandths of an inch) in diameter. It has a smooth coat of iron and nickel around a crystal of nearly pure titanium. The iron and nickel have melted in the heat of atmospheric entry, and then solidified around the titanium, which has a higher melting point.

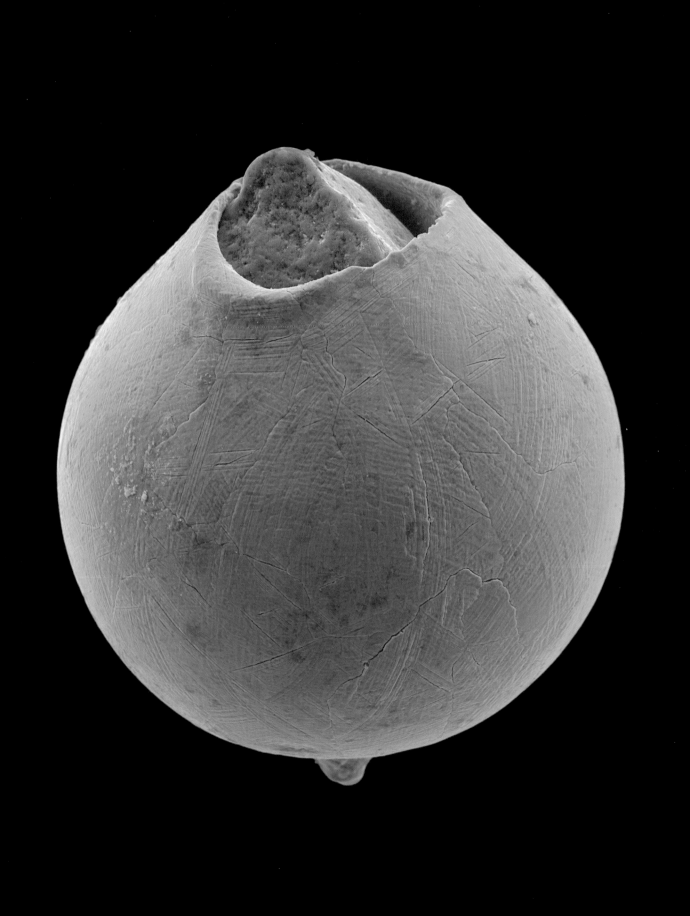

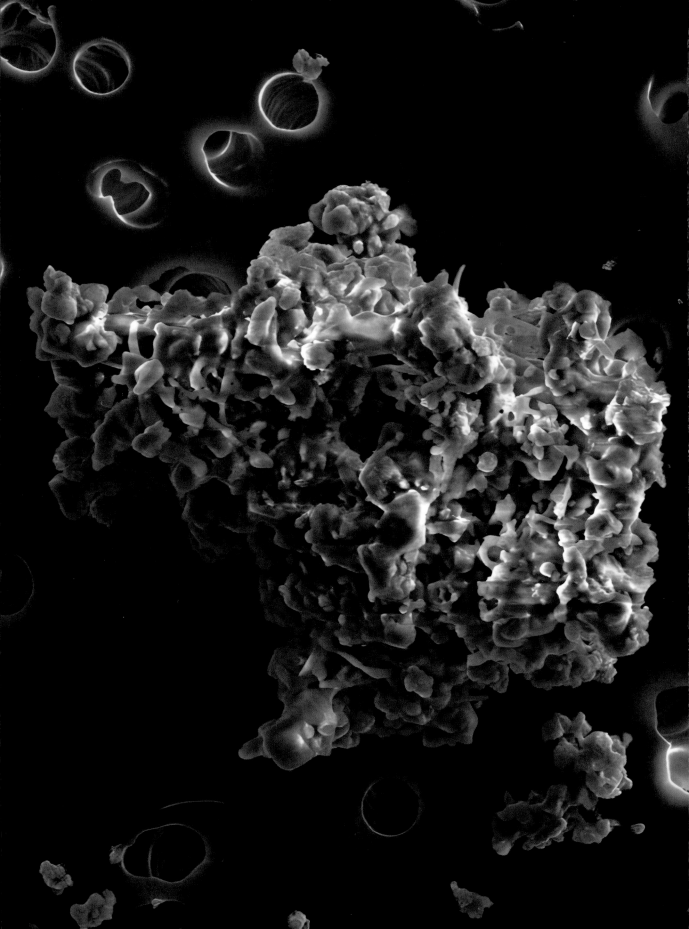

SEM of an Interplanetary Dust Particle

Dr. Hope Ishii, University of Hawaii at Manoa, 2018

At five-thousandths of a millimeter (0.2 thousandths of an inch) across, this particle is not visible to the naked eye. It was one of the dust particles gathered high in the atmosphere by collectors mounted onto aircraft. It was studied by a team at the University of Hawaii at Manoa[7], who found it to match the predicted composition of presolar dust, meaning that it has not been altered in any way during or since the formation of our solar system.

Particles in space smaller than micrometeoroids—most of them too small to see without a microscope—are called dust, or cosmic dust. When these particles enter the atmosphere, they do not become glowing meteors—they do not reach temperatures necessary to incandesce, since they radiate heat more effectively than larger particles (because of the ratio of their surface area to their volume). As a result, many do not suffer the heating that can cause larger particles to vaporize, or at least melt, and undergo chemical change on their way to the ground.

Somewhere between ten and several hundred tonnes (tons) of cosmic dust enter the atmosphere every day[5], and much of it is small enough to remain aloft, mixing with sand and soil whipped up by winds from the land below. Cosmic dust can therefore be intercepted by aircraft[6]—preferably at high altitude, where those terrestrial particles are less common. Samples from these missions provide scientists with an opportunity to study cosmic particles without needing to leave the atmosphere—a rare opportunity to study material from beyond our planet.

Some cosmic dust is produced when asteroids collide, or during crater-forming impacts on the Moon or other planets. But most dust particles come from the trails of debris left behind by comets as they travel through space in orbit around the Sun. A comet is a large object made of rock and ices (water ice and other frozen volatile compounds, such as ammonia), and many of them have remained unchanged since the formation of the solar system more than 4.5 billion years ago. The Sun, planets, asteroids, and comets all formed from a vast region of interstellar gas and dust called a molecular cloud. That cloud consisted mostly of hydrogen and helium that had existed unchanged since the early history of the universe. Mixed with that primordial gas was dust made of heavier elements that had been forged in the centers of stars from a previous generation and expelled into the interstellar medium when those stars died.

The solid grains accumulated, forming the solid bodies of our solar system—the planets and their moons, dwarf planets, asteroids, and comets. In most cases, the material was changed by chemical and physical processes—especially near the center of the solar system, where radiation and heat are more intense. Most comets, however, formed far away from the Sun, and some still contain pristine "presolar" dust.

Beyond the Visible Spectrum

The nature of light

Light is electromagnetic radiation—a form of radiant energy associated with a field called the electromagnetic field, which fills all of space. Electromagnetic radiation travels as waves, like ripples in a pond, that are oscillating disturbances of the field. Just as for water waves, electromagnetic waves can be characterized by their wavelength and frequency. The peak sensitivity of the human eye is in the yellow part of the spectrum, at a wavelength of 550 nanometers (0.02 thousandths of an inch)— a frequency of 5.45 terahertz (545 trillion oscillations per second). Electromagnetic radiation also travels as particles, called photons. Each photon carries a precise amount of energy. The energy of photons is directly related to the length of the corresponding waves; blue light has around half the wavelength (twice the frequency) of red light, and each of its photons has about twice the energy of photons of red light. A photon of red light carries an incredibly tiny amount of energy: about 2.8 electron volts (eV). It would take nearly a trillion trillion such photons to deliver an amount of energy equivalent to one food calorie (kcal). (The link between photons and food energy is not unreasonable: molecules of chlorophyll in plant leaves absorb the energy of photons, and use it to make sugars, the first step in the food chain. On a sunny day, countless trillions of photons are absorbed by these molecules.)

Electromagnetic waves and photons are not two different forms of electromagnetic radiation: they are one and the same. The fact that light, electrons (see page 20), or anything else can behave as a wave and a particle at the same time is well proven, but it brings with it deep paradoxes, and is still not properly understood.

Beyond the visible spectrum

In 1800, the astronomer William Herschel discovered invisible radiation just beyond the (long-wavelength) red end of the spectrum that causes a thermometer to register a higher temperature. He named the phenomenon "caloric rays," better known today as infrared radiation. The following year, the physicist Johann Wilhelm Ritter discovered invisible radiation beyond the (short-wavelength) blue/violet end of the spectrum that could darken paper soaked in silver chloride. He named the phenomenon "de-oxidizing rays," and today it is called ultraviolet radiation.

Mathematical physicist James Clerk Maxwell was the first to realize that these forms of radiation are disturbances of the electric and magnetic fields, nowadays united as the electromagnetic field. In the 1860s, he formulated equations that fully describe the behavior of electric and magnetic fields, and when he merged his formulas, the result was a wave equation, whose speed matched the speed of light. From that moment, it was plain that there must exist other forms of radiation, with wavelengths longer and shorter than light, infrared, and ultraviolet. And, indeed, the

electromagnetic spectrum extends much further in both directions: beyond the ultraviolet, with even shorter wavelengths, are X-rays (discovered 1895) and gamma rays (1900), while beyond the infrared, with longer wavelengths, are microwaves (first generated in the 1890s) and radio waves (1887). All electromagnetic radiation is a manifestation of the same phenomenon; the only difference is the wavelength/ frequency of the waves, the energy of the photons. Wavelengths range from hundreds of thousands of kilometers (miles) for radio waves down to less than one ten-billionth of a centimeter (inch) for gamma rays. The energy carried by each photon ranges from about one thousand-trillionth the energy of a photon of visible light for radio waves to about a million times the energy of a photon of visible light for the highest frequency gamma rays.

Detecting invisible rays

There are countless natural phenomena that produce nonvisible electromagnetic radiation. Since our eyes are only sensitive to that tiny portion of the spectrum we call visible light, it is no surprise that many fascinating phenomena were unknown until the invention of technologies that could detect them. Astronomy is, perhaps, the scientific discipline that has benefitted most from such technologies. Many objects in space produce no visible radiation at all and have only been discovered thanks to radio telescopes or infrared telescopes (see pages 58–59). The radiation emitted by astronomical objects provides valuable data (see chapter 2) that can reveal vital information, including what such objects are made of, their temperature, and what kind of energetic processes are happening within.

The importance of electromagnetic radiation beyond the visible spectrum does not lie in its detection alone: electromagnetic radiation can also be used as a probe, to make visible objects or processes that are otherwise hidden. For example, X-rays and gamma rays are highly penetrating, and can be used to "see inside" (see page 60), while illuminating materials with ultraviolet radiation can cause them to fluoresce, producing a visible glow. Fluorescence has become invaluable in microbiology, where fluorescent proteins are routinely used as markers inside cells, lighting up in precise colors only where and when certain processes occur (see pages 64–69).

Spectophotograph of the Solar Spectrum

N. A. Sharp, NOAO/NSO/Kitt Peak

FTS/AURA/NSF, 2017

This stunning image is a very detailed view of the *visible* spectrum. However, it does reveal features of the visible spectrum that are *invisible* to the naked eye: those dark lines, called "absorption lines," that pepper the otherwise continuous band of colors. The lines are caused by atoms in the solar atmosphere absorbing light of precise frequencies—photons (see page 48) whose energy exactly matches that needed to promote an electron from one energy level to another within the atom. Since each kind of atom (element) has a unique set of energy levels, these dark lines allow scientists to identify the elements that populate the Sun, without ever having to visit. +++

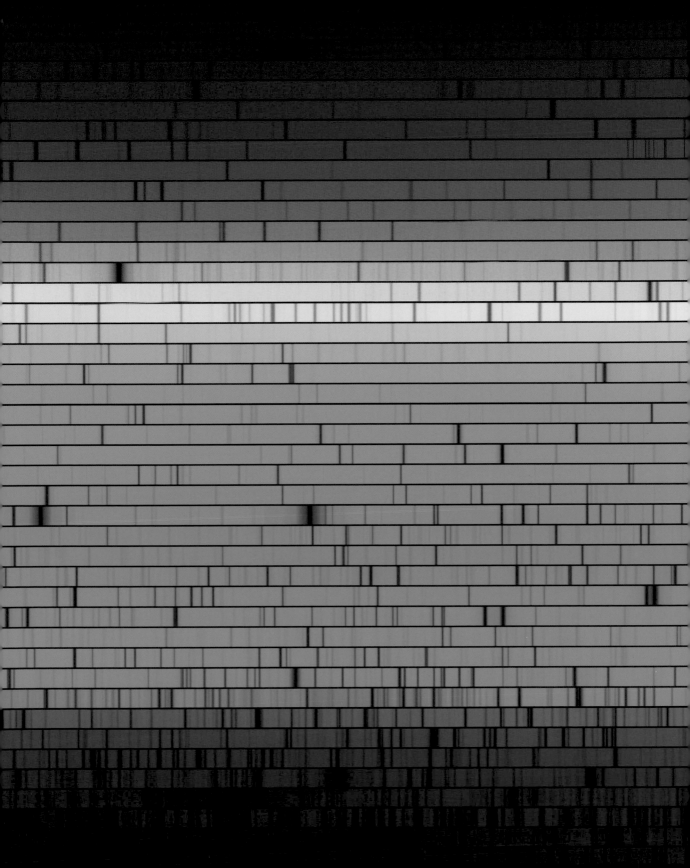

High-Resolution Image of the Sun

NASA's Scientific Visualization Studio, 2017

This beautiful high-resolution image of the Sun was captured by the Atmospheric Imaging Assembly (AIA) onboard NASA's Solar Dynamics Observatory (SDO). The AIA consists of four telescopes, each with a filter at the aperture (the opening at the front) that blocks visible light and infrared. Then, inside each telescope is a selection of two filters on a wheel, each of which allows precise wavelengths through to an image sensor at the focal plane of the telescope.[8] This particular image, highlighting sunspot activity, was made with ultraviolet radiation of a frequency known to be emitted by iron ions at extremely high temperatures. +++

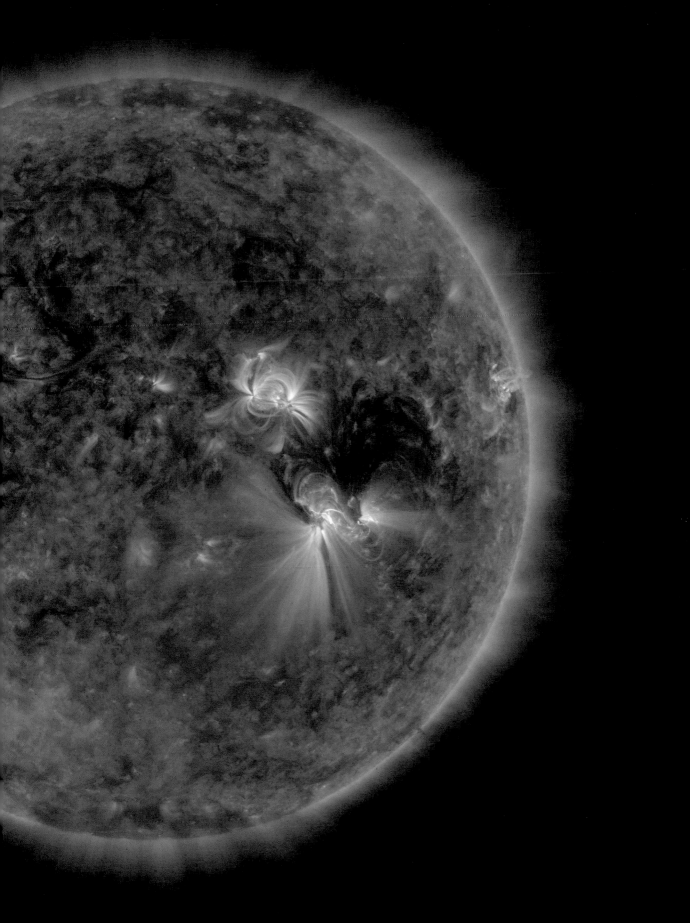

Many of the most interesting sources of invisible electromagnetic radiation—radio waves, ultraviolet, X-rays, and gamma radiation—are astronomical objects. Radio waves and long-wavelength microwaves easily make it through the atmosphere, so radio telescopes are normally ground-based. But large swathes of the electromagnetic spectrum are partially or fully absorbed as they pass from Earth to space. The only way of obtaining clear images of (and other information from) astronomical sources of short-wavelength microwaves, as well as infrared, ultraviolet, X-ray, and gamma rays is to launch telescopes into space. The images here and overleaf were all captured from space, by the European Space Agency's (ESA) Planck spacecraft, which orbited Earth from 2009 until 2013. They all show the same thing: a view of the whole sky, with one very prominent feature, the Milky Way.

Wherever you are in the world, if you gaze up at a dark, clear night sky, you will see it: a fuzzy, milky-white band punctuated by myriad stars. The milky background is actually made up of countless dimmer stars, too dim to see as more than a collective ghostly glow (see page 12). The fact that this region of the celestial sphere is much richer in stars than the rest of the sky is explained by our particular position in space. We live near the edge of a collection of several hundred billion stars: the Milky Way Galaxy. And just as an inhabitant of the suburbs of a large town would see many more streetlamps gazing into town than out of it, so it is with the galaxy. Look directly away from the center of the galaxy (the galactic anticenter, in the constellation of Auriga), and there is a relative paucity of stars. Look toward the galactic center (in the constellation of Sagittarius), and you will see many more of our stellar city's lights.

The shape of our galaxy is a bulging disk with spiral arms (our solar system is, in fact, in one of those spiral arms; see page 262), and it is a few hundred thousand light-years in diameter. This is why the Milky Way appears as a wide band across the sky, and not just a bright patch in one place. With the naked eye, even aided by a telescope, visible light from the stars is all we can see. But stars emit more than just visible light—and the Milky Way Galaxy contains much more besides stars, including objects that emit radio waves, microwaves, infrared, ultraviolet, X-rays, and even gamma rays.

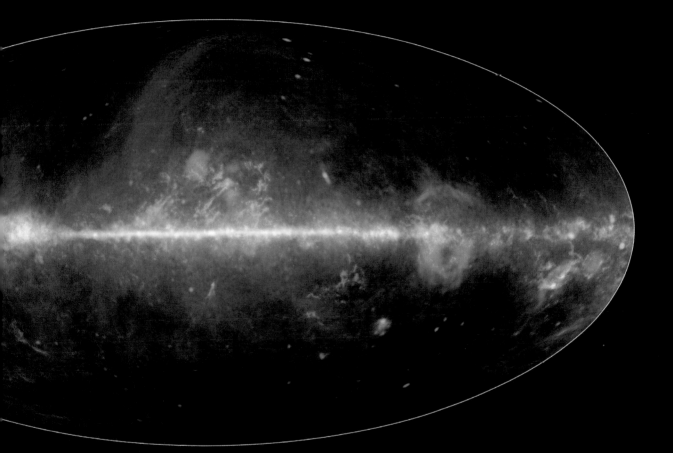

Whole-Sky Composite

Planck satellite (ESA / LFI and HFI Consortia), 2018

This remarkable image shows the whole sky, with the Milky Way particularly prominent, though it looks very different from how the Milky Way appears to the naked eye. It is, in fact, a composite of the four images overleaf, all captured by cameras aboard the Planck satellite. The colors are, of course, false: the radiation captured by the instruments is invisible, and therefore has no color. Each of the images overleaf is a monochromatic image in which the brightness represents the intensity of one wavelength or a small range of wavelengths.

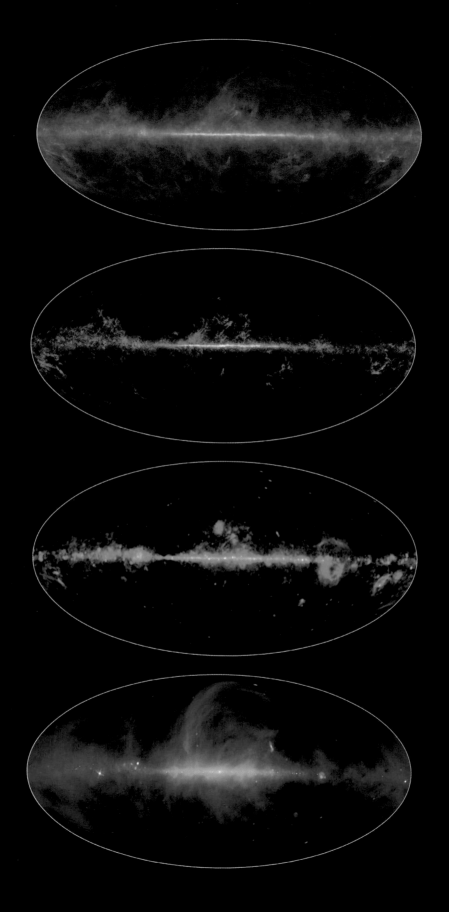

False-Color Whole-Sky Maps
Planck satellite (ESA / LFI and
HFI Consortia), 2018
The colors in these images
correspond to radiation from
the following sources, top
to bottom: interstellar dust
(infrared); carbon monoxide
molecules (microwaves); free
protons and electrons in plasma
(microwaves); and electrons
accelerated by magnetic fields
(microwaves).

On these pages are the four component images that make up the composite image on the previous pages. These images are, in a sense, a by-product of Planck's main mission, which was to produce a very detailed map of the cosmic microwave background (CMB), the thermal "afterglow" of the big bang. In order to construct such a map across the whole sky, long-wavelength radiation from sources within our own galaxy had to be discounted, and therefore had to be measured. Two instruments onboard measured specific frequency ranges: one detected long-wavelength microwaves, the other shorter-wavelength microwaves and infrared.

Infrared is often called thermal radiation: every object emits it, and the intensity and spectrum of the emission depends upon the object's temperature. (Of course, when an object's temperature is high enough, the spectrum of its thermal radiation extends into the visible range; this is why the Sun and candles glow, for example.) The orange-red-colored image is a far infrared map of the sky, and shows thermal radiation from very cold dust (only about 20°C/36°F above absolute zero) that would otherwise be invisible. This interstellar dust is present throughout the galaxy, and although it does not visibly glow, it can block radiation from other objects beyond it. Radio waves and microwaves, however, penetrate through dust clouds as visible light does not—so the microwave emissions of carbon monoxide molecules, also very common across the galaxy, form a bright image, here colored yellow. As you can see, carbon monoxide is concentrated along the central plane of the galaxy, unlike the dust, which is spread more evenly throughout.

Also concentrated largely along the central plane of the galaxy is plasma, a high-temperature gas consisting of charged particles. The green-colored image is a map of microwaves produced by protons and electrons (positively and negatively charged respectively) slowing down as they pass each other in the hot plasma that surrounds massive stars. The final image, colored blue, shows microwaves emitted by fast-moving electrons that have been thrown out by energetic processes such as supernovas (the violent end-of-life explosions of larger stars). Like any charged particles, such electrons only emit radiation when they are accelerating: speeding up, slowing down, or changing direction. The radiation given a blue color is synchrotron radiation, produced when those electrons spiral in the galaxy's magnetic field.

After removing the radiation from these galactic sources (and some other, extragalactic ones), the joint ESA and NASA Planck team produced an extremely high-resolution, whole-sky map of the cosmic background radiation (see pages 110–111)—one that supports and fine-tunes the big bang theory of the origin of the universe.

False-Color Image of a Supermassive Black Hole
International collaboration, 2019

This remarkable picture, the result of a collaboration between two hundred scientists, is the first-ever image of a black hole. Matter falling into a black hole produces radiation across the electromagnetic spectrum; this image, released in 2019, was constructed from radio waves, gathered by radio telescopes at eight sites across the world in 2017. The dark center is the black hole itself; the orange is a map representing the radio wave intensity. The black hole, found at the center of Galaxy M87, is rotating, and that gives the radiation on one side of the orange ring a boost—that is why one side is brighter than the other. +++

Many objects glow with invisible radiation. In 1896, while investigating the *visible* glow that certain uranium-rich minerals produce (as a result of phosphorescence), physicist Henri Becquerel discovered that those same minerals also produce an *invisible* glow. Unknown to Becquerel, uranium atoms inside the minerals were disintegrating, releasing subatomic particles and high-energy electromagnetic radiation from their nuclei. Both the (alpha) particles and the (gamma) radiation affect the light-sensitive emulsion on a photographic plate, causing the fogging.

+++

False-Colored Computed Tomography (CT) Scan of a Peruvian Mummy

Naval Medical Center, San Diego, 2011

Sometimes, it is not the electromagnetic radiation produced by an object that is of interest, but rather the way radiation interacts with an object. So it is with X-ray imaging technologies, which make use of the fact that X-rays pass through some materials more easily than others. In CT scanning, radiographers send X-rays through an object at many different angles and measure how much radiation makes it through. By comparing the values for each of the angles, a computer can work out the density variations inside the object—so this technique can differentiate, say, bone from other tissue.
+++

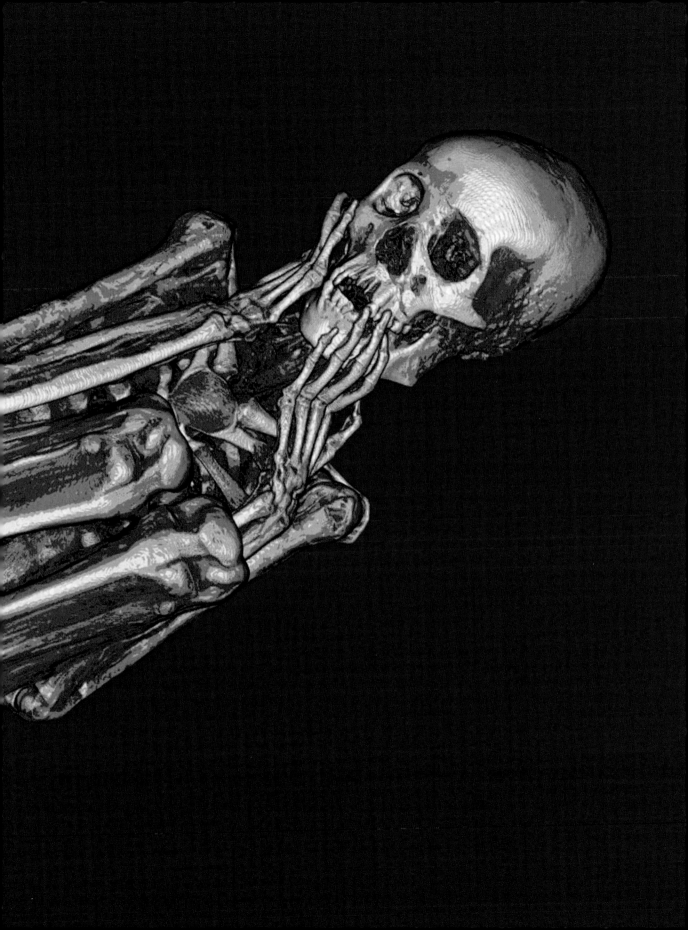

These beautiful images feature three of California's Channel Islands (left to right: San Miguel, Santa Rosa, Santa Cruz). Above them is a small section of the Californian coast that includes Santa Barbara. Both images were taken by the Operational Land Imager onboard NASA's Landsat 8. The image on the left was taken using visible light. The right-hand image was taken by a camera sensitive to near-infrared (a wavelength only slightly longer than visible light). Vegetation strongly reflects near-infrared waves; these pictures were part of a study on kelp forests around these islands, which are clearly visible in the infrared image. Near-infrared images also enhance the boundary between water and land, because water strongly absorbs near-infrared energy. +++

Fluorescence Micrograph of a Mouse Blastocyst

Jenny Nichols, Wellcome Trust Centre for Stem Cell Research, date unknown

The phenomenon known as fluorescence occurs when electromagnetic radiation of one frequency excites (energizes) a substance and causes it to produce electromagnetic radiation of a different, lower frequency. Typically, the incoming radiation is (invisible) ultraviolet, and the fluorescent glow is visible light. (This is why fluorescent makeup and clothing glow brightly under "black lights.") Fluorescence microscopy involves staining a sample with fluorescent dyes. The dyes are absorbed specifically by different parts of the sample—different organelles within a cell, for example. This enhances the contrast in the image and highlights certain features above others. Samples are then illuminated by radiation with precise frequencies (which can be ultraviolet or visible light), so that only the parts of the sample with fluorescent dyes will glow. As a result, even the background is black, enhancing the contrast still further. In this image of a mouse blastocyst (pre-embryo), a protein called Oct-4 inside the nuclei of undifferentiated (not-yet-specialized) stem cells is stained with fluorescent pink; another protein called Nanog, also a marker of undifferentiated cells, is stained fluorescent green; and the nuclei of the outer cells are stained with fluorescent blue. +++

Human Cells Under a Fluorescence Microscope

Dr. Torsten Wittmann, date unknown

Here, again, different components of living cells absorb different fluorescent dyes: chromatin in the cell nucleus glows red; actin in the cytoskeleton glows blue; tubulin in the cytoskeleton glows yellow. The cytoskeleton is a scaffold of long tubes that enable the cell to maintain its shape. Each tube is made of thousands, or millions, of protein molecules joined together. The tubes shrink and grow dynamically, as protein molecules join or leave the ends of the filaments. This is how a cell can change shape in response to its surroundings or its needs. +++

Fluorescence Micrograph of Genetically Modified Mosquito Larvae

Heiti Paves, 2010

This image shows genetically modified mosquito larvae (*Anopheles stephensi*) expressing green fluorescent protein (GFP). First isolated from the jellyfish *Aequorea victoria*, GFP is very popular among cell molecular geneticists. Typically, a researcher will insert a gene that codes for GFP into an organism's genome, close to another gene that is under study. The GFP gene can then act as a "reporter": whenever and wherever the target gene is expressed, the GFP gene will also be expressed, and so the fluorescent protein will be produced. This gives researchers the opportunity to watch otherwise invisible gene expression play out in real time. +++

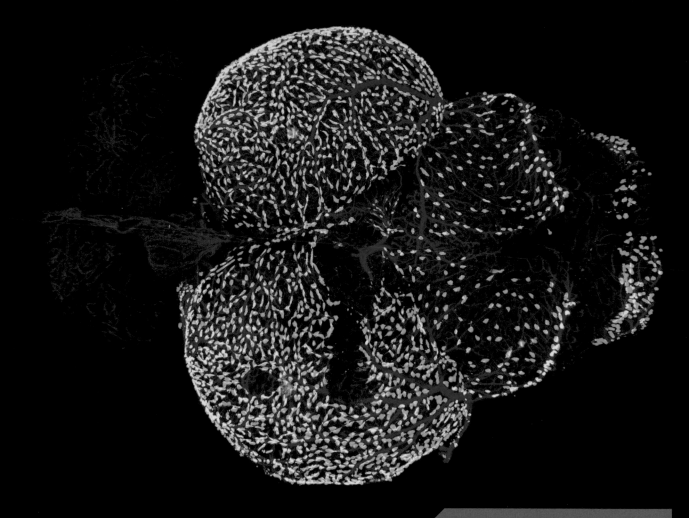

Fluorescence Micrograph
of the Brain of an Adult
Zebrafish (Danio rerio)
Ingrid Lekk and Steve Wilson, 2015

Above the dense network of blood vessels
(red) that serve the fish's brain is a collection
of cells (glowing yellow-green) called
fluorescent granular perithelial cells (FGPs[9]).
These cells sit close to blood vessels in the
blood-brain barrier, which isolates the brain
from potential toxins in the blood. FGPs
absorb cellular waste products, including
naturally fluorescent chemicals produced by
the breakdown of fats. +++

Fluorescence Micrograph
of Human Derived Cells

ZEISS Microscopy, 2016

A green fluorescent dye has stained a
protein called vimentin, present in the cells'
cytoskeletons. A blue fluorescent dye has
stained DNA in the nuclei. +++

Fields and Particles

The reality of fields

The notion of fields, originated by Michael Faraday in the 1840s (see page 11), has become a central theme in modern physics. Mathematically, a field is simply a set of values of a particular quantity, such as density, force, or temperature, that represents how that quantity varies across space. The two pillars of modern physics—relativity and quantum mechanics—led physicists to consider certain fields as fundamental parts of physical reality, rather than just mathematical constructs. According to "quantum field theory," there are dozens of physical fields that fill all of space, and fundamental particles are considered to be excitations, or quanta, of these fields. So, electrons are quanta of the "electron field," just as photons are quanta of the electromagnetic field (see page 48).

The roots of quantum mechanics lie in advances made in the second half of the nineteenth century, notably the discovery of the electron (1897, see page 72) and radioactivity (1899; see page 74). Developments in the understanding of processes and objects at the atomic and subatomic scale—things far too small to be seen— were extremely rapid in the first few decades of the twentieth century. Although these developments were fueled by theory and experiments in which the fields and particles remained unseen, the visible tracks of cosmic rays on photographic plates (see page 73) and of particles inside bubble chambers (see page 74) provided crucial evidence that helped foster these developments.

Seeing atoms

The limitations on the resolution of optical microscopes, and even electron microscopes (see page 20), mean that electrons, atoms, and molecules can never be seen directly. For decades, many scientists resigned themselves to the idea that these things would never be seen directly. But in the 1980s, scientists at IBM invented a revolutionary tool that produces stunning, detailed images of atomic surfaces. Gerd Binnig and Heinrich Rohrer's invention was the scanning tunneling microscope (STM). Inside an STM, a probe with an extremely sharp tip scans across a metal surface, registering the undulations of the surface that define the shapes of the atoms there.

Later developments in "scanning probe microscopy" have brought the ability to visualize a wider range of materials. In a sense, scanning probe microscopy does not belong in chapter 1: the images it produces are generated inside a computer, from data, where each datum is a number representing the force between the probe and an atom at one point of the surface, or the height of the probe. As such, they bring us neatly to chapter 2, which examines the importance of visual representations of data.

Photograph of Iron Filings Aligning with Magnetic Field

Windell Oskay, 2010

Iron is ferromagnetic, which means it becomes magnetized when placed within a magnetic field. As a result, each of the iron filings lining up in the invisible field around this bar magnet is itself a tiny magnet. This is why it aligns with the lines of force that make up the field. In the nineteenth century, the fact that magnetic fields could be visualized so easily gave weight to the notion that they are real entities, and not just mathematical constructions. This, in turn, fueled the development of modern physics in the late nineteenth and early twentieth centuries. +++

Photograph of a Cathode-Ray Tube

Andrew Lamert, date unknown

This photograph captures the trajectory of electrons in a cathode-ray tube, made visible via phosphorescence. In a cathode-ray tube invisible rays pass from the cathode (negative terminal, glowing white) toward the anode (positive terminal, Maltese cross). Some miss the target and hit the screen, making the phosphors there glow green. Physicists began studying these "cathode rays" in the 1860s; in 1897, Joseph John Thompson discovered that cathode rays are streams of particles, each one lighter than an atom. The existence of invisible, negatively charged particles invigorated the search for understanding of atomic structure. One result of that search was quantum mechanics; ironically, perhaps, that new discipline proved that electrons are waves in a field as well as discrete particles. +++

Cosmic-Ray Collision Caught in a Photographic Emulsion

Professor P. Fowler, 1940s

One phenomenon that puzzled physicists at the beginning of the twentieth century was that Earth's atmosphere becomes increasingly ionized (electrically charged) with increasing altitude. By the 1920s, physicists realized the reason for this was the presence of "cosmic rays"—charged particles arriving from space. In the 1940s, photographic emulsions sent into the upper atmosphere captured the tracks of these invisible particles. Here, a high-energy iron nucleus from space shoots into some photographic emulsion and collides with an atomic nucleus in the emulsion, creating a spray of secondary particles called mesons.

+++

Bubble Chamber Photograph
Patrick Blackett, 1920s

Two discoveries at the end of the nineteenth century prompted interest into all things atomic and subatomic: the electron and radioactivity. There are three kinds of radioactive emission: alpha and beta are charged particles, while gamma is electromagnetic radiation. Here, invisible alpha particles from a radioactive source (bottom, out of shot) produce tracks of tiny bubbles in a chamber of liquid helium. One hits an invisible helium nucleus, which has the same mass. As a result, the two bounce off each other at 90 degrees (the angle here is slightly foreshortened due to the angle at which the photograph was taken). +++

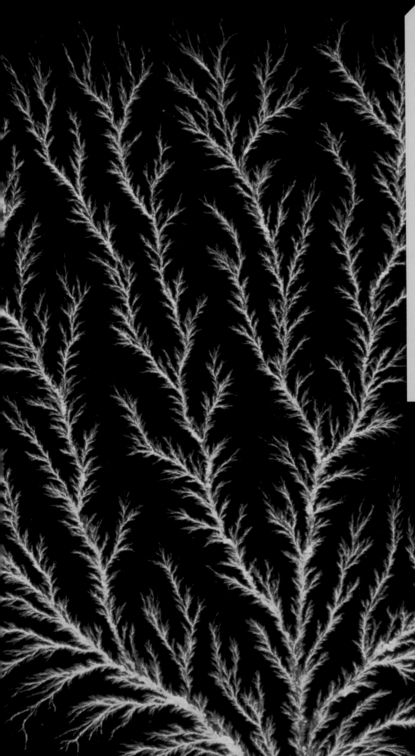

Photograph of an Electron "Tree"

Captured Lightning, date unknown

This electron tree is another way to visualize invisible electrons—or, at least, their presence and their behavior. This one is in a block of plastic 15 centimeters (6 inches) square and 2.5 centimeters (1 inch) thick. A beam of high energy electrons penetrates a little way into the block and stops. Electrons accumulate there, and their mutual electric repulsion begins to force them apart. A gentle tap with a metal punch releases the electrons suddenly and that repulsion causes them to shoot out like lightning, leaving a pattern of tracks that becomes frozen in the plastic, here illuminated with blue light. +++

False-Color Scanning Tunneling Microscope (STM) Image of a Gold Surface

Erwin Rossen, 2006

Despite the rapid advances that quantum mechanics brought to physicists' understanding of the atomic realm, atoms themselves remained frustratingly invisible until the 1980s. In this stunning image, individual gold atoms, too small ever to see directly with light, are clearly visible. (Strictly speaking, they are gold ions, since some of the electrons are free to move around within the crystal.) The image was created by scanning a probe with an extremely sharp tip back and forth across the surface, registering the force between the probe and the atoms, and adjusting the height accordingly. A computer then constructed the image from the probe's variations in height. +++

Colorized Atomic Force Microscope (AFM) Image of an Individual Molecule

IBM researchers, in collaboration with the Center for Research in Biological Chemistry and Molecular Materials (CiQUS) at the University of Santiago de Compostela, 2016

After the STM (see page 70), the AFM, invented in 1985, was the second of many developments of scanning probe microscopy. It measures the force between the probe tip and the surface, and can even be used to manipulate individual atoms. By combining AFM and STM, a team of scientists managed to cause a reaction to occur in a single molecule.[10] The starting point, shown here, was a molecule of 9,10-dibromoanthracene. The researchers first used the probe tip to remove the two bromine atoms (bright dots at the top and bottom). The resulting molecule could be "switched" between two states by further manipulations with the probe tip. +++

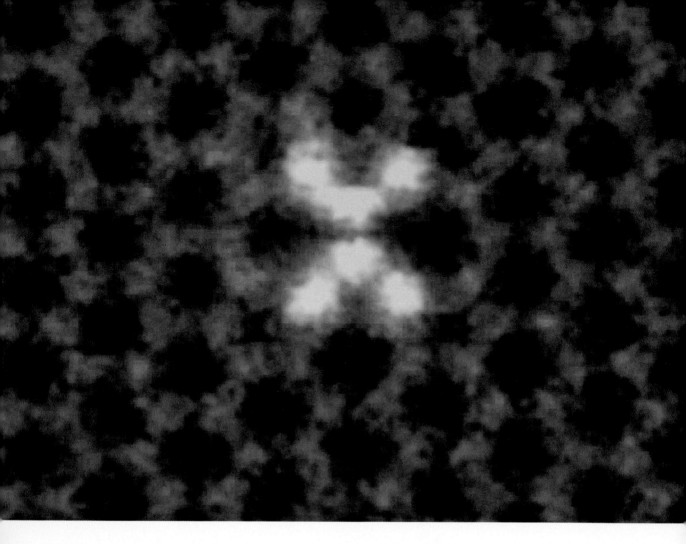

Scanning Transmission Electron Microscope (STEM) Image of Silicon Atoms on Graphene

Oak Ridge National Laboratory, Center for Nanophase Materials Sciences, 2018

STEMs are traditional transmission electron microscopes (see page 20) that are able to produce a very focused electron beam that scans back and forth with extreme precision over tiny distances. Since the late 1990s, physicists have used them to produce atomic-scale images. Graphene (brown in this image) is a form of pure carbon, in which the carbon atoms are arranged in hexagons in a layer one atom thick—easily thin enough, even with the silicon atoms (yellow) on top, for the electron beam to pass through and produce this remarkable image. +++

STM Image of a
Single Atom
Stan Olswekski for IBM, 2017

This atom of the element holmium was used in research aiming to utilize individual atoms to store data.[11] Every atom has an associated magnetic field, which can be in one of two orientations. The STM that captured this image was also able to deliver tiny electrical pulses that flipped the field orientation back and forth. This two-state system is ideally suited to computing, since each state can correspond to a binary digit (bit): a 0 or a 1. The fact that it is atoms that are storing the data also means that a system such as this could be utilized in quantum computing, a development that promises to revolutionize computing. +++

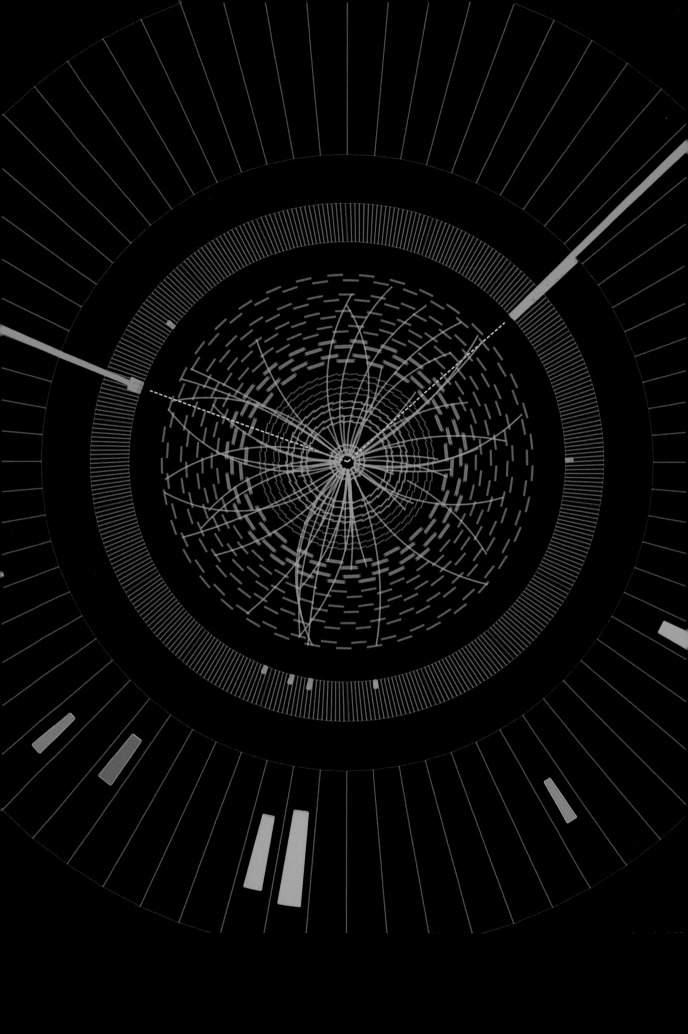

2: Data, Information, Knowledge

The word "science" comes from the Latin *scientia*, meaning "knowledge"; science is a quest for knowledge about the world in which we live. In modern science, knowledge is not gained by faith, or even common sense. It comes by creating and testing hypotheses. To generate hypotheses, one needs information, and in order to produce information (and also to test those hypotheses), one needs data. This hierarchy—with "wisdom" added at the top—is referred to as the "data, information, knowledge, wisdom" (DIKW) pyramid; in science, wisdom is optional, though very much desired. This chapter considers the importance of visualization in making sense of data, in communicating information, and in passing on knowledge.

Decay of a Higgs Boson
CMS, CERN, 2012

The CMS (Compact Muon Solenoid) is a detector in the Large Hadron Collider (LHC) at CERN, on the Swiss-French border (see also, pages 104–105). This intriguing image was constructed inside a computer, from data gathered by an array of instruments that measure the energies and momenta of subatomic particles. Those data can help support or refute hypotheses in particle physics, and visualizing them in this way is a crucial part of the process.

Visualizing Data

The importance of data in science

There are other fields of human endeavor, besides science, in which data (singular "datum") play a vital role; politics and business are notable examples. And there, too, visualization is crucial, to help people make sense of their data and to communicate those data with others. In science, data come in many flavors—they could, for example, be measurements of distance, speed, electric charge or time, observations of animal behavior, or the colors of stars. One important use for data is the production of reference materials (see page 94)—for example, databases containing the melting and boiling points of various substances, the positions of galaxies in the sky, or records of population numbers of particular species in an ecosystem. But most scientific data have a different purpose, and one that lies at the heart of the scientific method.

 Scientists formulate theories to explain and predict features of the real world; the hypotheses on which those theories are built must therefore be tested rigorously, by gathering and analyzing real-world data. That may seem obvious today, but until about four hundred years ago, people we would now think of as scientists—those with a thirst for knowledge about how the world works and what it is made of— relied upon logic, common sense, and even confident guesswork rather than on observational data. The ancient philosopher Aristotle epitomizes this approach. He wrote volumes about physics, chemistry, biology, astronomy, meteorology, and geology, but he created his theories in these subjects using a system of pure logic that he devised; he did not test his ideas, as scientists today would be duty bound to do. Aristotle's logical system, and his theories, prevailed for many centuries. Although scientists during that time did, of course, carry out practical investigations, none of them used data from their investigations systematically to test their hypotheses. The result was a body of knowledge that changed extremely slowly, held back by dogma—and inevitably, when new knowledge was founded, it was often false.

Empiricism

The modern scientific method has its roots in the sixteenth century. It developed hand in hand with the rise of empirical philosophy. Empiricism is the belief that all knowledge comes from experience of the world, *a posteriori* ("after the fact"). Its opposite is rationalism—the belief that some, or all, of our knowledge about the world is derived from reason alone, including those truths held to be self-evident ("before the fact," or *a priori*). Logic and reason are still clearly very important in science, and particularly so in mathematics, a subject in which *a priori* knowledge provides the foundations, but a reality check is always required. An early proponent of the empirical approach to science, often credited with establishing the basis of the scientific method, was Francis Bacon, who in 1620 published *Novum Organum*. The title of

Bacon's book refers to Organon, a collection of works written by Aristotle, setting out his approach to finding knowledge through logical deduction. Bacon's book was a criticism of Aristotle's system. While debates raged between empirical and rationalist philosophers in the seventeenth and eighteenth centuries, empirical science itself raced ahead, generating knowledge at an ever-increasing pace. With data now so crucial to science, finding ways to visualize them became increasingly important.

Having said that, there are instances where there is no need for scientists to produce a visualization of their data. For example, some experiments require only simple observations. And there are a number of techniques or scientific instruments that produce a direct visual output of the data they collect; X-ray crystallography (see page 85) and the seismograph (see page 86) are examples of this. But most experiments across all scientific disciplines produce a collection of individual measurements that are hard to interpret without visualization, and nearly all scientific research papers include images that represent data. An experiment might result in thousands of temperature readings, or the weights of hundreds of moth larvae, the lengths of dozens of flower petals or the masses of different solvents dissolved in a solution.

Cartesian coordinate system

The most commonly used tool for data visualization is the Cartesian system, on which data are plotted as coordinates in the space defined by two or more axes at right angles to each other. This system was devised by one of Francis Bacon's contemporaries and, ironically perhaps, very much a rationalist in his approach to science: René Descartes. According to legend, Descartes devised the system while watching a fly on the ceiling above his bed, wondering how he might describe the animal's location at any given moment. He realized that one of the corners of the ceiling could be used as a fixed point of reference (the "origin"). Plotting data sets as Cartesian coordinates makes them immediately accessible, even to the untrained eye. Probably the first scientist to use line charts to visualize data using Cartesian axes was Edmond Halley, who plotted readings of atmospheric pressure at different altitudes, in 1688.[1] But line charts only became commonplace in science (and other fields) after the work of engineer William Playfair in the eighteenth century (see page 116).

Plotting each of two variables on a different axis creates a "bivariate" chart, which can highlight correlations between quantities (see page 96); using measurements of time along the x-axis clearly shows how a certain quantity develops (see pages 98–99). It is also possible (in fact, typically required) when displaying data graphically, to show margins of error—to account for the fact that no measurement is perfectly accurate or completely reliable (see pages 94–95). Cartesian systems

are not restricted to two axes: they can have three or even more—though this can be difficult to visualize. One way to show the relationships between more than two variables is to assign one of the variables at each point of a Cartesian space a color, depending upon its value there. You can see this in the map of the Chicxulub crater (see page 112) and the graphical display of a dolphin's call (see page 100).

The importance of computers

Most modern scientific instruments—from mass spectrometers to magnetometers—produce electric voltages as their output that reflect the quantity being measured. These are often logged automatically, as streams of binary numbers stored in databases on a computer. This is increasingly important in modern science, much of which relies on vast amounts of data (see Big Data, page 102). And computers are useful not only in storing, but also in producing the visualization of the data. It is commonplace for scientists in most disciplines to task their computers with producing clear and engaging visuals, not only in order to analyze the data for themselves, but also to share that data with colleagues and the wider public.

Some of the visualizations in this first part of chapter 2 would have been quite at home in chapter 1, for they are essentially images or maps, effectively making invisible things visible. For example, on pages 110–111 we feature three maps of the cosmic microwave background (CMB), with increasing resolution. They were produced in the same way as the multi-wavelength images of the Milky Way in chapter 1 (see pages 54–57). But featuring these images here emphasizes the fact that they are created from data produced by scientific instruments—in this case, radiometers, which measure the intensity of radio waves coming from a small part of the sky. Moreover, in the case of the CMB, the incredible improvement in resolution was literally made possible by enormous increases in the amount of data collected.

Photo 51, X-Ray Crystallography of DNA

Raymond Gosling and Rosalind Franklin, 1952

Here is an example of a technique that produces its own data visualization. X-rays have a wavelength close to that of the spacing between the atoms in a crystal. The X-rays therefore diffract around (their paths are bent by) the atoms, and as they reach the photographic plate, they create an "interference pattern" consisting of bright dots and lines, and darker areas. The resulting pattern provides data for crystallographers working out the positions of atoms in a crystal. In this case, the pattern was a crucial clue in the quest to discern the structure of DNA (deoxyribonucleic acid, see page 147). +++

Seismograms of the 1906 San Francisco Earthquake

April 18, 1906

The seismograph is an instrument that produces its own visual data—the lines (that constitute the seismogram) are a direct analogue of the movement of the ground beneath the recorder. Several modern seismograph designs originated in the 1870s and 1880s, including engineer James Ewing's unusual double pendulum design, which produced the chaotic two-dimensional pen trace seen in the Carson City image. The two traces that represent the shaking of the ground as more familiar horizontal wavy lines are from widely separated locations: Albany, New York, and Cairo, Egypt. The times and amplitudes of the ground's movements at different locations allow seismologists to work out how the vibrations travel through Earth's crust. +++

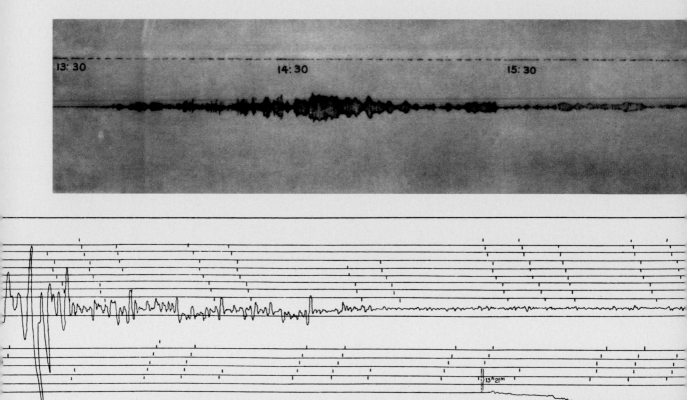

ALBANY, N. Y. Bosch-Omori Seismograph. (*From photographic copy.*) Correction to G. M. T.=+20ˢ.

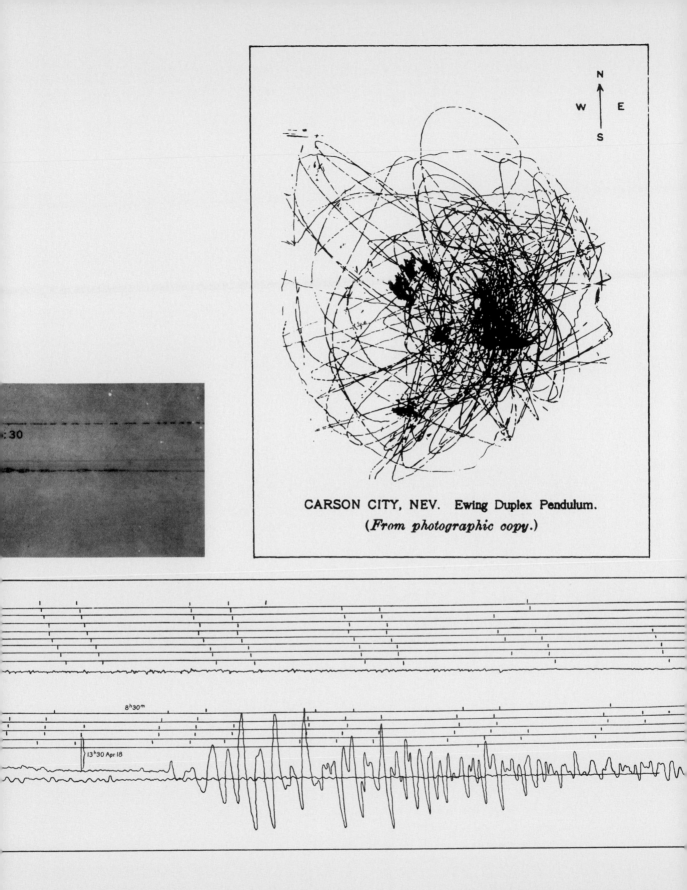

CARSON CITY, NEV. Ewing Duplex Pendulum.
(*From photographic copy.*)

The Complete Sequence for the Human Gene INSR

Author's own work, from public database, 2021

The four letters in this sequence—A, C, G, and T—represent nucleobases, groups of atoms that sit along the double helix of the DNA that constitutes the gene. These bases (adenine, cytosine, guanine, and thymine) are the basis of the genetic code that carries the instructions required to build proteins—in this case, a receptor for insulin. The human genome—the entirety of the DNA contained in each cell—holds between 20,000 and 25,000 genes, and a total of three billion bases. Sequence data for all human genes is available in freely accessible databases. +++

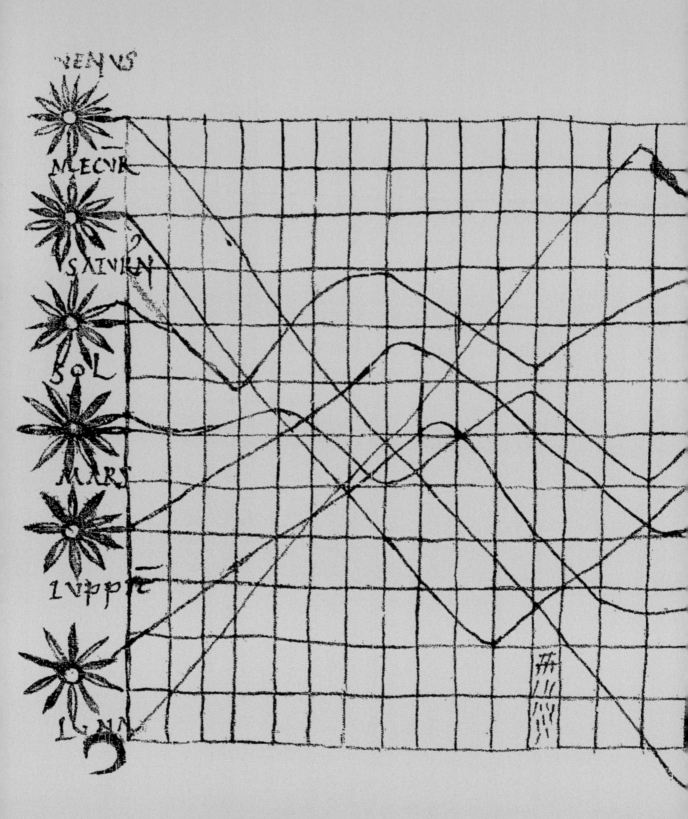

The charts that scientists commonly use to display and analyze data are powerful tools, and they are intuitive—so much so, that some people made charts resembling Cartesian spaces long before Descartes formulated his system of coordinates (see page 83). An unknown astronomer produced this diagram as part of their lecture notes for teaching at a monastery. It shows how the Sun, Moon, and planets change their positions in the sky. The horizontal and vertical lines make this image reminiscent of graph paper, which only became commonplace in the late nineteenth century. +++

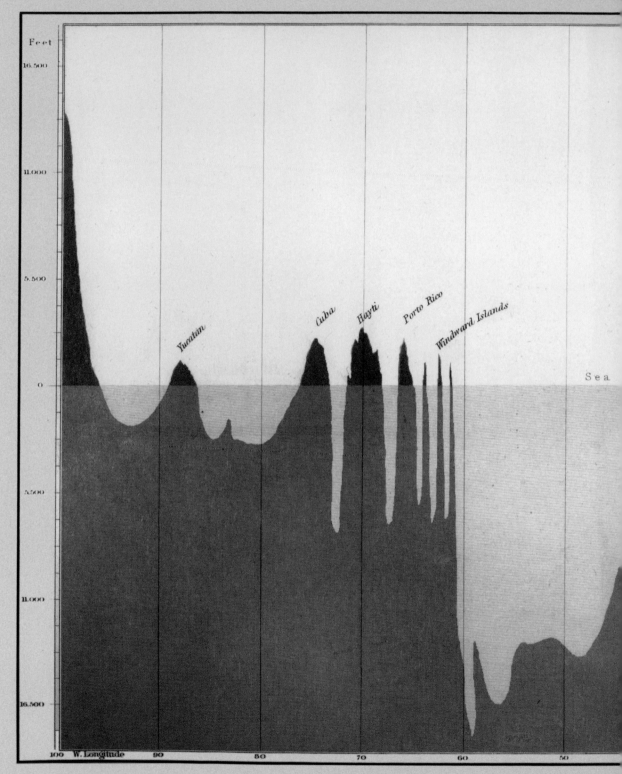

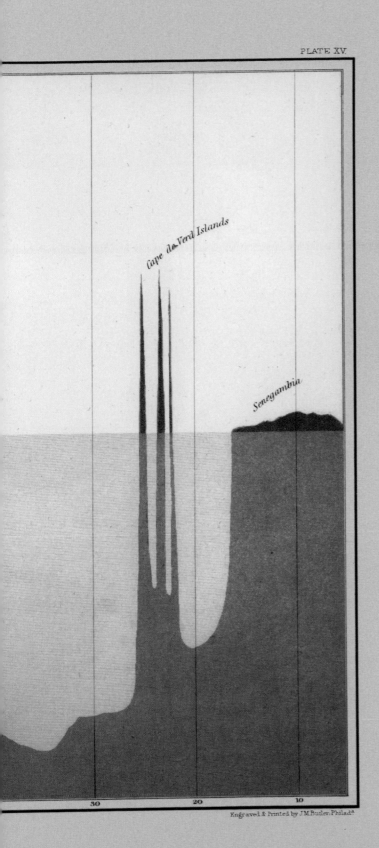

PLATE XV.

Cape de Verd Islands

Senegambia

30 20 10

Engraved & Printed by J.M.Butler, Philadª

First-Ever Profile of an Ocean Basin
Matthew Fontaine Maury, 1854

This remarkable chart, showing the depth of the ocean versus longitude for a line across the Atlantic Ocean, was produced by astronomer and oceanographer Matthew Fontaine Maury. Sailors had conducted "soundings" in rivers and shallow seas since ancient times, dropping heavy weights into the water from a boat to measure the water's depth. But nothing was known about the nature of the deep ocean floor until Maury organized two expeditions in the early 1850s. Plotting the results of many soundings on a chart (vertical scale exaggerated), he found a shallow region centered around longitude 45 west. This was the first inkling of the existence of the Mid-Atlantic Ridge (see also, page 208). +++

Chart Showing Intensity Versus Wavelength of Light

Karl Vierordt, 1873

The curves in this beautiful, hand-drawn chart show the intensity versus wavelength of light from an oil lamp. The chart appears in a book detailing how chemists can identify chemical elements by the amount of light they absorb at specific wavelengths. When carrying out that analysis, researchers have to take into account how the light source's intensity varies with wavelength, and this chart acted as a reference for that purpose. The measurements plotted on this chart were made by painstakingly *estimating* the dimming of light at many points in the spectrum—hence the fairly wide margin of error inherent in the measurements, as represented by the horizontal bars. The measurements are much more accessible when visualized on a chart like this, than in tables of numbers. +++

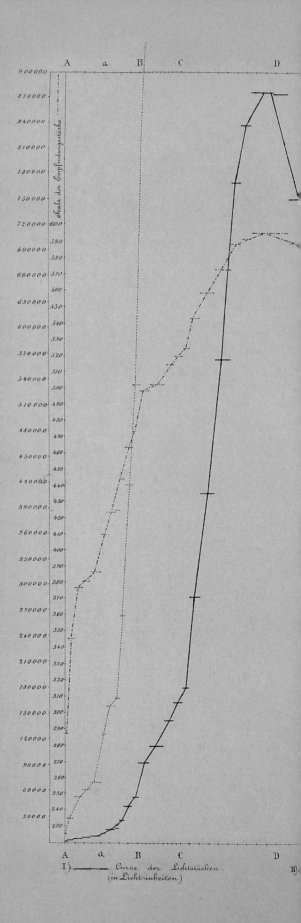

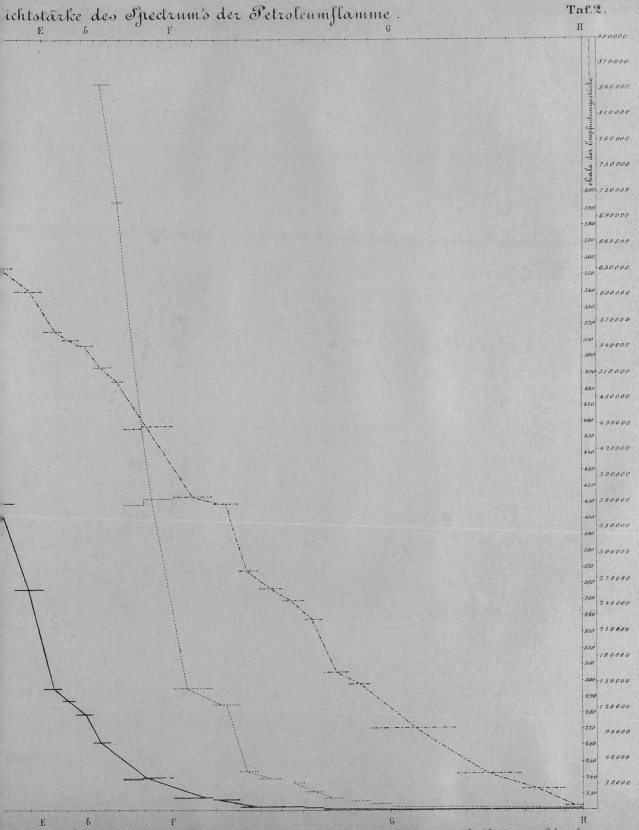

ielle Curve der Lichtstärken in minder hellen Spectralbezirken Ⅲ) _____ Curve der Empfindungsstärken (Logarithmen der Lichtsstärken).
(mit um das Zehnfache vergrösserten Ordinatenwerthen.)

Plot of Galaxies' Speed (Receding) Versus Distance from Earth

Edwin Hubble, 1929[2]

This chart provided the first evidence of the expansion of the universe. In an expanding universe, the more space between any two galaxies, the faster they are receding from each other. This correlation is immediately visible, and the various "best fit" lines Hubble has drawn are attempts to find the coefficient of expansion (the slope of the line). Hubble could only measure distances to relatively nearby galaxies, whose movement *through* space is statistically significant; hence the imperfect correlation. In the years since this chart was published, speeds of more distant galaxies have been measured, and corresponding plots show much more precise correlation, and allow for very accurate determination of that coefficient[3], which in turn provides an age for the universe. +++

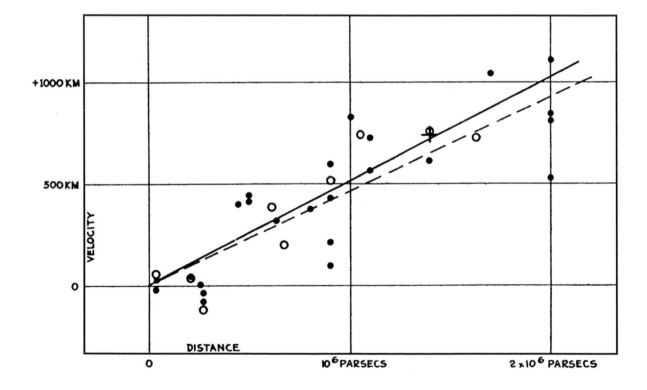

Plot of Animal Body Size Versus Metabolic Rate

Max Kleiber, 1947[4]

Here is another example of a data plot showing correlation—in this case, between the amount of heat produced by animals versus their body mass. Notice that both scales are logarithmic: each gradation on each axis denotes a multiple (in this case, ten) of the previous one. A straight line on a log-log plot (a plot with logarithmic scales on both axes) means that the correlation follows a "power law." Kleiber hypothesized that the heat produced would be proportional to the body mass raised to the power ⅔ (the line marked "Surface")—but the data showed the power was actually ¾ (the red line). The data points would have been on the line marked "Weight" if there was a direct correlation (a power of 1) between heat produced and body mass. +++

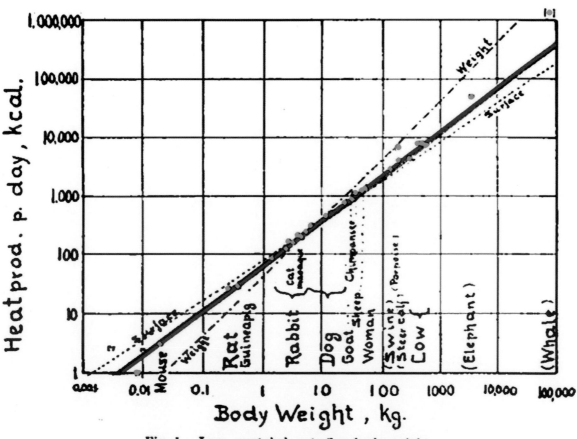

Fig. 1. Log. metabol. rate/log body weight

Chart Showing Global Temperatures Over the Past Thousand Years

Michael E. Mann, Raymond S. Bradley, Malcolm K. Hughes, 1999

This chart appeared in a scientific paper by climatologist Michael Mann and his colleagues.[5] Another climatologist, Jerry Mahlman, coined the term "hockey stick," because the sharp uptick at the right extreme of the curve is reminiscent of the blade of an ice hockey stick, while the steady decline in temperature in the rest of the curve represents the stick's handle. Mann and his team used data from many other researchers and databases to "reconstruct" global temperatures over the past millennium. Temperature records have only been kept systematically since the nineteenth century, so most of the data were indirect proxies. Data sources included the width of tree rings and the gases dissolved in ice cores taken from ice caps. +++

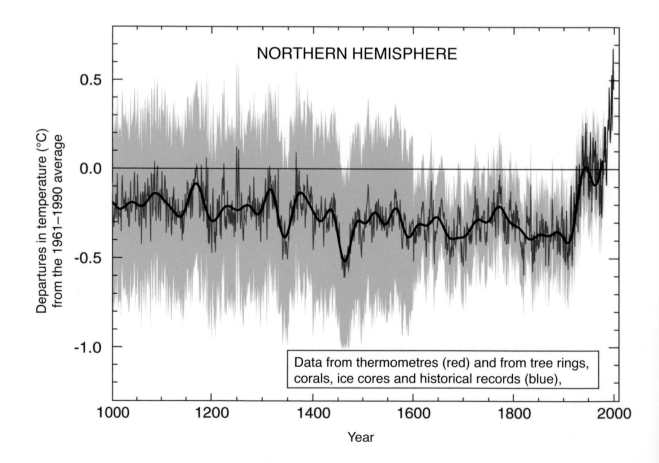

NORTHERN HEMISPHERE

Data from thermometres (red) and from tree rings, corals, ice cores and historical records (blue),

Chart Showing Atmospheric CO$_2$ Concentration, 1958–2021

Author's own work using data from the Scripps Institution of Oceanography, 2021

In 1958, geochemist and oceanographer Charles Keeling began monitoring the atmospheric concentration of carbon dioxide at Mauna Loa, Hawaii. The effort has continued ever since (even after Keeling died in 2005). Plotting the values of the concentration of carbon dioxide yield a curve, commonly referred to as the Keeling curve, that illustrates two clear phenomena. The first is a clear seasonal variation in the levels of atmospheric carbon dioxide, due to the fact that there are more trees in the northern hemisphere, which take up the gas as they grow during spring and summer. The second is the clear increase in overall levels of carbon dioxide—from 315 parts per million (ppm) in 1958 to nearly 420 ppm in 2021. +++

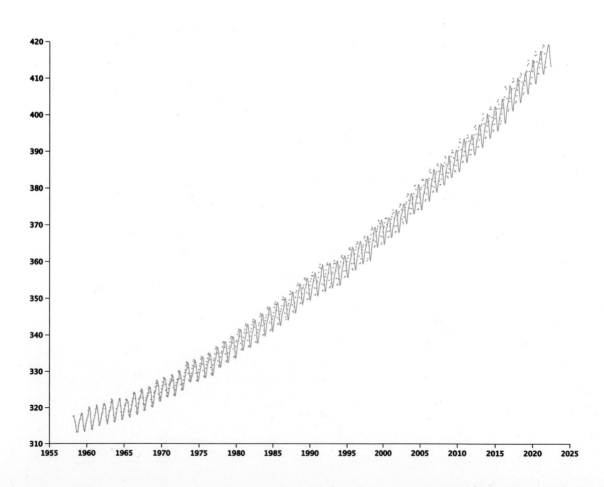

Vocalizations of a False Killer Whale Using Polar Coordinates

Aquasonic Acoustics, date unknown

This plot is in polar coordinates—essentially wrapping one of the Cartesian axes (here, the time axis) around in a circle, and is proof that data visualization can be beautiful and intriguing, as well as useful. It is a visualization of the high-frequency clicks, whistles, and cries of a false killer whale (*Pseudorca crassidens*), actually a species of dolphin. It was created by a technique called wavelet analysis: a mathematical function separates the raw signal into its component frequencies and displays them as a function of time.[6] Wavelet analysis also eliminates unwanted noise from the signal, allowing researchers to focus more clearly on the signal itself. +++

IN FOCUS:
Big Data

Many people will be familiar with the term "big data," in connection with business, government, and health care. As the name suggests, big data involves the storage and the analysis, or "mining," of huge volumes of data. Big data often attracts controversy over who owns the data and to what extent people's privacy is compromised, despite the obvious potential advantages in using the technology. This controversy is most prevalent in health care. Here, databases containing the medical records of millions of people can help track the effectiveness of medicines or study what factors influence the incidence of certain diseases—but those databases can contain the most personal of information.

There are no such issues in most other scientific applications of big data, where the data are most likely to be measurements from instruments such as voltmeters, calorimeters, or infrared spectrometers. In combination with artificial intelligence (AI), big data offers new approaches to science; with such huge amounts of data coming in, it is left to AI to filter out data that will likely not be relevant, and to predict and find patterns in what remains. As AI becomes increasingly powerful, it threatens to render the traditional hypothesis-driven scientific method obsolete. In its place would be "algorithms and statistical tools to sift through a massive amount of data to find information that could be turned into knowledge."[7] For now, however, the tools of data science are still being used within the established scientific process.

Big data is often characterized by three Vs: volume, variety, and velocity. It involves the collection of huge amounts (volumes) of data, often from a number of different sources and of a number of different kinds (variety), and typically arriving and being processed quickly (velocity). With such large amounts of data arriving rapidly, many computers carry out the storage and processing simultaneously (distributed storage and parallel processing). Whenever such large amounts of data are involved, another V—visualization—is going to be key.

One scientific application of big data in which visualization is perhaps the most important aim, is the tracking of animal movements. An international organization called Movebank[8] acts as a repository for data gathered by electronic tags that transmit signals to satellites, as well as ground-based information from researchers in the field. Movebank carries a wide range of data from more than two billion locations and offers scientists the data they need to face challenges such as "climate and land use change, biodiversity loss, invasive species, wildlife trafficking, and infectious disease."

Visualization of White-bearded Wildebeest Movements in Kenya
422 South and Movebank, 2020
The technologies that zoologists and ecologists use to record animals' journeys have come a long way since these researchers began tagging animals at the beginning of the twentieth century. Since the 1980s, researchers have had access to Argos, a global data collection system in which thousands of animals carry transmitters that convey data to a low-Earth orbit satellite. Since 2020, researchers have also had access to a much more sophisticated system called Icarus. Lightweight transmitters send a wealth of information to a receiver onboard the International Space Station. Movebank offers free access to data from Argos and Icarus, as well as data submitted by researchers using ground-based technologies such as radio collars.

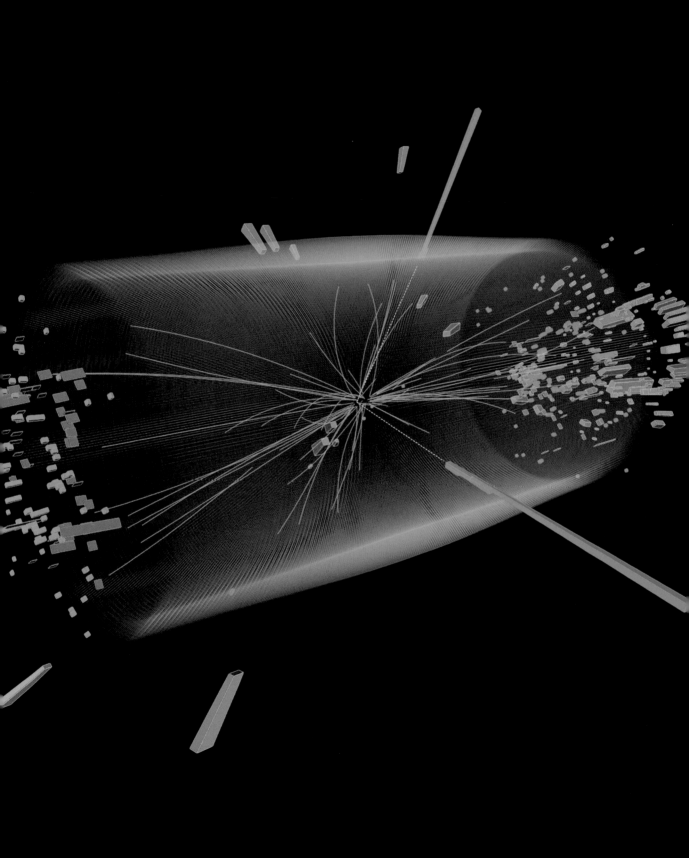

Candidate Event for the Decay of a Higgs Boson

CMS detector, CERN, 2012

Only one in a billion events at LHC represents a "Higgs boson event"; the tip of an enormous data iceberg. In this picture, a Higgs boson created during the collision of very high energy protons has decayed, producing a shower of particles as predicted by theory. Images are very important in interpreting experimental data in particle physics. This image was reconstructed from data supplied by the CMS (Compact Muon Solenoid) detector in the LHC at CERN.

The volume of data collected and processed by Movebank is dwarfed by some other projects. Consider the Vera C. Rubin Observatory, in Chile, which will provide the data for the Legacy Survey of Space and Time. Its telescope is equipped with a 3.2 gigapixel camera that will take a 15-second exposure every 20 seconds (during the night). It will cover the whole sky in very high definition every few nights. By the end of the project, around 2033, every point in the sky will have been captured a thousand times. This will enable astronomers (and AI systems) to discover and study a huge range of astronomical objects. The observatory will produce about 20 terabytes (equivalent to about two hundred ultra-high-definition, or 4K, movies) per night every night for ten years—a total of more than 15 petabytes (15,000 terabytes). Computers across the world will store and mine the data constantly throughout and after the end of the observing phase of the project.

Other examples of the potential for big data in science are the particle collision experiments in the Large Hadron Collider (LHC) at CERN. Inside, beams of particles traveling in opposite directions at very close to the speed of light smash into each other inside four detectors. Instruments inside each detector give the positions and energies of particles created by the high-energy collisions. Whenever the LHC is active, there are around six hundred million collisions every second, and vast numbers of data are generated. Fewer than a thousand of the collisions will be of potential interest, so from a massive 40 terabytes produced each second, processors at the detectors themselves reduce this first to 100 gigabytes (GB), and then to just over 10 GB. More than seventy thousand computer processors at CERN's data center now mine these data and store them at CERN and in eleven centers around the world, before passing them to more than 160 sites in forty-two countries, for further analysis. The system, developed by the high-energy physics community to achieve such a feat, is called Worldwide LHC Computing Grid.[9] Traffic between sites averages 20 GB per second, and total data stored so far amounts to well over 1,000 petabytes.

One final intriguing example of the expanding role of big data in science is "connectomics": the effort by neuroscientists to map the connections within the human brain (and the brains of other species) in exquisite detail, using a range of tools including electron microscopes (see following pages). Because the brain is so complex, much of the data are gathered and processed automatically, and big data plays an important role.[10]

Tractogram of the Human Brain
Thomas Schultz, 2006

Connectomics is the effort to map the extremely complex architecture of the brain, ultimately down to the level of individual neurones. Many of the techniques used involve the processing of huge amounts of data (see pages 102–105), including the technique that produced this remarkable image. Magnetic resonance imaging (MRI) was used to map the diffusion of water molecules in the brain. Each tiny volume element (voxel) of the brain produced a measurement, and a computer algorithm combined all the measurements to deduce the locations and directions of the myelin fibers in the brain's white matter tracts, and construct this image. +++

Tractogram of the Human Brain
Patric Hagmann, Connectomics Lab,
University Hospital Lausanne, Switzerland,
date unknown

This image was constructed by the same
method as the one opposite: diffusion MRI
and subsequent tensor imaging. Note that
each volume element (voxel) of the brain
is represented by coordinates in a three-
dimensional Cartesian space (see page 83).
As a result of the diffusion MRI process, each
voxel is assigned a number that describes
the amount of diffusion (randomness of
motion) of the water molecules and a number
that describes their preferred direction of
movement. One feature that stands out is
the corpus callosum (false-colored orange-
red), the wide bundle of fibers joining the two
hemispheres of the brain's cortex. +++

Tractogram of the Human Brain
Human Connectome Project, date unknown

Another tractogram of the human brain,
created by diffusion MRI and tensor imaging.
These techniques are playing an important
role in the quest to formulate a detailed map
of the human brain—the Human Connectome
Project (HCP)[11]—but they are also becoming
increasingly useful as a tool for the diagnosis
of brain injuries. The HCP utilizes a wide
range of other sophisticated techniques,
besides diffusion MRI, to collect the vast
amounts of data required to piece together a
map of the human brain at every scale. Note
that the fibers are color-coded according to
their direction (red is left to right; green is
front to back; blue is through the brain stem).
+++

X-Ray Data from the Entire Sky

Neutron star Interior Composition Explorer
(NICER), 2019

The Neutron star Interior Composition
Explorer (NICER) is carried aboard the
International Space Station. This image
is a visualization of the first twenty-two
months of data from NICER, as it orbits
Earth, occasionally skewing to look toward
certain targets. The brightness of each pixel
represents the intensity of X-rays coming
from a different point of the sky. Most of the
very brightest blobs are pulsars (spinning
neutron stars) inside our galaxy, or extremely
energetic active galaxies. Many of them do
not emit any visible light, and are therefore
completely invisible in conventional optical
telescopes. +++

Three Whole-Sky Views of the Cosmic Microwave Background

COBE (1992), WMAP (2003), Planck (2013)

These three views could have appeared in chapter 1: if we were above the atmosphere, and our eyes were sensitive to microwave radiation, this is what we would see. But the increasing resolution in these images is due to a massive increase in the data gathered by successive missions. Cosmic Background Explorer (COBE) provided the first evidence of anisotropy (non-uniformity) in the microwave radiation that is a remnant of the heat of the early universe, a crucial test of big bang theory. That anisotropy is necessary to explain how galaxies formed from the matter produced at the beginning of time and space. The other two images are from the Wilkinson Microwave Anisotropy Probe (WMAP) and the Planck satellite. +++

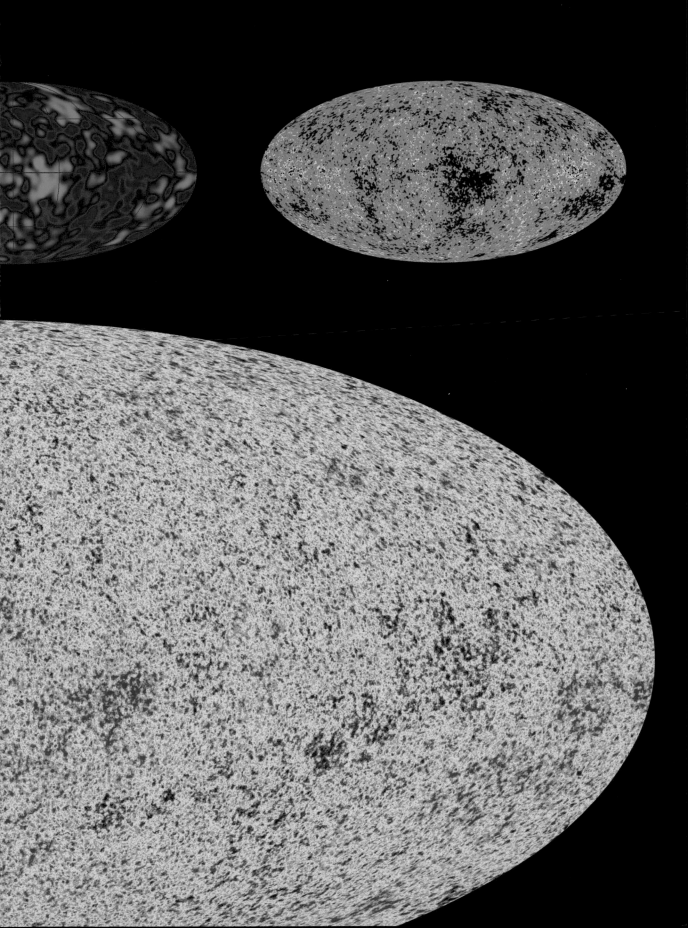

Satellite Image
and Infrared Image
of the Yucatan
Peninsula, Mexico
NASA/JPL, 2003

These two views of the Yucatan Peninsula, Mexico, provide data about the Chicxulub crater, which was created sixty-five million years ago as the result of the impact of an asteroid. This impact event spelled the end of the dinosaurs. The top view looks like a photograph, but it was produced from relief data gathered by a radar instrument in the Shuttle Radar Topography Mission. The bottom image was created from data collected by instruments sensitive to infrared, part of the Thematic Mapper, carried aboard the Landsat 4 satellite. The radar image shows clearly the rim of the crater, while the infrared image shows vegetation types, affected to this day by the underlying geology created by the impact. +++

Development of a Mouse Embryo

Kate McDole et al, 2018[12]

Mice have long been used as a model organism to study the biology of mammals in general, and humans in particular. One crucial area of study is the development of organs and body shape from a tiny number of cells in the early embryo (the gastrula). This image is a time series of the development over forty-eight hours, starting with the gastrula (the smallest blue blob). The blue swirls are tracks of individual cells as they migrate and divide. The images were constructed inside a computer, using an algorithm to analyze the 10 terabytes of data produced by an experimental setup that included everything the embryos needed to survive and grow, plus a microscope that automatically adjusted its view as the embryos grew. +++

Development of a Mouse Embryo

Kate McDole et al, 2018

In the remarkable research featured on the previous page, artificial intelligence was used to identify dividing cells, and to track the fate of the resulting daughter cells. Furthermore, labeling molecules were used, to make it easier to identify certain cell types, such as those in the heart. These strategies made it possible to follow organogenesis (the development of organs) over the duration of the experiment, at cellular level. Repeating the experiment several times, with different embryos, enabled the researchers to establish an "average" mouse embryonic development model. In this series of images, the colors represent cell speed, from blue (slower) to red (faster). +++

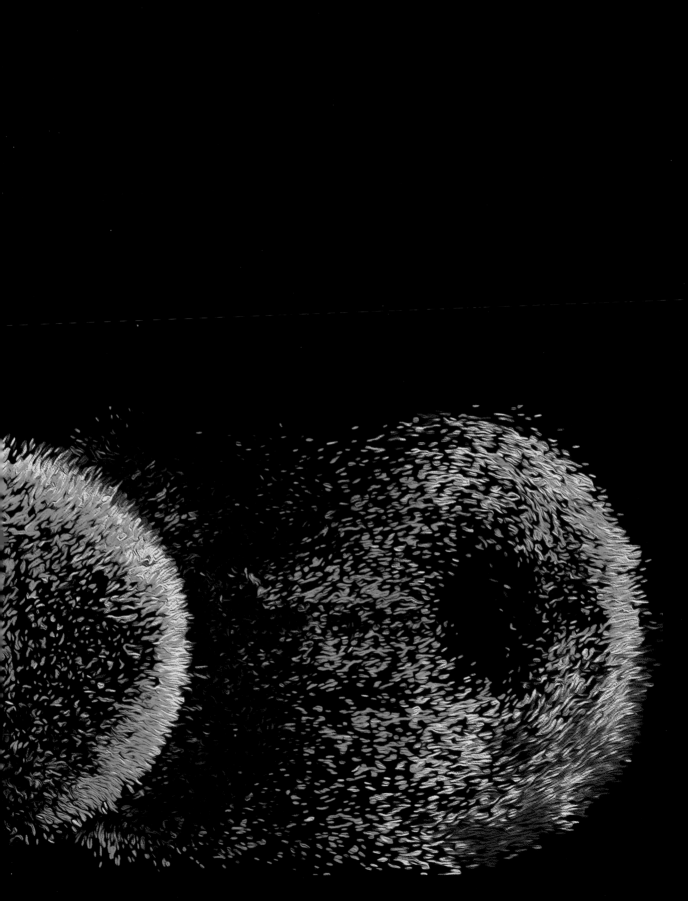

Communicating Information

Data versus information

As mentioned in the introduction to the first part of this chapter, it is not only scientists that rely on data, and for whom data visualization is crucial. The same is true for the subject of this second part of the chapter: information. The distinction between data and information is fuzzy at best—but people writing about the DIKW pyramid (see page 81), or data and information in general, typically propose that information is data with context, or meaning.[13] The creators of the informational visualizations that follow have collated their data, and perhaps the data of others, and have set it out in a way that will inform—and, in some instances, make a point. In any case, visualizations of information, rather than data, are generally either intended to have some kind of impact on the viewer, or to be utilized as reference by other scientists.

As before, the same techniques used by scientists to visualize information are used in many other fields, such as politics and economics. Indeed, one of the pioneers of information visualization was an economist: William Playfair (he had many other professions, including engineer). In the 1780s, Playfair devised or popularized several types of diagrams for representing information visually, including line charts, bar charts, and pie charts (see page 117). Playfair's statistical charts were eagerly adopted by scientists, and the growing use of the visualization of information inspired another pioneer of statistics—someone who is more of a household name: Florence Nightingale. You will find her most celebrated and influential contribution to statistics and the visualization of information on page 118. Maps are another important graphic tool. Here, we feature John Snow's map of a cholera outbreak in London (see page 124)—an easily accessible way of communicating the results of his groundbreaking epidemiological research. Geology is another science in which maps play an important role in summarizing information (see pages 125–127).

Infographics

Today, it is easy to come across some engaging examples of information visualization (not only in science), thanks to the dramatic rise of infographics. Nurtured by designer Edward Tufte's 1983 landmark book *The Visual Display of Quantitative Information*, and nourished by the digital revolution, infographics are intriguing, engaging, and able to get across a great deal of information efficiently. The kinds of graphic devices used in infographics are becoming commonplace in the communication of scientific information. This can be particularly significant when the information is of real importance, such as the rise in global temperatures as a result of human activities (see Warming Stripes, page 128).

Arcs colors

■ Fossil fuels

■ Nuclear (TWh; substituted energy)

■ Renewables

■ Traditional biomass (TWh; substituted energy)

1800

1850

1900

1950

2000

2019

Pie Charts Showing World Energy Use, 1800–2019

Author's own work, via RAWGraphs[14], 2022

Pie charts are useful for showing proportionate values of quantities. The first published examples appeared in William Playfair's 1801 book *Statistical Breviary*. This series of pie charts gives a clear visual overview of humans' use of energy in 1800. The total area of the pie in each case represents the total energy used, while the colored slices inside the circle represent the proportion of the total accounted for by each of several energy sources. (Note: the values are adjusted according to the "substitution method," which takes into account the inefficiencies of certain types of energy compared with others; much of the energy released when burning fossil fuels is lost, for example—something that is less of a problem when using solar or wind energy.) +++

Polar Area Diagram of the Causes of Mortality in Soldiers

Florence Nightingale, 1856

Florence Nightingale spent two years in a British army hospital during the Crimean War. She was horrified by the conditions there and the subsequent mortality rates among soldiers. She gathered statistics on the causes of death of soldiers, and presented them in graphic form, "to affect thro' the eyes what we fail to convey to the public through their word-proof ears." The deaths among soldiers from preventable causes (blue wedges) far outnumbered the deaths from wounds (red) and other causes (black). The chart had the desired effect: improvements in army hospitals led to a dramatic reduction in mortality from preventable causes. +++

2.

APRIL 1855 TO MARCH 1856.

The Areas of the blue, red, & black wedges are each
 the centre as the common vertex.
The blue wedges measured from the centre of the circle
 for area the deaths from Preventible or Mitigable Zym
 red wedges measured from the centre the deaths fro
 black wedges measured from the centre the deaths fr
The black line across the red triangle in Nov.ʳ 1854 ma
 of the deaths from all other causes during the monte
In October 1854, & April 1855, the black area coincides
 in January & February 1855, the blue coincides wi
The entire areas may be compared by following the b
 black lines enclosing them.

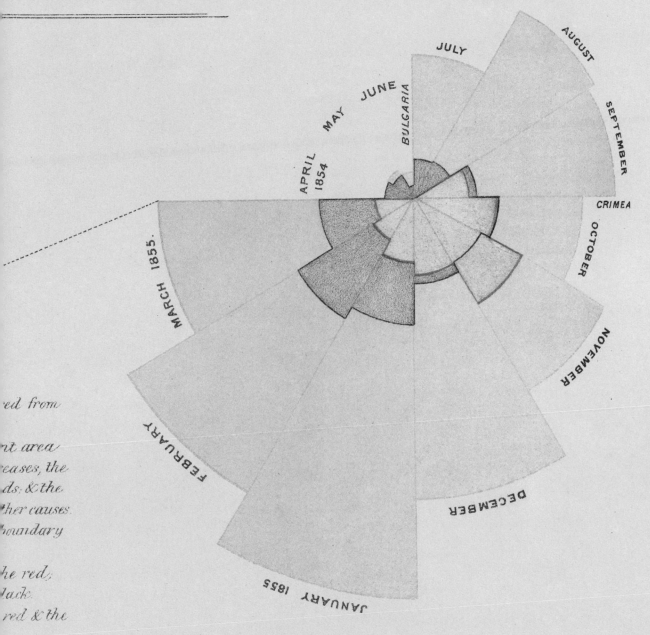

ed from

nt area
eases, the
ds, & the
ther causes.
boundary

he red,
lack.
red & the

AUGUST

JULY

SEPTEMBER

MAY JUNE BULGARIA

APRIL 1854

CRIMEA

OCTOBER

MARCH 1855.

NOVEMBER

FEBRUARY

DECEMBER

JANUARY 1855

Harrison & Sons, St Martins lane.

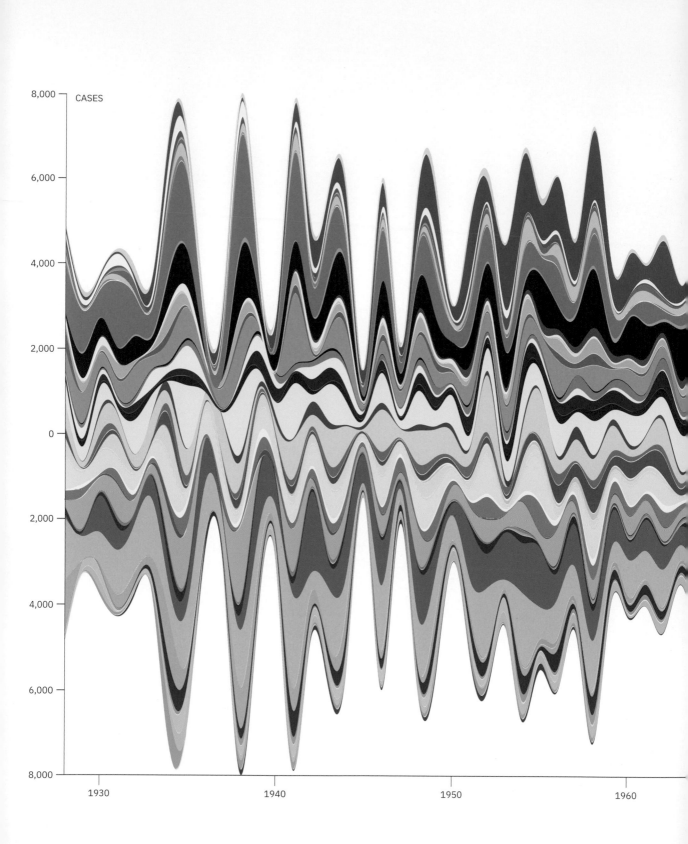

CASES

8,000

6,000

4,000

2,000

0

2,000

4,000

6,000

8,000

1930 1940 1950 1960

Streamgraph of Measles Cases in the United States

Author's own work, via RAWGraphs, 2022[15]

Measles became a nationally notifiable disease in the United States in 1912. In the first decade of reporting, the disease claimed around six thousand deaths each year. As a result of general improvements in medical care, that number decreased but was still around five hundred deaths per year by the 1950s. A vaccine was introduced in 1963, and the incidence of the disease fell dramatically as a result, as did measles deaths. The impact of the vaccine can be seen clearly in this streamgraph. The overall height of the stream shows average number of cases per week of measles in the United States from 1928 to 2002. Each color represents a different U.S. state. Data is from Project Tycho.[16] +++

YEAR

1970 1980 1990 2000

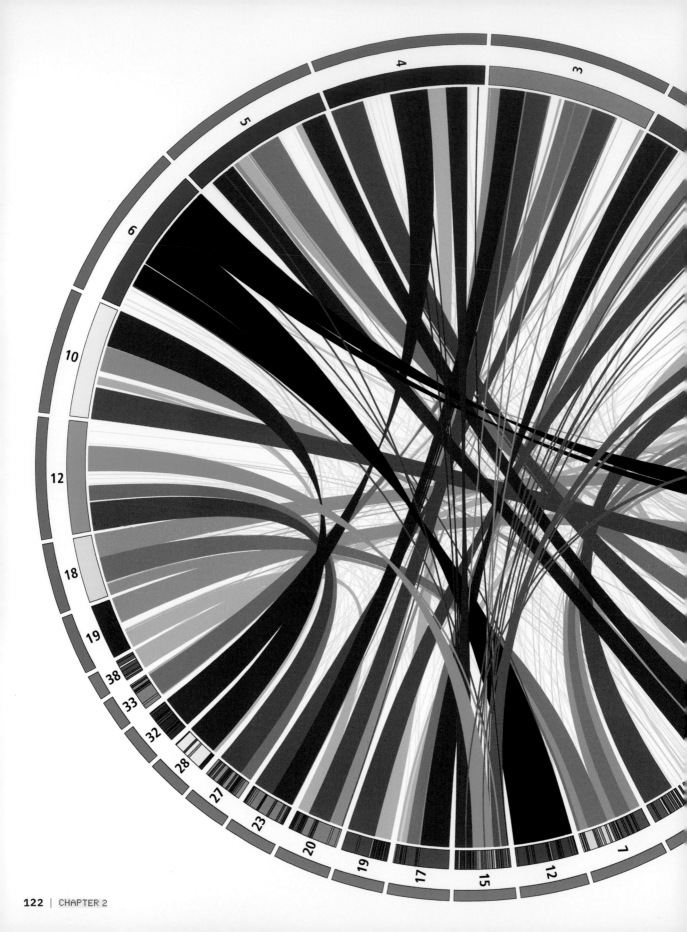

Circular Visualization of Similarities in Genomes
Martin Krzywinski, 2007

In 2005, a team of scientists developed software called Circos that can be used to visualize genomes in a way that makes it possible to identify and analyze similarities between genomes or between chromosomes within genomes.[17] The information Circos provides is useful across a wide range of biomedical applications (and it has since been used for a range of other visualizations). This image highlights similarities between the genomes of humans and dogs. Ten of the twenty-three human chromosomes are arranged around the top (blue), while seventeen of the thirty-nine canine chromosomes are arranged around the bottom (orange). The ribbons that crisscross the circular array link sections where the two genomes have significant lengths of DNA sequence in common. This chart focuses on one chromosome: all the canine chromosomes are grayed out, except for those found in canine chromosome 15. +++

Dot Map of Soho, London, Showing Cholera Cases

John Snow (and Charles Cheffins), 1854

In the 1830s, physician John Snow hypothesized that cholera is a waterborne disease, and that it can spread easily wherever fecal matter finds its way into drinking water.[18] In 1854, Snow identified a pump on Broad Street, Soho, as the source of an outbreak of the disease there. One of the first cases in the outbreak was a woman who lived in the house next to the pump. Cartographer Charles Cheffins drew this map for Snow, with lines showing the number of cases at each property. In March 1855, surveyors found that the bricks of the sewer next to the pump were damaged, and that as a result, sewage was leaking into the well beneath the pump. +++

After years working in mines across his native Great Britain, William Smith noticed that rock strata always appeared in the same order—and that particular strata always contained the same kinds of fossils. This led him to investigate the strata across the country, and eventually to publish this, the first-ever geological map of a large area. In an accompanying memoir,[19] he wrote: "The edges of the strata, which may all be crossed in journey from east to west, are called their outcrops; and the under-edge of every stratum, being the top of the next, and that being generally the best defined, is represented by the fullest part of each colour." +++

Map Showing Age of Earth's Oceanic Crust
Flliot Lim, CIRES & NOAA/NCEI, 2008

This remarkable image shows the age of the oceanic crust in millions of years, where red is youngest and blue oldest. An international team of geologists[20] laid the colors over a digital grid of the ocean floor, using data from studies of the magnetic properties of the crustal rocks in all the world's ocean basins. Iron- and nickel-rich rocks forming from magma at mid-ocean ridges become magnetized by Earth's magnetic field. Every two or three hundred thousand years, Earth's magnetic field flips, and the resulting changes in the direction of magnetization are frozen into the crust as "stripes" as the magma solidifies. +++

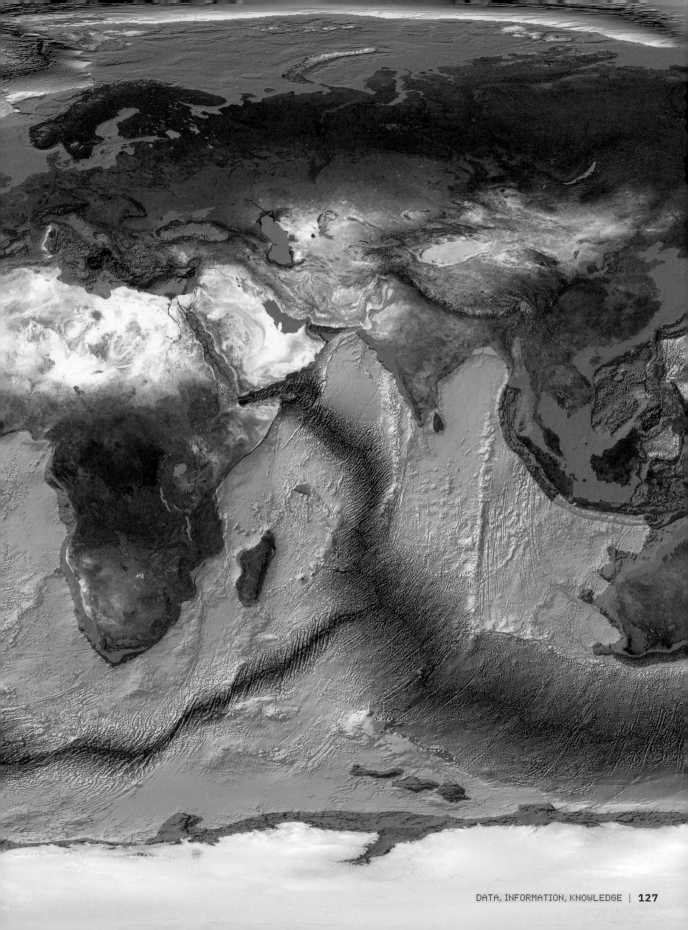

Warming Stripes, Representing Global Temperatures 1850–2020

Professor Ed Hawkins (University of Reading), 2020

In this clever visualization, the colors represent the change in average global temperature from the year 1850 to 2020— a rise of over 1.2° Celsius (2.2° Fahrenheit). On the project's website,[21] localized versions are available that show temperature changes in specific regions. Representing data in this minimal way makes for a more impactful chart, and the choice of colors helps. +++

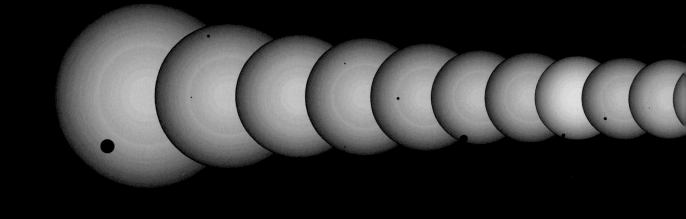

Kepler Transiting Planets

Jason Rowe, 2012

Between 2009 and 2018, the Kepler space telescope gathered light from more than half a million stars in our own galaxy. Variations in photometric data (brightness measurements) from the spacecraft alerted mission scientists to the possible existence of a planet, since, when planets transit (pass in front of) their host star, they reduce the star's brightness. Candidate planets were later checked with other methods. This clever "family portrait" shows all the candidate stars up to the end of 2012, to scale, along with the predicted sizes of the transiting planets. The Sun, with Jupiter (and Earth, barely visible) is shown as a comparison, just below the top row. By the end of the mission, Kepler had discovered a total of 2,662 planets. +++

Passing on Knowledge

Generating knowledge

Science produces new knowledge: it helps us become aware of previously unknown facts about the world; it helps us become familiar with previously unknown things; and it helps us understand previously misunderstood phenomena. In the four hundred years since Francis Bacon outlined the modern scientific method (see page 82), scientists have created a huge volume of knowledge. The enlightenment that knowledge brings is a joy and a fascination in its own right, but knowledge also has practical benefits. Scientific knowledge is utilized by people in many walks of life, among them engineers, architects, policy makers, and artists. For that reason, scientists who discover new knowledge have a duty and desire to pass it on— not only to other scientists, but beyond, into the wider community.

Knowledge for learners

Diagrams and other visual aids are vital for passing on scientific knowledge. When Watson and Crick made their momentous discovery about the structure of the DNA molecule, there was no better way to communicate it than with a model (see page 147). Sometimes, a visualization is a way of condensing a vast body of knowledge into something manageable, something that can act as a reference for scientists and an aid for learners (visual explanations are a powerful learning tool[22])— as is the case with the Hertzsprung–Russell diagram (see page 136) and the periodic table (see page 142). The kinds of visualizations featured in this last part of chapter 2 are mostly abstract: schematic or diagrammatic. This sets them aside from artists' impressions, which attempt to portray objects or scenes we cannot see. Such portrayals feature in chapter 4.

There is an irony in science: although it is a quest for knowledge, all the hypotheses, theories, and experiments in world will never yield absolute truth or absolute knowledge. They can only rule out things that are not true. Results of an experiment can either disprove a hypothesis or lend it support—but they can never prove it correct, since there will always be another hypothesis that could explain the same phenomenon. Albert Einstein summed it up beautifully (although it is paraphrased here, as it so often is[23]): "No amount of experimentation can ever prove me right; but a single experiment can prove me wrong." No surprise, then, that scientific understanding is always changing and developing (see Visualizing Atoms, page 138). What we think we know today will be superseded or at least refined by new discoveries and theories in the future. But then, in science, as in life, the journey is the destination.

Explanation of Refraction and the Formation of Colors from White Light

Isaac Newton, 1704

These diagrams explaining refraction and the formation of rainbows appear in Newton's groundbreaking book, *Opticks*.[24] Other thinkers had come up with similar explanations of how rainbows form, and drawn diagrams of them—in particular, Kamal al-Din al-Farisi and Theodoric of Freiberg, both in the fourteenth century.[25] But Newton's is the first modern, rigorous explanation (figure 15) to be a product of the scientific method proper. Newton was also the first to show that colors were inherent in sunlight itself, rather than being a quality given to white light as it passes through a prism. Newton demonstrates this in figure 16.

+++

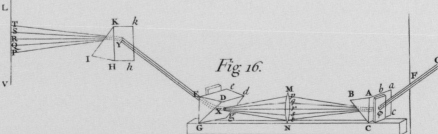

Diagram of Suggested Explanation of Auroras
Sir John Ross, 1835

Sometimes, a diagram explains a new hypothesis—potential knowledge, that has not yet been established. Such illustrations can be an important part of the process of science, even if they are wrong, as is this, drawn by naval officer Sir John Ross[26] to help explain his hypothesis of the aurora borealis (northern lights). Ross's hypothesis was that the aurora is caused by the reflection of sunlight—first, off the "vast body of icy and of snowy plains and mountains which surround the poles," and then off clouds that are "only rendered visible to us by such illumination."

+++

Hertzsprung–Russell Diagram

Devised by Ejnar Hertzsprung and
Henry Norris Russell, ca. 1910[27]

The Hertzsprung–Russell diagram is used
as a reference for astronomers and as an aid
to learning. The x-axis shows stars' surface
temperatures (in units called Kelvin, K),
with the hottest toward the left. Often this
axis denotes "spectral class" and is labeled
with letters; it amounts to the same thing,
since surface temperature is directly related
to a star's color. The y-axis gives a star's
luminosity—how much light it emits (this is
a logarithmic axis—see page 97). The most
luminous stars are at the top. Nearly all stars
fall into one of four well-defined areas on
the chart. The most prominent is the long
diagonal band, called the main sequence.
All stars in the main part of their lifetime are
found here—fusing hydrogen to form helium.
When the hydrogen fuel runs low, stars move
from the main sequence to one of the other
three areas. The very brightest stars, which
are also the largest, burn so brightly that they
spend only a few tens of millions of years on
the main sequence, before expanding to an
even greater size, to become supergiants.
Stars somewhat larger than the Sun also
swell to a greater size, becoming giants. Stars
like the Sun, currently a yellow dwarf, will end
up as small, dim stars called white dwarfs.
+++

LUMINOSITY (compared to the Sun)

10^6

10^5

10^4

10^3

10^2

10^1

1

10^{-1}

10^{-2}

10^{-3}

10^{-4}

10^{-5}

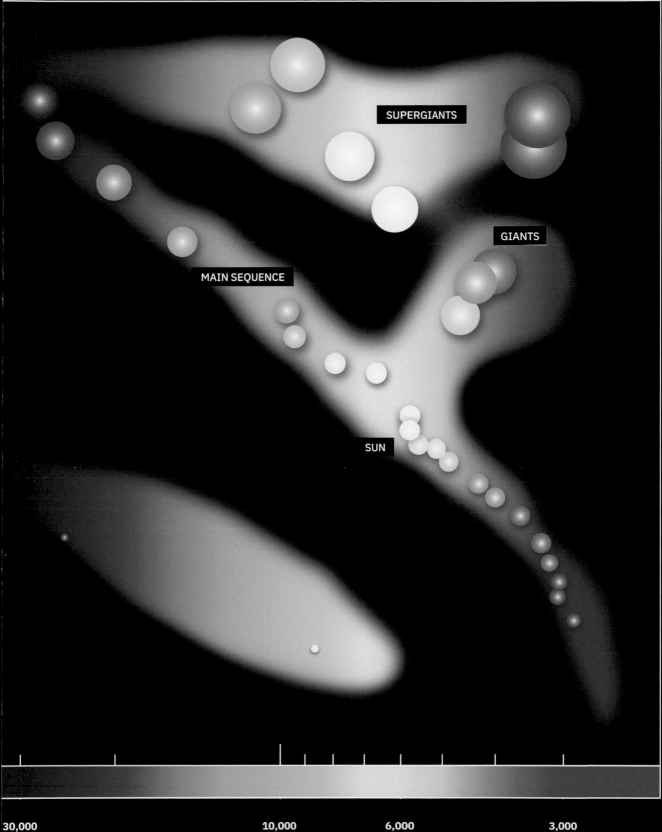

SUPERGIANTS

GIANTS

MAIN SEQUENCE

SUN

30,000 10,000 6,000 3,000

IN FOCUS:
Visualizing Atoms

It is in the nature of science that our understanding in any subject changes over time. Unsurprisingly, then, the ways in which scientists illustrate concepts or facts also change. One of the topics that best illustrates the shifting sands of scientific knowledge is the history of atomic theory. The story of how we came to the sophisticated modern understanding of the atom spans many centuries.[28] Philosophers have toyed with the atomic concept—the notion that all matter is made up of tiny particles—since ancient times. The word derives from the Greek word *atomein*, meaning "uncuttable." It was the philosopher Democritus, in ancient Greece, who first established a comprehensive theory of how matter might be made of indivisible particles. Some philosophers adapted Democritus's theory to fit with the ancient theory of the elements, with just four different kinds of atoms—one for each of the elements air, earth, fire, and water. They pictured atoms as solid objects with different, characteristic shapes: cubes for earth, tetrahedrons for fire, for example.

The atomic view of matter languished in the sidelines for hundreds of years, until seventeenth-century scientists began to draw atoms, typically as round balls. In 1690, mathematician and astronomer Christiaan Huygens drew stacked spheres, like oranges at a fruit stall, to illustrate how the existence of atoms could explain the regular shapes of crystals.[29] He wrote: "It seems in general that the regularity that occurs in these productions comes from the arrangement of the small invisible equal particles of which they are composed." In 1738, mathematician Daniel Bernoulli illustrated his vision of how a gas made of atoms flying around at high speed could account for air pressure.[30] He represented atoms as round balls, in a picture of a cylinder with a piston at the top; "very minute corpuscles . . . in very rapid motion" were striking against the underside of the piston and supporting it "by their repeated impacts."

The first modern atomic theory did not appear until the beginning of the nineteenth century. From practical experience, experiments, and reason, meteorologist and chemist John Dalton realized that all atoms of a particular element must have the same weight—and that the atomic weights of any two elements would be different. Dalton represented atoms as circles and even wooden balls, to help explain how they joined together to form molecules. Modern chemists and chemistry teachers still represent atoms as solid balls when building models of molecules. But atomic theory has moved beyond this simplistic view . . . atoms are not the indivisible objects scientists once assumed they were.

Drawings of Proposed Molecules
John Dalton, 1808
In his groundbreaking book *A New System of Chemical Philosophy*, John Dalton made an excellent and compelling case for the fact that matter is "constituted of a vast number of extremely small particles, or atoms." In this illustration from the book[31], "arbitrary marks or signs" are used to distinguish between atoms of different elements. So, for example, 1 is an atom of hydrogen; 4 is an atom of oxygen; 21 is a molecule of water (Dalton used the word "atom" even for molecules, and had the formula for water as HO, rather than H_2O).

ELEMENTS.

Simple

Binary

Ternary

Quaternary

Quinquenary & Sextenary

Septenary

After Thomson (1897),
Rutherford (1910), Bohr (1912),
Schrödinger (1928)

Here is a drawing of J.J. Thomson's "plum pudding" model of the atom (1), which has a sphere of positive charge peppered with negatively charged electrons. Ernest Rutherford found Thomson's model could not be correct and that, instead, the positive charge was concentrated at the center, with the electrons in orbit (2). In Niels Bohr's model (3), the electrons' orbits are quantized, and in Schrödinger's, the electrons are not really in orbit at all: they exist as three-dimensional "standing waves" of probability (4).

Although atomism was popular with physicists and chemists throughout the nineteenth century, it was only really at the very end of that century that the idea was accepted as fact.[32] But just as the notion that matter was made of tiny indivisible particles had become well established, scientists found evidence that atoms have inner structure. It began with physicist J. J. Thomson's discovery of the electron in 1897. (In fact, other scientists had hypothesized that atoms contained electrical charges, and had even come up with the name "electron" in the decades before the 1890s.) Thomson knew that atoms were electrically neutral overall, and he suggested that the tiny negatively charged electrons resided in a ball of positive charge—like plums in a plum pudding.

In 1909, another physicist, Ernest Rutherford, carried out an experiment that proved that an atom's positive charge is concentrated in a tiny object at the atom's center—which he named the nucleus—and not spread out, as Thomson had proposed. And so, the picture of what an atom might be like changed again: Rutherford envisaged the atom to be like a miniature solar system, with the nucleus as the Sun and the electrons in orbit like tiny planets. Physicist Niels Bohr refined this model of the atom in 1912, after the rise of quantum theory and some key experiments led to the inescapable conclusion that electrons could only orbit at specific distances, their orbits "quantized." As quantum physics matured, another physicist, Erwin Schrödinger, established the basis of the modern conception of the atom: the tiny, positively charged nucleus (made of protons and neutrons) is surrounded by negatively charged electrons. The electrons exist everywhere, spread out, their presence more probable in certain locations than others, in "clouds" of probability with definite shapes.

The modern view of the atom is far more detailed than that last sentence suggests—and to represent it in one simple illustration would be impossible. This means that the representation of atoms in scientific papers and in education is always a schematic compromise. Indeed, every piece of scientific knowledge in whatever field, every scientific theory, however well established, is only ever an analogy, a description. As scientist and philosopher Alfred Korzybski wrote: "The map is not the territory."[33] In other words, however accurate a model or description of reality, and however well it predicts the behavior of something in the real world, it will only ever be a model, not the reality itself.

Curled Ribbon Periodic Table

James Franklin Hyde, 1975

The standard periodic table, so familiar to every student of chemistry, is not the only way to arrange the chemical elements in a logical visual system. In this, one of many alternative periodic tables, hydrogen (lilac, atomic number 1) is at the beginning of a continuous ribbon. The ribbon curls around, each successive layer of the ribbon representing a period (the periods are the rows in the standard table). Elements that are in the same group line up, as they do in the standard periodic table. Elements in each group share properties with others, because they also share the same configuration of their outermost electrons (denoted by the letters s, p, d, and f around the outside of the ribbon). The lanthanides and actinides, elements here shown in the turquoise loop, are separated from the rest of the elements in the standard table. A couple of other things to note: element 104, shown here as kurchatovium (Kh, "proposed"), is now called rutherfordium (Rf); elements whose spaces contain an asterisk were either undiscovered or unnamed in 1975 (all elements up to atomic number 118 have since been discovered and been given official names).

+++

Protostomes

Trilobites - extin[ct]
Sea scorpions - extinct
Horseshoe crabs
Centipedes
Millipedes
Ostracodes
Barnacles
Crab
Crayfish
Lobster
Shrimp
Lice
Ants
Bees
Hornet
Beetles
Fleas
Flies
Butterfly
Dragonflies
Cockroaches
Termites
Grasshoppers
True bugs

Fungi

Acoelomorpha
Placozoans
Ctenophores
Corals
Sponges
Choanoflagellates

Plants

Red algae
Green algae
Amoebas
Mosses
Club mosses
Ferns
Horsetails
Conifers
Ginkgo
Cycads
Flowering plants

Eukaryotes

Protists

Archaea

Bacteria

Global Ice Ages

Oceans Rust

| Today | 66 | 201 | 252 | 370 | 444 | 541 | 700 | 1000 | 2000 | 3000 | Million |

Simplified Evolutionary Tree of Life

Leonard Eisenberg, 2017

It is not the purpose of this diagram to show the evolutionary history of life on Earth accurately and comprehensively. Its aim, according to the website that hosts it[34], is to help students understand evolution at a glance. The diagram gives a broad overview of the history of life, representing the major branches of the evolutionary tree in the context of important events such as mass extinctions, and it clearly puts across the idea that all living things on the planet today are descended from a common ancestor. The notion that evolution is branched like a tree originated with naturalist Charles Darwin, whose theory of evolution by natural selection is the basis of the modern understanding of how species develop. However, in recent years, evolutionary biologists have gathered evidence that competition and extinction make up just one mechanism behind evolution—symbiosis (biological cooperation) and exchange of genetic information being two others —and that the very idea of evolution as a "tree" is mistaken.[35] +++

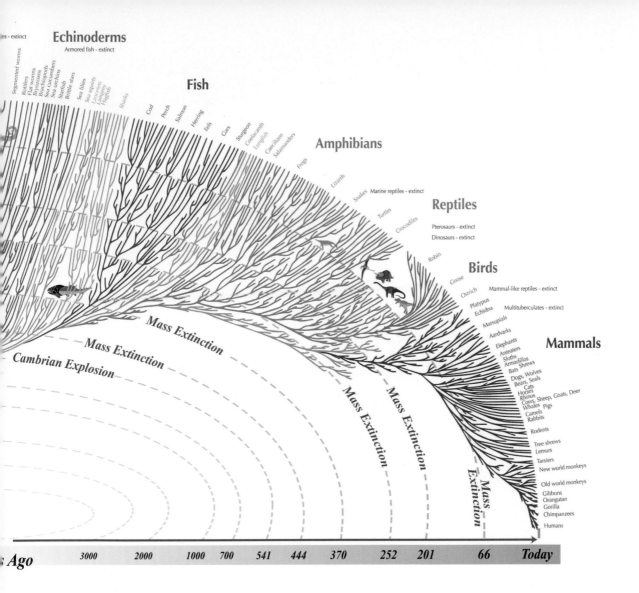

Echinoderms

Armored fish - extinct

...es - extinct

Segmented worms
Rotifers
Flat worms
Bryozoans
Brachiopods
Sea cucumbers
Sea urchins
Starfish
Brittle stars
Sea lilies
Sea squirts
Lancelets
Lampreys
Hagfish
Sharks

Fish

Cod
Perch
Salmon
Herring
Eels
Gars
Sturgeon
Coelacanth
Lungfish
Caecilians
Salamanders
Frogs

Amphibians

Lizards

Snakes
Marine reptiles - extinct

Turtles

Crocodiles

Reptiles

Pterosaurs - extinct

Dinosaurs - extinct

Robin

Birds

Goose

Ostrich
Mammal-like reptiles - extinct

Platypus
Echidna
Multituberculates - extinct

Marsupials

Aardvarks

Elephants
Anteaters
Sloths
Armadillos
Bats Shrews
Dogs, Wolves
Bears, Seals
Cats
Horses
Rhinos
Cows, Sheep, Goats, Deer
Whales Pigs
Camels
Rabbits

Mammals

Rodents

Tree shrews
Lemurs

Tarsiers
New world monkeys

Old world monkeys
Gibbons
Orangutan
Gorilla
Chimpanzees

Humans

Mass Extinction

Mass Extinction

Cambrian Explosion

Mass Extinction

Mass Extinction

Mass Extinction

s Ago 3000 2000 1000 700 541 444 370 252 201 66 *Today*

Model of Penicillin Molecule

Dorothy Hodgkin, 1945

In the 1940s, chemist Dorothy Hodgkin pioneered the use of X-ray crystallography for determining the structure of biomolecules (in other words, the relative positions of atoms of the elements that make up a molecule). Biomolecules tend to be large and complex, and their structures much more difficult to work out than regular crystals, whose structures X-ray diffraction had been used to ascertain since the 1910s. Hodgkin also relied on enormously complicated calculations to map the density of the electrons around the atoms that make up the molecules she studied. The variations in electron density are visible as a contour map on the three sides of the display case. +++

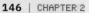

Model of DNA Double Helix
James Watson and Francis Crick, 1953

The discovery of the structure of DNA (deoxyribonucleic acid) was one of the greatest achievements of twentieth-century science. Working from data provided by Photograph 51 (see page 85), molecular biologists James Watson (pictured, left) and Francis Crick (right) hypothesized that the DNA molecule was in the form of a double helix—and they built this model, from pieces of laboratory equipment, in order to test the hypothesis. The DNA double helix is iconic, and instantly recognizable to people within and outside the molecular biology community. +++

Three Representations of Protein Tyrosine Kinase

Rendered by author using data from public database, 2021

Protein molecules are long chains made of smaller molecules called amino acids. The sequence of amino acids is called the protein's primary structure. Some of the amino acids form helices and ribbons, so-called secondary structures, which are important to how the protein functions inside the cell. The long molecule folds into itself as a result of electrical forces between atoms and groups of atoms, giving the overall shape of the protein, its tertiary structure. Molecular biologists represent proteins in a variety of different ways, to highlight the structures of interest. The main image here shows the protein's individual atoms (colored according to the elements—oxygen atoms are red, for example); the net superimposed on the molecule represents the surface of constant electron density—the actual shape of the molecule in space. The lower rendering shows the main twisting "backbone" of the molecule. The colors relate to the molecule's "functional groups," and the helices show secondary structure. The images were produced by freely available software called iCn3D.[36] +++

Plaque Attached to Pioneer 10 Spacecraft

Carl Sagan, Frank Drake, Linda Salzman
Sagan, 1972

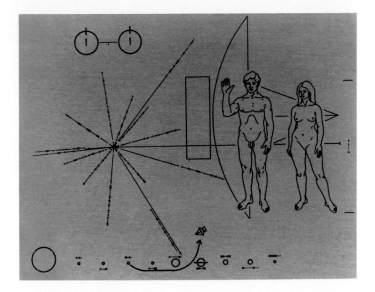

This gold-anodized aluminum plaque was attached to the Pioneer 10 and Pioneer 11 spacecraft, both launched in 1972. The images engraved into the plaque were designed to pass on knowledge—but not to fellow humans. They carry information about our species and our location in space. A silhouette of the spacecraft suggests the relative size of two naked humans; the smaller silhouette of the craft is shown leaving the third planet in a system of planets around a star (the Sun). The radiating lines represent the distances to fourteen bright pulsars (rotating neutron stars) that reveal our location in the galaxy. The idea for the plaque came from journalist Eric Burgess, who communicated it to astrophysicist Carl Sagan; Sagan and astronomer Frank Drake designed the plaque, and Sagan's wife, artist Linda Salzman Sagan produced the artwork. The two spacecraft left the solar system and are still traveling at very high speed into deep space. +++

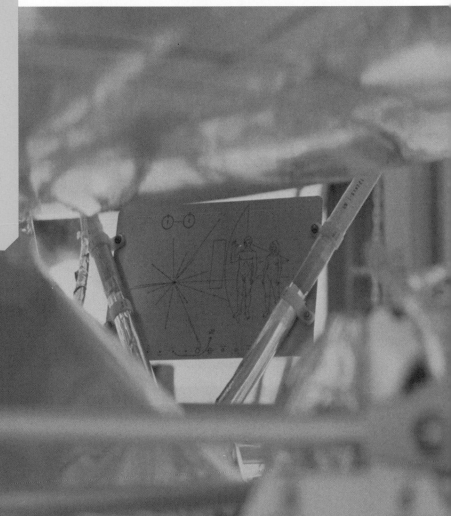

3: Mathematical Models and Simulations

Lorenz Attractor

After Edward Lorenz, 1963

The lines that make up this figure are defined by a set of three simple algebraic equations, formulated in 1963 by mathematician and meteorologist Edward Lorenz, to model convection in the atmosphere. Setting the variables in the equations to certain ranges of values gives rise to chaotic solutions, reflecting the complex, unpredictable nature of the atmosphere (see page 204). It was Lorenz's work that led to the phrase "the butterfly effect," alluding to the unpredictability of complex systems, and that even slight changes to a system's starting conditions (such as the flapping of a butterfly's wings) can make a huge difference to what happens down the line. Intriguingly, the Lorenz equations are good models of many other chaotic systems.

Mathematics has an important role in science, beyond simply gathering and analyzing data. Scientists use algebra to describe and predict the behavior of objects and systems. Algebraic equations can therefore be used to "model" phenomena in the real world. In this age of computing, mathematical models can be "run" with different starting conditions, so that they simulate real-world systems. This offers scientists new ways of testing hypotheses, since computer simulations make predictions that can be compared to outcomes in the real world. Importantly, computers also enable scientists to visualize the output of simulations, making the results more accessible to the scientists themselves and to a wider audience. This chapter presents some of the most beautiful and thought-provoking visualizations of mathematical models and computer simulations.

Mathematics as a Model of Reality

Mathematics and reality

In 1623, the Italian astronomer and physicist Galileo Galilei wrote that the universe is a "grand book . . . written in the language of mathematics."[1] For the previous thirty years, while experimenting with motion, Galileo had found consistent mathematical relationships between variables such as speed, distance, and time, for freely moving objects. He discovered, for example, that the distance through which an object falls is always proportional to the square of the duration of the fall (so, for example, double the duration, and the object will fall four times as far; triple it, and it will fall nine times as far). Galileo also found that the period of a pendulum (the time taken for one complete swing) is proportional to the square of the pendulum string's length.[2]

Mathematical relationships like these, between real-world variables, can be formulated as algebraic expressions. Algebra, invented in the eleventh century, by the mathematician Muḥammad ibn Mūsā al-Khwārizmī, provides generalized methods of manipulating mathematical relationships, for solving mathematical problems. (The alternative is having to treat each problem as unique, since it is populated by specific numbers.) Al-Khwārizmī did not use the letters and other symbols we now associate with algebra; their use grew slowly over hundreds of years. Even the humble plus, minus, and equals signs were only invented in the fourteenth, fifteenth, and sixteenth centuries respectively—in 1360, 1489, and 1557. In the seventeenth century, partly owing to Galileo's influence, scientists began describing natural phenomena algebraically—initially using words, and then, increasingly, using symbols. So, for example, Isaac Newton wrote out his three laws of motion in (Latin) sentences, but they can just as easily, and—more succinctly and more usefully—be expressed as equations with symbols standing for the variables such as force, velocity, and time. Newton's laws of motion, together with his law of universal gravitation, appeared in his 1687 book, appropriately called *The Mathematical Principles of Natural Philosophy* (normally called "Principia" for short; in Latin, *Philosophiæ Naturalis Principia Mathematica*[3]).

Scientific laws

Newton's laws are by no means the only scientific laws. There are many others, in every field of science, each one a description of a particular phenomenon, based on repeated observations. Most can be expressed as formulas; a formula is an algebraic "function"—a relationship between variable quantities, written using mathematical symbols. So, in the formula for Newton's law of universal gravitation, the force (F) between any two objects "is a function of" the values of the objects' masses (m_1 and m_2) and the distance between them (d). Most formulas are equations, with one or more variables on either side of the equals sign. By entering values for some of the

variables in a formula that represents a scientific law, it is possible to determine values for other variables in order to predict the behavior of objects or systems under varying conditions. For example, enter the value of the temperature of an object into the formula for Planck's Law and you can work out the radiance (intensity) of any frequency of light or other electromagnetic radiation that the object would emit in real life.

Scientists routinely derive other algebraic expressions that are not laws, but that can similarly predict or describe natural phenomena. This is testament to the validity of Galileo's comment above—though Galileo was not the first to realize the importance of mathematics in describing the world. Mathematicians in all ancient civilizations used arithmetic to study the land and the movements of the stars, and to study shapes (geometry), for example. And in the thirteenth century, the mathematician Leonardo Bonacci, better known as Fibonacci, attempted to use mathematics to describe the increase in numbers in a population of rabbits. The resulting "Fibonacci sequence" of numbers—or sometimes the ratio between successive numbers in the sequence (the so-called Golden ratio)—is found embedded in many real-world systems, including flower heads and animal body shapes. But it was the use of algebra by Galileo and his contemporaries, and in particular, Newton and those who came after him, that really brought mathematics into the heart of science.

Since algebraic functions like the formulas for Planck's law mentioned above can describe and predict phenomena, they can act as "models" of reality. A mathematical model produces data, just as an experiment in the real world does. Compare the model's output with the real-world data, and you test the validity of the model—and since the model is often a mathematical expression of a hypothesis, mathematical modeling provides a way for scientists to test the validity of that hypothesis. And, just as real-world data can be visualized using Cartesian coordinates (see chapter 2), so too can the data produced by mathematical models.

Although a single equation can model reality, the term "mathematical model" is normally reserved for sets of equations along with certain constraints needed to define the extent of the model's reach, such as starting conditions. Either way, computers have become indispensable to scientists developing models. Computers can carry out millions or billions of calculations every second, and can "run" a model, to produce a simulation of the system being studied. Computer simulations are most often found in the physical sciences—physics, chemistry, geology, and astrophysics—but they are used elsewhere, too. In biology, for example, accurate computer models of organs can provide researchers with ways of experimenting with "living" systems *in silico* (inside a computer), rather than *in vivo* (using living organisms)—see pages 164–165.

Dynamical systems

Most mathematical models are related to dynamical systems: systems that change over time. Most are based on a branch of mathematics called calculus. Isaac Newton developed calculus, as a way of analyzing quantities that undergo continuous change. (His contemporary, the mathematician Gottfried Leibniz, developed calculus independently.) One of the features of calculus that is most common in mathematical models is the differential equation—that is, an equation that involves variables, such as x or y, and the rates at which those variables change. For any dynamical system, there is normally a set of differential equations that can describe and predict the changes, and therefore act as the basis of the mathematical model. The equations that produce the Lorenz attractor on page 150 are differential equations, for example.

A common approach in computer simulations of real-world phenomena is to break a complex system down into smaller parts, called elements (or volumes), and allow the computer to work out how each part interacts with its neighbors. This approach is useful in models that describe the behavior of fluids (see page 190). A similar approach is the basis of molecular dynamics, in which the bulk behavior of a substance can be simulated by modeling the interactions of the individual atoms or molecules of which the substance is composed. Molecular dynamics can provide valuable information to chemists hoping to better understand the dynamics of chemical reactions. They also allow molecular biologists to work out how biomolecules such as proteins interact (see page 162). A similar approach can be used to model human or animal behavior. For example, in "agent-based" modeling, a large number of individual, virtual entities, called agents, are defined. Each is given a position in Cartesian space and equipped with a set of simple goals (such as finding food, energy, or safety) and things to avoid (such as obstacles or temperature). Interesting collective patterns emerge from such simulations, enabling scientists to study human and animal behaviors (such as flocking or disease contagion, see pages 170–171).

Proposed Mercury Orbiter Space Probe Trajectory

NASA Science Working Team, 1991

A team at NASA used a computer to prepare this graph of the proposed trajectory of a space probe headed for planet Mercury, tentatively named Mercury Orbiter. The computer was programmed with Newton's law of gravitation and his laws of motion, plus information about the motions of the planets of the inner solar system. Mercury Orbiter never took off, but its orbital plan was adapted for use by a different probe, MESSENGER, which launched in 2004, and orbited Mercury from 2011 until 2014. +++

Electric Field Simulation

After Carl Friedrich Gauss, 1835

The electric field that carries forces of attraction and repulsion between electrically charged objects has a strength and a direction (it is a "vector" field). The law that can be used to predict the field at any point in space is Gauss's law, derived by mathematician Carl Friedrich Gauss in 1835 (and previously by Joseph-Louis Lagrange). Here, a computer program has used the formula for Gauss's law to visualize the electric field around two small electrically charged objects—with two like charges and two dissimilar ones. The direction of the field (the direction in which a positive "test charge" would be attracted) is represented by the green arrows, and the strength of the field by their brightness. +++

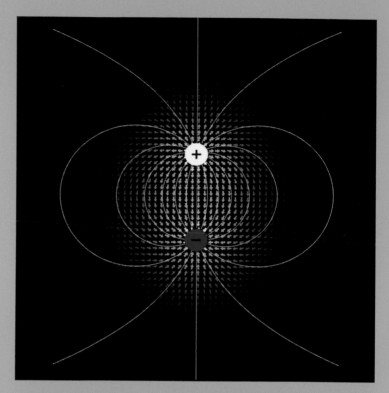

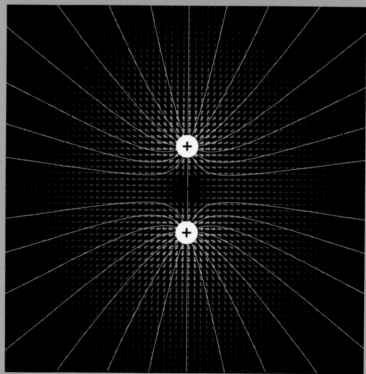

Bifurcation Diagram of the Logistic Map

After Robert May, 1976[4]

In the 1970s, mathematical biologist Robert May formulated a simple algebraic function that works out how animal populations develop over many generations. The initial population size is set to 0.5—half its maximum value—and the function includes a variable r, which is the growth rate. Plotting the size of the population, x, after many thousands of generations against r produces this chart, called the logistic map. With r set at 2 (not shown here), each breeding pair produces two offspring, and the population remains constant at 0.5. With r below 1 (not shown here), the population diminishes to 0. For all values of r between 1 and 3, the population settles on a particular value after many generations (the single line on the chart). Surprisingly, above $r = 3$, the population oscillates regularly between two values—the line splits, or "bifurcates." Above $r = 3.4$, there is another bifurcation: the population now oscillates between four values. In certain ranges of r-values, the population never settles to particular values— this is chaotic behavior. In between there are "islands of stability," where the population settles down. May's equation and the chart it produces after many iterations (generations) is a mainstay of chaos theory. +++

Population (x)

Growth rate (r)

Schrödinger Wave Equation

After Erwin Schrödinger, 1926

In 1926, physicist Erwin Schrödinger derived
one of the most important equations in
quantum physics. The Schrödinger equation
calculates the "wave function"—an algebraic
function that determines the probability
of finding a particle at any particular time
and space (see page 141). Schrödinger
applied his equation to a simple system:
the hydrogen atom, where the particle in
question was the electron. The equation has
a number of solutions, each corresponding
to the electron being in a state described by
a combination of certain quantised (rather
than continuous) values, including quantities
relating to energy (n) and angular momentum
(l). These two quantum numbers define the
spatial distribution of the probability of an
electron being present at any point. Shown
here is a selection of those solutions, each
one corresponding to a three-dimensional
shape called an orbital. Each orbital has
a unique pair of n and l values, given by
a number and a letter. The number is the
energy level, while the letter can take one of
four values: s, p, d and f, each with a different
shape. The orbitals were visualized by a
computer, using the Schrödinger equation.
Increasing brightness at any point represents
increased probability that the electron will
be found there (the colors refer to different
"phases" of the wave). +++

1s

2p

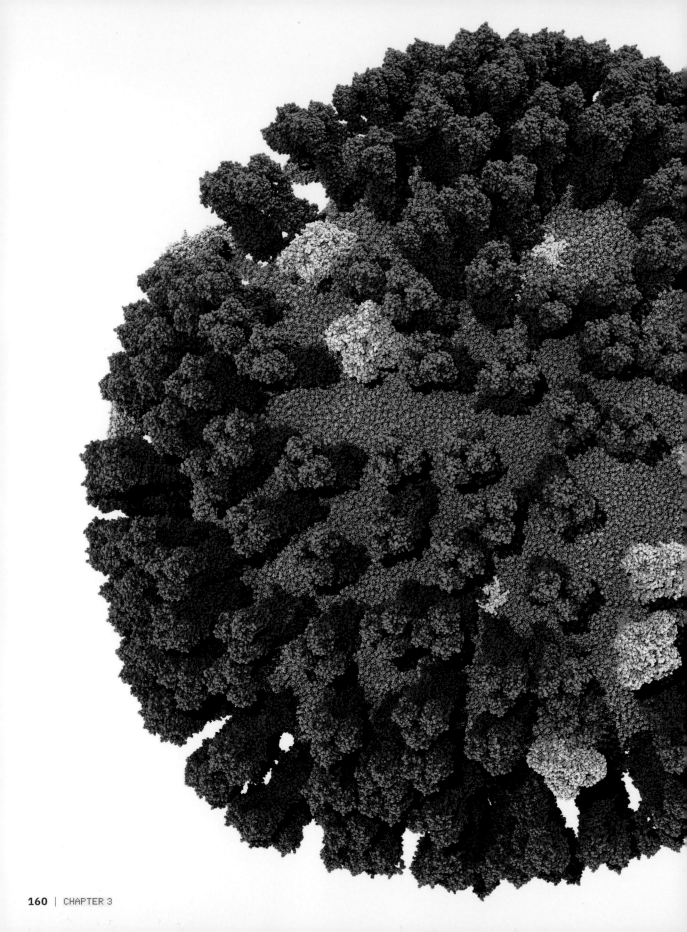

Molecular Dynamical Model of H1N1 Virus

Amaro Lab, 2015[5]

What cannot be captured in this stunning still image is, perhaps, the most important part of a molecular dynamical simulation: the movement of the atoms and molecules involved (the dynamics). The image comes from a simulation of H1N1—one of the viruses that causes influenza (flu). H1N1 virus strains were responsible for the swine flu epidemic of 2009 and the Spanish flu pandemic of 1918, which killed tens of millions of people. The model contains hundreds of millions of atoms, and the simulation was run on a supercomputer. It enables researchers to study the action of immune system molecules known to neutralize the virus, and provides the opportunity to develop and test new ways to fight the disease. +++

Molecular Dynamical Model of a Microtubule

David Wells and Aleksei Aksimentiev, 2010[6]

A microtubule is a very thin filament found in eukaryotic cells (those of plants, animals, and fungi), where they help define a cell's shape. They provide a network of "cables" to transport proteins around the cell and are essential in cell division, dragging parts of the daughter cells in opposite directions. Each microtubule filament is a polymer, made of repeating units of two proteins, alpha (α) and beta (β) tubulin, here shown in orange and blue, respectively. This still is from a molecular dynamical simulation that was designed to calculate the mechanical flexibility of microtubules—something that is not possible to achieve physically, because of their size (approximately 0.002 millimeters, or 0.08 thousandths of an inch). As well as the microtubule, thousands of water molecules are also included in the model (the smaller, red and white molecules). +++

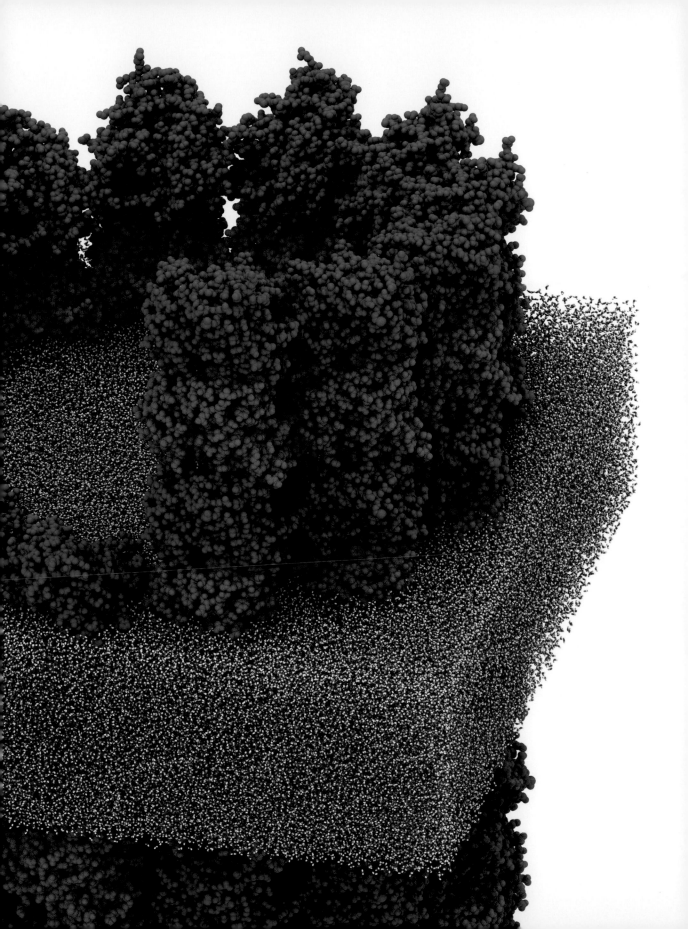

Computational Heart

Guillermo Marin et al, Barcelona
Supercomputer Center, 2012

Using a very detailed three-dimensional model of a heart, obtained by high-resolution magnetic resonance imaging (MRI), scientists set about creating a computation cardiac model. The simulation was run simultaneously on ten thousand computer processors at the Barcelona Supercomputer Center and its startup company, ELEM Biotech, in a project named Alya Red. They took a "finite elements" approach: the bulk of the heart was defined inside the model by more than four hundred thousand tetrahedra. The overall aim of the model's simulations was to improve scientific understanding of the heart, to improve diagnosis of cardiac problems, and to design and test new medicines. +++

One of the most important features of the
heart is the arrangement of its muscle fibers.
Electrical signals travel much faster along
these fibers than across them, and the way
the fibers twist and turn is vital for producing
the correct pumping profile. The precise
arrangement of the fibers can be determined
by diffusion tensor imaging (see chapter 2).
As part of the Alya Red project, scientists
imported this information into their model in
order to ensure that the electrical signals and
pumping profile were simulated accurately.
+++

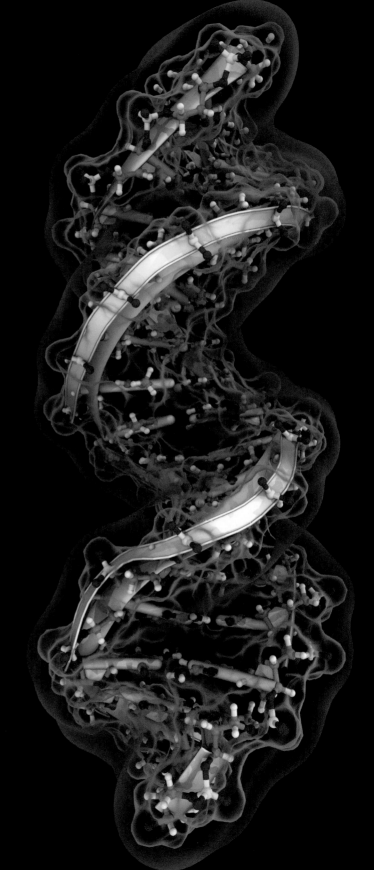

Visualization of a Simulation of Ions Affecting DNA

Dan Roe, University of Utah[7]; Antonio Gomez and Anne Bowen, Texas Advanced Computing Center, 2013

Inside cells, DNA exists in an aqueous (watery) environment, in which it is surrounded by ions: atoms or charged groups of atoms that carry electric charge. The electron density of the nearby ions causes the DNA to change its shape, with potentially dramatic and important consequences. The molecular dynamics simulation from which this visualization snapshot is taken ran for twenty thousand timesteps. Each timestep represents a tiny fraction of a second—and the position of each molecule is calculated and updated based on the forces it experiences at that moment. Running the necessary programs in parallel on the supercomputer at the Texas Advanced Computing Center reduced the run time from days to just minutes. +++

Visualization of a Simulated Tumor

Abdul Malmi-Kakkada[8], University of Texas at Austin; Anne Bowen, Texas Advanced Computing Center, 2017

The growth of any biological structure is the result of the proliferation of cells, via repeated cell division. The precise way any new growth develops depends upon several factors, including the rate of cell division and cell death and forces between cells, including adhesion. In order to study this important phenomenon, scientists at the University of Texas ran a simulation of a growing tumor. In the snapshot shown here, the virtual tumor (in cross section) consists of about ten thousand cells. The colors indicate the speeds of the cells (red is fastest) as they are pushed in various directions by the cell division—indicated by the arrows. The tumor has been (virtually) cut in half, to allow comparison of the movements of cells at the center with those at the periphery. +++

ln[Velocity(μm/s)]

-1.200e+01 -5.000e+00

Three-Dimensional Model of Cow Cells

Heiti Paves, 2011

This remarkable image was rendered from a detailed three-dimensional (3D) model of cultured cow cells. The model was built up from a large number of two-dimensional (2D) "slices," each one captured using a confocal microscope, using fluorescent markers (see chapter 1) to pick out certain features within the cells: nuclear material is blue, mitochondria red, microfilaments green. The 3D virtual space inside the computer's memory is divided into millions of "voxels" (volume elements), just as the 2D space of a digital photograph is made up of thousands or millions of pixels. This picture illustrates the difference between a computer model and a simulation. A model is a representation of a real system; a simulation would have to "do" something. +++

"Boids" Flocking Simulation

Craig Reynolds, 1987[9]

One of the most fascinating aspects of mathematical modeling on computers is "emergence." This is where realistic collective behaviors arise in a group of individual entities, called agents, each of which is given a set of simple rules. Flocking is a classic example of such emergent behaviors in agent-based models. The pioneer of flocking simulations is Craig Reynolds, who developed a computer program called Boids (short for "bird-oids") in the 1980s. Each agent in Boids is given an initial position in Cartesian space, and an initial speed. The simulation runs as a large number of timesteps. Every timestep, each agent adjusts its speed and direction of movement according to the behavior of neighboring agents in the flock. Boids has been adapted for use in many settings, including special effects in film and in computer games. +++

COVID-19 Epidemiology Simulation

R. Hinch, W.J.M. Probert, K. Bentley, et al., 2021[10]

Mathematical modeling is increasingly used to inform public health policy[11], and is especially useful in times of potential or actual epidemics and pandemics. The charts shown here were prepared from the results of an agent-based model called OpenABM-Covid19, created by an international and interdisciplinary team of scientists. The model consists of a population of one million (virtual) people in a large city, and it can be "parameterized" to match different characteristic patterns of activity. The team ran the simulation with parameters matching typical contact patterns of the population of England, both pre- and during lockdown in 2020. The blue lines represent the results of fifty runs of the simulation, scaled up to a population of 56 million; the orange marks are the actual figures for England during the pandemic. (Seroprevalence is the prevalence of the SARS-CoV-2 virus in the population's blood serum.) +++

Observed

Simulated

COVID19 patients in hospital beds

Hospital admissions

Daily deaths (by death rate)

Seroprevalence

Simulation of an Asteroid Impact

Francesca Samsel, David Honegger Rogers,
John M. Patchett, Karen Tsai, 2017[12]

As is true for many computational mathematical models, the output of this simulation of a medium-sized asteroid impacting the ocean is a three-dimensional (3D) dataset. Values are assigned to each of many small volumes (voxels) within a virtual 3D Cartesian space. In this simulation, each voxel has values for temperature, water content, and quantity of asteroid material, and each of these values varies with time. When creating a visualization, modelers create a two-dimensional (2D) projection of the three-dimensional data. They employ a technique called volume rendering, in which the computer creating the visualization calculates an overall value of color for each (2D) pixel based on the values in the (3D) voxels along each line of sight. Choosing relative opacities for the different values in each voxel can lead to any number of different views of the same scene. In the image shown here, equal weight is given to the three values, and the resulting colors give an accessible view of the mixture of water and asteroid material, and the temperature, in the area surrounding the impact. +++

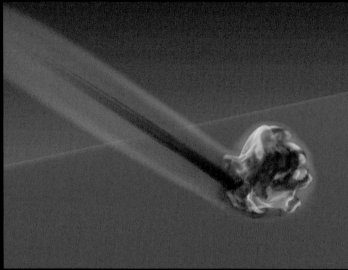

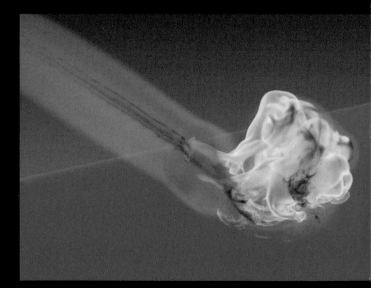

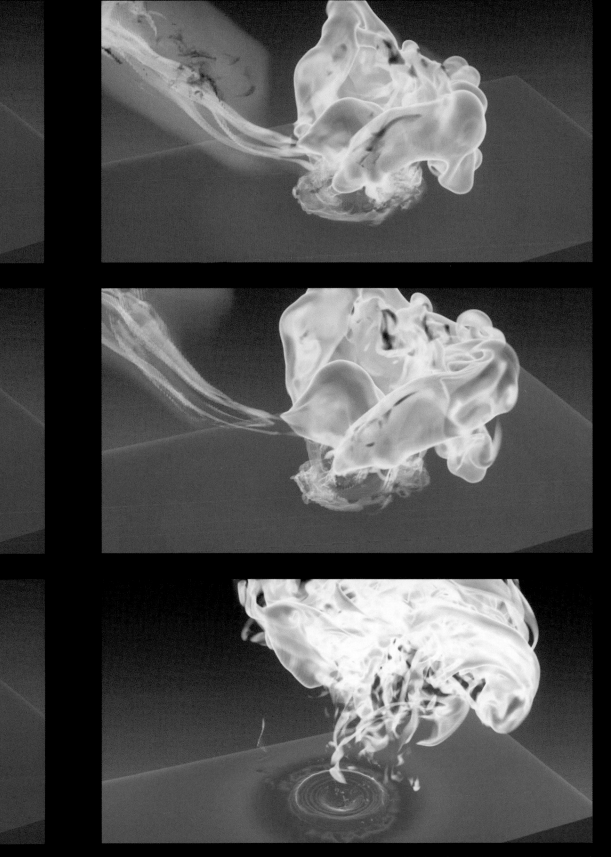

Simulation of Toroidal Plasma Currents in a Tokamak

Wendell Horton and Lee Leonard, University of Texas at Austin; Greg Foss, Texas Advanced Computing Center, 2018[13]

Nuclear fusion is the reaction that powers the sun. Achieving sustained fusion here on Earth is a dream of many nuclear scientists, as it will provide near limitless energy with no toxic waste and almost no carbon footprint. Currently, the most promising practical approach to making fusion work is to contain the reaction using powerful magnetic fields inside a donut-shaped vessel called a tokamak. These two visualizations are taken from a simulation of the conditions inside the tokamak—the donut shape has been morphed into a cuboid. The picture on the left shows the arrangement of powerful radio waves whose energy heats the plasma (gas of electrically charged particles) in which the reaction takes place. The picture on the right shows the electron density in the plasma. In both pictures, the white contours show the magnetic fields that contain the plasma; the top part is where the reaction takes place, while the bottom part channels away impurities. +++

Simulation of the Flow of Antarctic Ice Sheet

Cryosphere-Ocean Visualization
Project, 2020[14]

The colors in this simulation of the Antarctic
ice sheet represent the speed of the virtual
ice as it flows downhill toward the ocean.
Speeds range from 0 (dark gray) to 10
(orange-red) meters per day (33 feet per
day). Simulations of ice sheet behaviors
will help scientists predict and understand
the sea level rise and disruption of ocean
currents that will come as global temperature
continues to increase as a result of climate
change. The simulation used the MPAS-
Albany Land Ice (MALI) model, in turn a part
of the Energy Exascale Earth System Model
(E3SM). The E3SM, a major initiative of the
U.S. Department of Energy, is designed
for use in exascale computing, in which
supercomputers carry out more than a billion,
billion operations each second. +++

Simulation of a Dying Star
Oak Ridge National Laboratory, 2011

Computer modeling is one of the most important tools for astrophysicists, who have extremely sophisticated and detailed theories, but no way to test them directly. The objects astrophysicists study are extremely far away and incredibly large, and most take millions of years to form. What happens when a star reaches the end of its life depends upon the star's mass. A star of eight times the mass of our Sun, or greater, will collapse in on itself and then rapidly explode into a supernova. Simulations running on powerful supercomputers provide unique insight into the many complex processes that occur when such a star collapses.[15] The threads in this dramatic image represent the twisting magnetic field lines produced when outer layers of the dying star collapse inward as an initial expansion stalls. +++

Simulation of Self-Forming Magnetic Structure in the Solar Corona

Irina Kitiashvili, Timothy Sandstrom,
NASA/Ames, 2019

The Sun's corona (outer atmosphere) is much hotter than its photosphere (the visible, luminous surface), for reasons that are not completely understood. This image, looking down into the corona, is from a simulation of a cuboid of virtual corona, with sides of about 11,000 kilometers (7,000 miles) and a depth of about 10,000 kilometers (6,200 miles). Color represents temperature: red is 1 million degrees Celsius (1.8 million degrees Fahrenheit). The simulation was based on magnetohydrodynamics—the study of the interaction between magnetic fields and fluids (in this case, a plasma). The prominent structure (bright yellow), which grew from a small variation in magnetic field below the corona, was highlighted by the motion of (virtual) particles in the corona. +++

Simulation of Hydrogen Ingestion in 45-Solar-Mass Population-III Star

Paul Woodward, Huaqing Mao, Falk Herwig, and Ondrea Clarkson, 2019[16]

The (hypothesized) earliest stars in the universe are called population-III stars. It was inside these stars that carbon, oxygen, and many other elements were first made. The beautiful images shown here are visualizations of a simulation of an energetic process inside a population-III star, called a hydrogen ingestion flash. During that process, hydrogen gas is drawn downward into a zone of convecting gas, where high temperatures initiate a rapid and violent ignition of nuclear fusion involving that hydrogen. The colors in these images represent the vorticity (turbulent spinning) of gases within the star: dark blue (low vorticity) through white and yellow, to red (high vorticity). These images are made all the more intriguing by the careful use of colors and the level of detail (the simulation exists in a virtual cube with more than fifty-six billion volume elements, or voxels). +++

IN FOCUS:
Colliding Galaxies

Galaxies—enormous structures made mostly of gas and dust and billions of stars and planets—are generally millions of light-years apart. But they occur in groups and clusters, and their mutual gravity causes them to interact and, occasionally, to collide. A galaxy collision is really a gravitational interaction, since the stars are so far apart that even if the galaxies merge completely for a time, very few stars will actually collide physically. When two large galaxies collide, they twist around one another and their material mixes together. Waves of compression within the gas and dust of each galaxy cause new stars to form. Research shows that nearly all larger galaxies have undergone at least one merger, causing "starbursts"—intense periods of star formation.[17] Although most galaxies in the early universe were irregularly shaped, the majority are now grand spinning spirals, their spin caused by matter "falling" in toward the dense center. When spirals collide, they typically create elliptical and irregularly shaped galaxies. Understanding how galaxies collide is crucial in piecing together the evolution of galaxies and of the universe as a whole.

Our own Milky Way Galaxy is currently colliding with one of its small neighbors, the Sagittarius Dwarf Galaxy—and in about 4.5 billion years, it will collide with a much larger galaxy, the Andromeda Galaxy (currently 2.5 million light-years away—see pages 26–27). In 2008, a survey of Hubble Space Telescope images cataloged nearly sixty instances of distant galaxies colliding, each a snapshot of a different stage of the interaction. Galaxy collisions were much more common in the early universe, and the James Webb Space Telescope, launched in 2021, will enable astronomers to look further back in time, revealing more collisions as they happened in the early universe (looking farther out equates to looking further back in time, since light takes time to reach us).

A typical galaxy collision takes hundreds of millions of years, making it impossible for astronomers and astrophysicists to watch them take place. And even if they could watch them, they would not be able to interact with them and carry out experiments. Computer simulations enable researchers to explore what happens during collisions between galaxies from a variety of different angles and at varying speeds. Comparing the results to images of real colliding galaxies allows astrophysicists to improve their models and, as a result, their understanding of the evolution and structure of galaxies in the real world.

**Galaxy Collisions:
Real and Simulated**
F. Summers, C. Mihos, and L. Hernquist, 2015[18]
The validity of a theoretical model of galaxy collisions is best tested by running a simulation based on that model, then comparing the results with observations of real colliding galaxies. In each pair of images shown here, the collision on the left was created in a simulation, while the one on the right is an image of real galaxies colliding, captured by the Hubble Space Telescope.

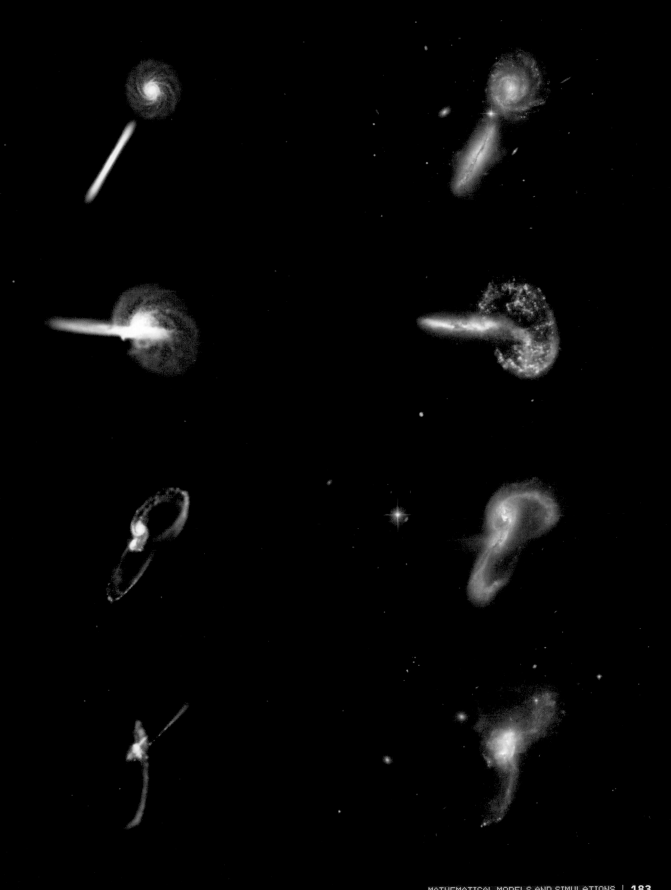

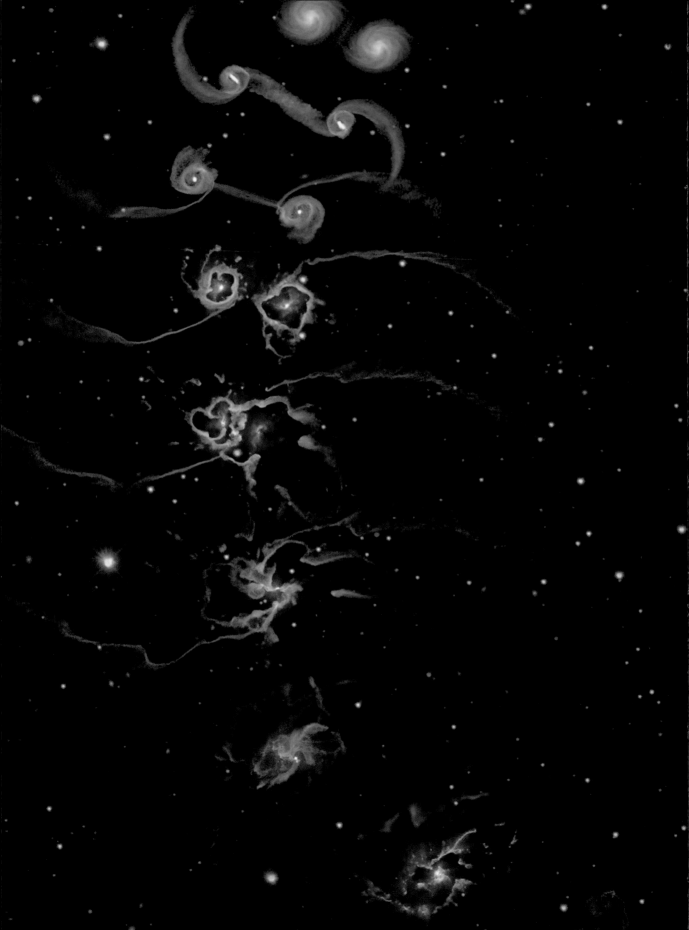

Simulation of Merging Galaxies

Tiziana Di Matteo, Volker Springel, Lars Hernquist, 2005

Running from top to bottom, these images present visualizations of different phases during the merger of two galaxies with supermassive black holes. The galaxies collide once, then separate, then come together again, this time coalescing. As gravity pulls matter into the center, each black hole grows, and huge amounts of energy are released as a result, creating a quasar for about one hundred million years. Ultimately, the release of energy produces powerful radiation that pushes gas away from the center, into extragalactic space. The result is an almost empty irregularly shaped galaxy containing two supermassive black holes, but very little else.

In a simulation of a galaxy collision, the stars are represented as points in Cartesian space, and the computer works out how each star moves, from one timestep to the next. The movement of each star in a real galaxy is determined by the gravitational influence of all the other stars—a horribly complex situation to attempt to simulate, given that a typical large galaxy is home to a few hundred billion stars. In addition, there is the gravitational effect of the gas and dust to consider, as well as other influences, such as magnetic forces and radiation pressure. If one galaxy collides with another, the situation becomes many times more complex still. It is no surprise, then, that even the most accurate models of galaxy collisions are considerably simplified—and even then, they can only run on powerful supercomputers.

Despite their limitations, simulations can help to inform astrophysicists' ideas about some of the important influences on galaxy evolution brought about by collisions and mergers. For example, in the early universe, most young galaxies were home to supermassive black holes—the result of huge amounts of matter falling in toward their centers. The accretion disk around the black hole (see page 58) becomes extremely hot, and glows brightly, becoming a type of "active galactic nucleus" called a quasar. It has long been suspected that the intense radiation from a quasar regulates star formation, by pushing away the gas from which stars form—and at the same time, limiting the growth of the black hole and causing the quasar to dim. One way to verify or refute this suspicion, is to run simulations of galaxy collisions, since these cause the black holes to grow as more material comes together. In 2005, scientists at the Max-Planck Institute for Astrophysics and Harvard University ran just such a simulation (see images opposite), testing a range of different sizes of galaxies and black holes.[19]

The scientists represented each supermassive black hole as a large particle, which grew as it accreted more gas from the other galaxy. At first, the gas falling into the center of each galaxy became compressed, triggering a rapid flurry of star formation. But that compression, especially around the black hole itself, released huge amounts of energy, heating up the accretion disk around the black hole as theory had predicted. In the simulation, the correlation between the size of a black hole and the rate and distribution of star formation was in very close agreement to observations.

Simulation of the Magnetic Bubbles in the Heliosheath
NASA/J.F. Drake, M. Swisdak, M. Opher, 2011

The Sun's magnetic field twists into two helices as the Sun rotates, one way at the Sun's north pole and the opposite way at its south pole. Where the two halves of the magnetic field meet (above the Sun's equator) they form spiraling magnetic ripples that flow away from the Sun. At the heliosheath, the edge of the solar system, these ripples slow down and bunch up, as they meet a stream of energetic charged particles from deep space (the interstellar wind). In 2011, data from the two Voyager spacecraft (which left Earth in 1977) suggested that the stagnation of the ripples at the heliosheath caused the two halves of the magnetic field to break up, forming a chaotic array of "bubbles." This remarkable image is from a simulation that supports this hypothesis. +++

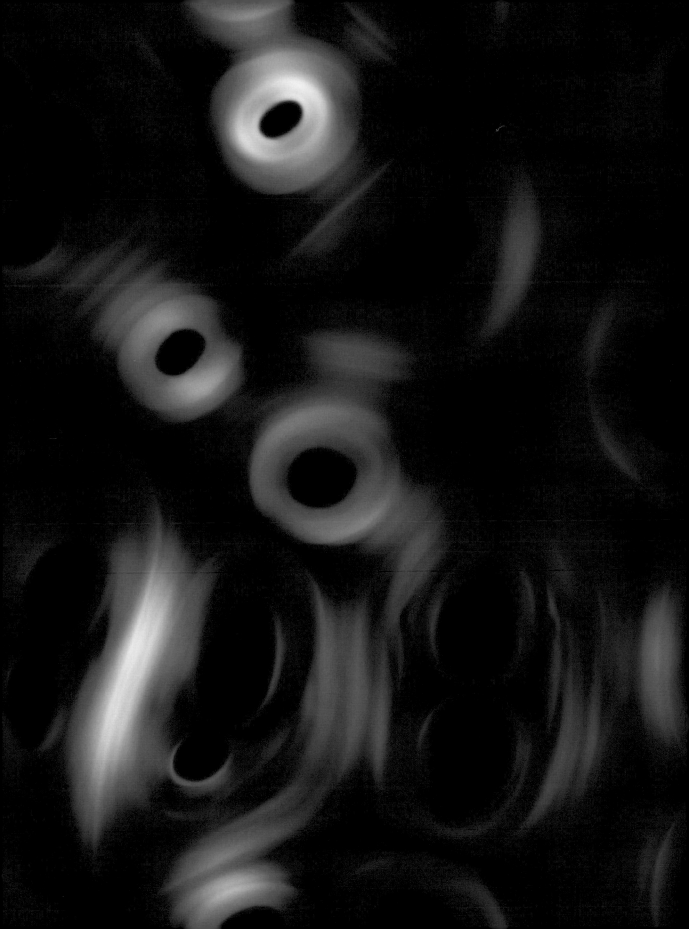

Simulated Dark Matter Density Map
Jie Wang, Sownak Bose, Carlos Frenk et al., 2020[20]

According to the best current cosmological models, most of the matter in the universe is "dark matter"—that is, it does not interact with light or other forms of electromagnetic radiation. The existence of dark matter is only betrayed by its gravitational influence—for example, as "haloes" that encompass entire galaxies and affect the galaxies' rotation. These hypothetical dark matter haloes, and equally hypothetical filaments that connect them, form the scaffolding of the universe, upon which the massive structures from galaxies to groups, clusters, and superclusters of galaxies formed. In 2020, scientists used supercomputers in China, Europe, and the United States to simulate the distribution of dark matter haloes at different scales. Shown here is the largest scale—equivalent to about 750 megaparsecs across (more than two billion light-years). In the simulation, dark matter was represented by "weakly interacting massive particles" (WIMPs) that clump together to form the haloes and filaments. Their simulated distribution matched what would be expected from current cosmological models. +++

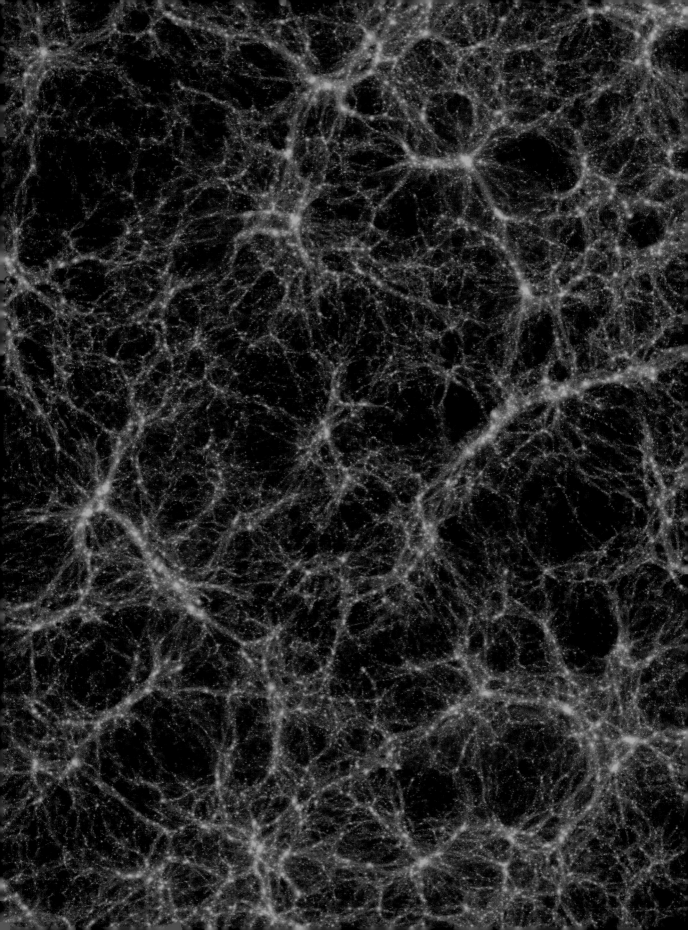

Computational Fluid Dynamics

Why simulate fluids?

One of the most important applications of computer-based mathematical modeling and simulation is computational fluid dynamics (CFD). The ability to simulate the motion of fluids (both liquids or gases) and the forces they exert is beneficial in a wide range of scientific disciplines. Predicting fluid behavior is useful in engineering applications—most notably, perhaps, in aerospace (see page 195)—and also in the science of meteorology (see Modeling Weather and Climate pages 202–205). Mathematical analysis of a fluid dynamical problem without the aid of computers is possible using physical scale models but can be expensive and extremely laborious. Such experiments are also necessarily generalized, and so can only be used to analyze simple situations. Computers, on the other hand, can run a simulation many times, with any number of the parameters changed.

At the heart of most mathematical approaches to fluid dynamics, with or without computers, are the Navier–Stokes equations (developed in the first half of the nineteenth century, by the engineer Claude-Louis Navier and the mathematician George Gabriel Stokes). Building a fluid dynamical model inside a computer involves dividing up the (virtual) fluid into a "mesh" of "cells" and the time into small timesteps. Some cells are smaller, giving higher resolution to the simulation in places where, for example, turbulence or obstructions make the flow of the fluid more complex.

Using computers

Computational fluid dynamical simulations are always and necessarily simplified— to model a fluid (or anything, for that matter) perfectly would require knowing the position, speed, and energy of every single atom. The required level of accuracy for a project determines the computing power needed. Simple, less detailed simulations (with longer timesteps and larger cells) can run on desktop computers, while some of the most detailed and challenging simulations take hours or days of time on supercomputers with hundreds or thousands of powerful processors running simultaneously. Modeling turbulence, for example, requires small cells and very short timesteps, and is computationally extremely challenging.

One of the greatest advantages of using CFD over other methods of studying fluids is that computers can produce informative visualizations that are all the more intriguing because they show movements that are invisible to the naked eye, sometimes from viewpoints that are not otherwise possible. In some cases, real-world data is a starting point for a CFD simulation, the simulation then filling in the gaps and improving understanding of the system being studied (see, for example, the oil spill simulation, opposite).

Oil-Spill Simulation
Marcel Ritter, Jian Tao, Haihong Zhao,
Louisiana State University Center for
Computation and Technology, 2010

In response to the Deepwater Horizon oil
leak in the Gulf of Mexico in April 2010,
the National Science Foundation allocated
scientists at universities across the United
States a total of one million hours of
computing time on its (now defunct) TeraGrid
of supercomputing facilities. The aim was
to simulate the movement of "oil parcels"
from the leak as they moved around the
gulf, and to produce a three-dimensional
model that could be applied to future spills
and leaks, enabling authorities to mitigate
against the environmental damage oil can
cause.[21] The model used data from maps
of the area, together with wind and ocean
currents. This image is a visualization of
one run of the simulation, in which colors
represent the speed of movement of the
parcels. The section dominated by yellow
ribbons represents (slower) movement of the
oil over the marshes and other shallow-water
features along the Louisiana coast. +++

Model of Groundwater Flow

United States Geological Survey (USGS), 2021

The movement of water underground is determined by its pressure—which is, in turn, determined by the weight of water above it—and the ease with which water can move through a particular patch of soil or rock (called hydrologic conductivity). In this simulation, produced using software called MODFLOW, developed by the USGS, the ground is divided up into a mesh of triangular cells. The cells are smaller in areas where the water pressure is greater, such as along the banks of the stream, around three circular wells, and at the shore of the lake. +++

Simulated Airflow
NASA, Boeing, and the Exa Corporation, 2017

Aerodynamics are not just concerned with creating lift and reducing drag. During the approach to landing, noise from turbulence around the fuselage and landing gear of an airplane can be as loud as the noise of the engines. Understanding the sources of that noise can help aircraft designers to reduce the problem. This simulation investigated the noise produced by turbulence around the nose landing gear of a Boeing 777. The colors represent the relative speed of the air around the landing gear (red being fastest, green slowest). Simulating the complex, turbulent flow and the rapidly spinning vortices produced as air flows past the jagged parts of the landing gear, is particularly demanding of computing power. +++

Simulated Shock Waves Passing Through Water
Jordan B. Angel, NASA/Ames, 2019

The Space Launch System (SLS), NASA's new primary launch vehicle for all deep-space missions, is NASA's most powerful rocket to date. Engineers designed a technology—the Ignition Overpressure Protection and Sound Suppression System (IOP/SS)—that floods the launch pad with more than 450,000 gallons (two million liters) of water in sixty seconds. The water absorbs some of the extreme heat and acoustic vibrations that could otherwise damage the launcher and its payload. During development of the IOP/SS, scientists carried out detailed simulations of shock waves (fast-moving pressure waves) passing through water. In this visualization, darker colors indicate increases in the water's density. The shock wave produces bubbles (a phenomenon known as cavitation). +++

Simulated Shock Waves from Supersonic Flight

NASA/Marian Nemec and Michael Aftosmis, 2020

Supersonic flight is banned for all but military purposes in most countries, because of the sonic booms aircraft produce. Lockheed Martin's new airplane, the supersonic X-59 QueSST (Quiet SuperSonic Technology), is designed to produce several smaller sonic booms, rather than one big one. This will produce a series of quiet thuds when heard at ground level, instead of one loud boom. Engineers used NASA supercomputers to produce three-dimensional fluid dynamical simulations of the booms. For this visualization, the computers worked out how light would interact with the areas of high and low pressure (dark and light respectively), producing a Schlieren image (see page 34). +++

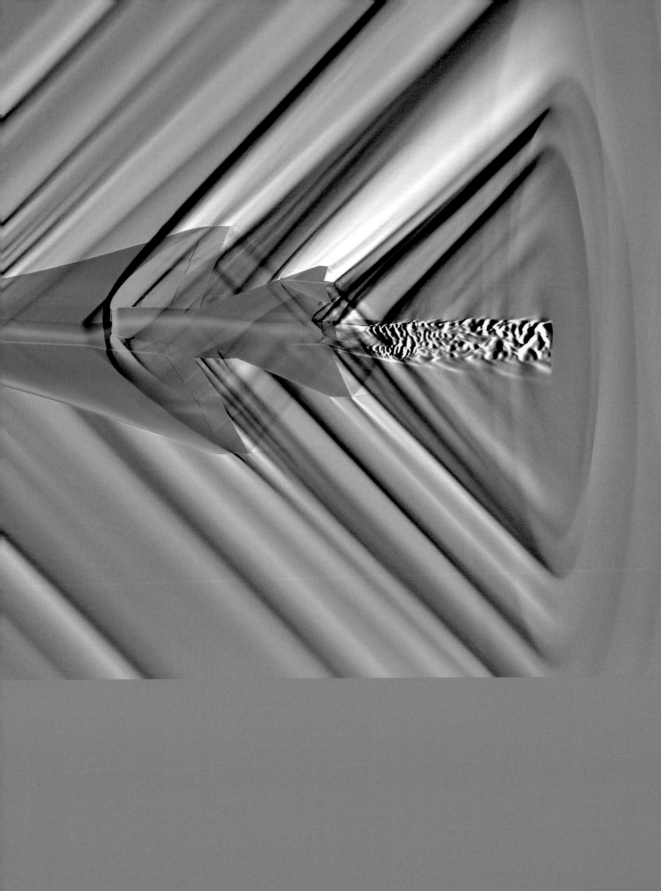

Simulation of Rayleigh–Bénard Flow in a Closed System with Induced Shear

Alexander Blass et al., University of Twente, 2018[24]

When a fluid is heated from below (so that it is, in effect, cooled from above), warmed fluid rises and cooler fluid sinks to take its place. This process results in self-organized "cells" of convection, as one might see in an unstirred pan of soup on a stove—a phenomenon known as Rayleigh–Bénard convection, after physicists Henri Bénard and Lord Rayleigh, who studied it in the late nineteenth and early twentieth centuries. Rayleigh–Bénard convection is a classic problem in fluid dynamics, and scientists have studied what happens when some of the conditions are changed. In the simulation from which this dramatic visualization was produced, the (virtual) fluid was enclosed by a heated flat plate at the bottom and a cooled flat plate at the top, and the plates were made to move in opposite directions. This relative motion created "shear" in the fluid, with the result that, instead of forming static convection cells, the rising and sinking fluid self-organized into meandering waves. In the visualization, the orange-red represents warmed fluid turbulently rising, and the blue tubes are "vorticity structures"—regions in which the fluid spins. +++

IN FOCUS:
Modeling Weather and Climate

One of the most important applications of computational fluid dynamics is modeling weather and climate. The meteorologist Vilhelm Bjerknes was the first to suggest that mathematics could be used to forecast the weather. In 1903, Bjerknes combined insight from fluid dynamics and thermodynamics to formulate a unified mathematical theory of the weather. He adapted the Navier–Stokes equations and combined them with formulas that predict the transfer of heat, to produce his "primitive equations." Input real data—for example, measurements of quantities such as temperature, pressure, and humidity—and these equations would predict how these quantities would develop over time.

In 1922, mathematician Lewis Fry Richardson tested Bjerknes'vision. Using slide rules and tables, Richardson worked for six weeks to calculate changes in atmospheric pressure and winds over a region of Europe during a six-hour period. He got the answer hopelessly wrong, but only because he had failed to take "gravity waves" into account. The atmospheric equivalent of ripples on a pond, these small, regular changes in atmospheric pressure were missing from Richardson's calculations, severely affecting his results. Nevertheless, he envisioned a "forecast factory"—a hollow spherical building in which sixty-four thousand people would work day and night to predict the weather across the globe. A controller at the center would ensure that all the human calculators were working at the same speed by shining colored lights at the various teams.

More than twenty years after Richardson's contributions, computer-science pioneer John von Neumann was looking for a project to test the capabilities of the world's first programmable, electronic, general-purpose digital computer, ENIAC (the Electronic Numerical Integrator and Computer). He chose to follow in Richardson's footsteps in attempting to make regional weather forecasts using numerical calculations.[25] Von Neumann and his colleagues ran four different numerical forecasts, using real data from four different dates supplied by the U.S. Weather Bureau. Each forecast predicted the general weather situation twenty-four hours ahead, and took twenty-four hours to process—although, as von Neumann remarks, "much of this time was consumed by manual and I.B.M. operations, namely by the reading, printing, reproducing, sorting, and interfiling of punch cards."

Early Synoptic Weather Charts
ENIAC, 1950
These maps are from one of the weather predictions produced by ENIAC in 1950, based on weather data supplied by the U.S. Weather Bureau. Each of the maps is a synoptic chart, giving the general weather situation across a large region. The top two charts show the actual weather at the beginning and the end of the twenty-four hour forecast period; the two charts at the bottom present a visualization of the results of the computed forecast.

a

b

c

d

The model covered a large area that included all of North America and parts of the Pacific, Atlantic, and Arctic Oceans. The resolution of the model von Neumann used was not ideal: the area was divided up into cells with sides measuring 460 miles (about 740 kilometers)—larger than many important meteorological features. As a result, the forecasts were not very accurate, but this groundbreaking experiment has formed the basis of all numerical weather forecasting since.

Modern weather forecasting is of vital importance to many people. It is used as an early warning of hurricanes; many retail businesses use forecasts to decide what products to stock; localized forecasts can help firefighters predict the course of a wildfire; and city authorities use forecast data to predict air quality. Largely owing to hugely increased computing power, numerical weather prediction has improved dramatically since the early experiments of 1950. Automated gathering of data and the use of supercomputers mean that meteorologists around the world can predict the weather with a high degree of accuracy days, or even weeks, in advance. The models are of ever-higher resolution—some with cells as small as 5 kilometers (3 miles) across—making forecasts much more localized. But several important features of the weather, such as many clouds or thermal convection cells, are much smaller than this. And, since the atmosphere is a chaotic system—even the flap of a butterfly wing can affect the way the weather develops (see page 151)—weather prediction would need accurate data at the molecular scale, and unreasonably powerful computers, to make truly accurate predictions. One approach that takes into account the chaotic, inherently

Simulation of Ocean Surface Carbon Dioxide Flux

MIT ECCO2/NASA, 2015

The oceans are a very important source (releaser) and sink (absorber) of carbon dioxide to and from the atmosphere. Since there is no way to monitor this flux of carbon dioxide to and from the oceans, a team of scientists at the Massachusetts Institute of Technology (MIT), NASA, and the University of California set up a project that estimates flux via a detailed ocean-atmosphere model.[26] The ECCO2-Darwin project takes data from MIT's global circulation model, its ECCO2 model (see page 206), and NASA's Darwin project (an initiative to model marine microbial communities). The visualization shown here (centered on the Atlantic Ocean) is from a simulation of carbon uptake (blue) and release (red) by the oceans in 2010. White arrows represent surface winds.

effects of global warming. The most comprehensive general circulation models take into account a wide variety of influences, including the concentrations of gases in the atmosphere (most notably the greenhouse gases); the land cover (snow absorbs less heat from solar radiation than, say, soil); and the effect of the ocean circulations (see page 206). The oceans are extremely important in climate; they absorb and release heat and carbon dioxide, not only through physical, but importantly through biological processes, too. Ocean currents can stretch for thousands of miles horizontally, but they also transport and mix water and nutrients vertically.

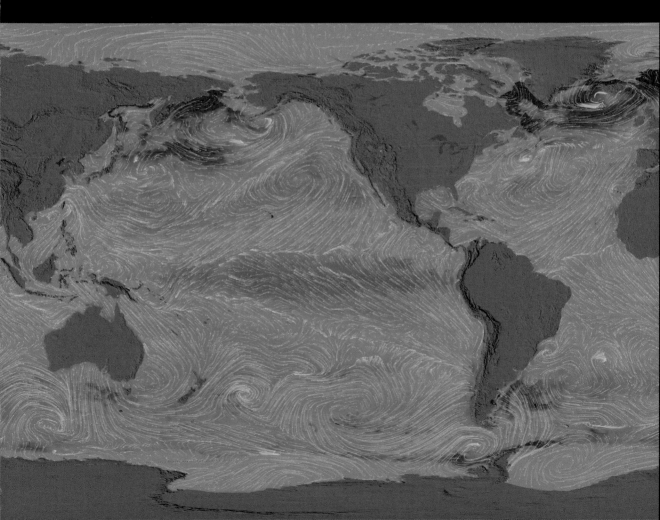

Perpetual Ocean
ECCO2 Collaboration, 2011

This beautiful image is a still from Perpetual Ocean, an animation produced as part of the NASA-funded project, Estimating the Circulation and Climate of the Ocean, Phase II (ECCO2). The main aim of ECCO2 is to improve scientists' understanding of the role oceans play in the global climate. The animation shows how ocean currents shifted and changed between June 2005 and December 2007. The still frame shows a snapshot of the currents in the North Atlantic Ocean; you can see North America on the left. White lines indicate the flow of surface water. In addition, the variations in depth of the ocean are represented as darker and lighter blues (deeper and shallower water). To make the modeling of the currents as faithful to reality as possible, ECCO2 scientists had access to vast amounts of real-world data from satellites and ocean-based vessels. As a result, Perpetual Ocean is a hybrid visualization: an unusual synthesis of real data and computer model. +++

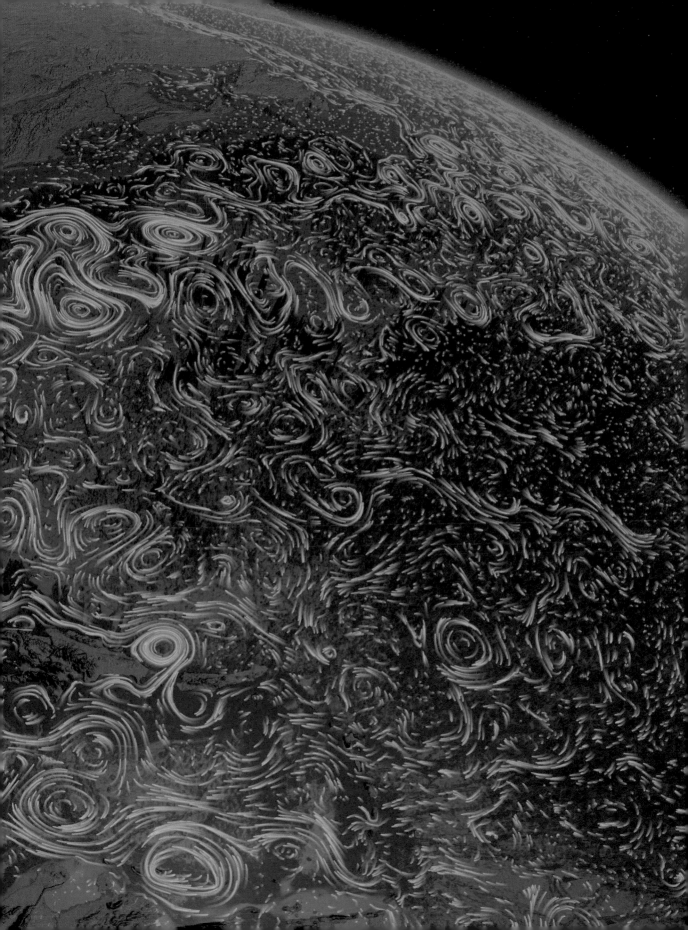

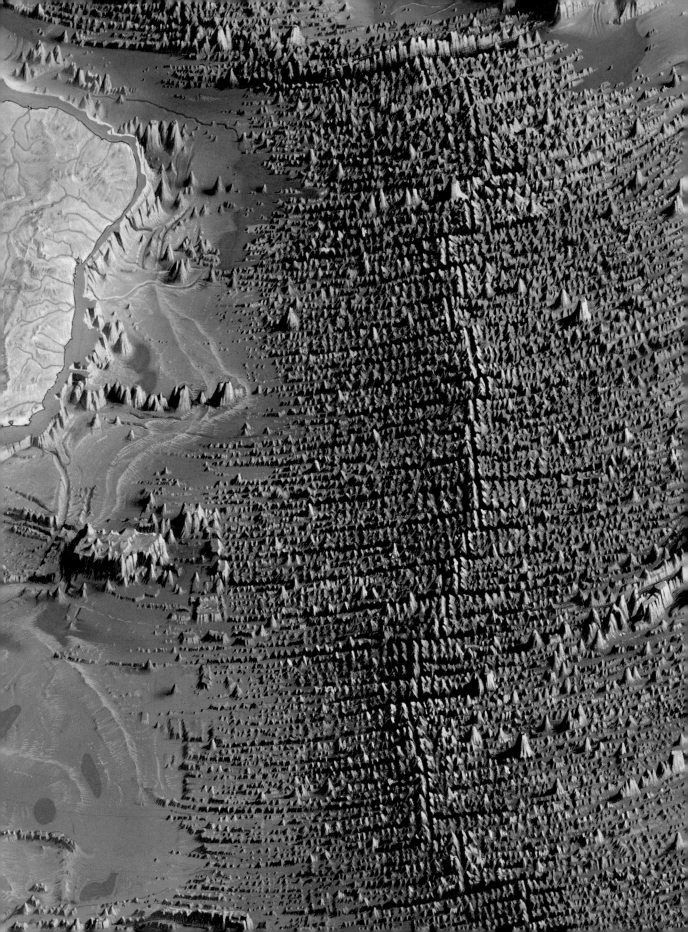

4: Art in Science

Science is analytical, methodical, and relies upon logic, precision, and facts. Art, on the other hand, is free-spirited and emotive—and there is no need for artists' creations to be faithful representations of the real world. Despite their differences, both of these human activities rely on creativity and imagination—and scientists have much to gain from an artistic mindset. Furthermore, collaborating with artists can help scientists to visualize or explain their work in an impactful way, while the new insight science brings can provide fertile inspiration for artists. This chapter explores the importance of art in science.

Painted Visualization of Seafloor (detail)
Heinrich Berann, ca. 1977
In the 1950s and 1960s, geologist and cartographer Marie Tharp used bathymetric data (depth measurements) of the oceans to produce the first comprehensive map of the ocean floor. Tharp and her colleague Bruce Heezen worked closely with the celebrated painter Heinrich Berann, who produced this stunning representation of the ocean floor. This zoomed view shows the Mid-Atlantic Ridge (see also page 93) in the South Atlantic Ocean. You can see the full map in all its glory on pages 216–217.

Art and Science

The importance of imagination

In his 1878 lecture "Imagination in Science," chemist Jacobus Henricus van 't Hoff said, "imagination plays a role in the ability to do scientific research."[1] He went on, "I consider artistic inclinations a healthy expression of imagination," and he listed many great and influential scientists who had also been artists, poets, or both. Van 't Hoff was responding to criticism he had received for his imaginative ideas about the shapes of molecules—the previous year, the chemist Hermann Kolbe, had described van 't Hoff's ideas as "trifles." Nevertheless, some of the shapes that van 't Hoff had imagined turned out to be correct, and others provided crucial clues on the journey to discovery. Imagination is, of course, a vital part of science—not least in forming new hypotheses and designing cunning experiments to test them. Paintings, drawings, sculptures, and the moving image have important roles in all stages of science—from sketched doodles that help a scientist to formulate their ideas to creative ways of communicating their results to a wider audience.

Realism versus abstraction

Sometimes a work of scientific art is a "straightforward" portrayal of a body of knowledge—an illustration or an artist's impression. Still, most illustrations are more than a direct representation of a subject, highlighting as they do certain features over others, or integrating pieces of knowledge from different sources, to produce a more informative portrayal. This is certainly the case with the stunning illustrative watercolors of David Goodsell[2] (see page 218), who wrote that "the field of structural biology has enjoyed a particularly productive marriage of art and science."[3] Artists' impressions are generally as realistic as possible—though still, of course, works of the imagination— helping nonscientists to visualize things that can never be seen directly, such as scenes from the distant past (paleoart; see pages 230–245) or objects in deep space (space art; see pages 246–265).

Beyond illustrations and artists' impressions, there are more abstract works of science-inspired art. Some are the result of collaborations between scientists and artists—something that is becoming more common, as STEM (science, technology, engineering, and mathematics) gives way to STEAM (the A standing for art). It is not uncommon to find artists who are fascinated by science. After all, art and science both tend to seek answers to important questions of identity, ethics, our place in the universe, and the meaning of life. Artworks inspired by scientific ideas can help communicate some of the wonder or passion of topics that are complex or inaccessible to those who are not scientists themselves. Furthermore, art can convey emotion in ways that the visualization of data or the output of mathematical models rarely can.

Models Illustrating Jacobus van 't Hoff's Theory of the Asymmetric Carbon Atom

Science Museum Workshops, 1920–1925

Jacobus van 't Hoff's imagination (see main text opposite) served him well. It allowed him to work out how the atoms in carbon-based compounds might be arranged in space. He set out his ideas, supported by illustrations, in his 1874 book *The Arrangement of Atoms in Space*. The molecular models shown here were made to illustrate van 't Hoff's ideas. In each of the molecules, a carbon atom (blue-gray) sits at the center of a tetrahedron, attached by chemical bonds (brown) to other atoms or groups of atoms.

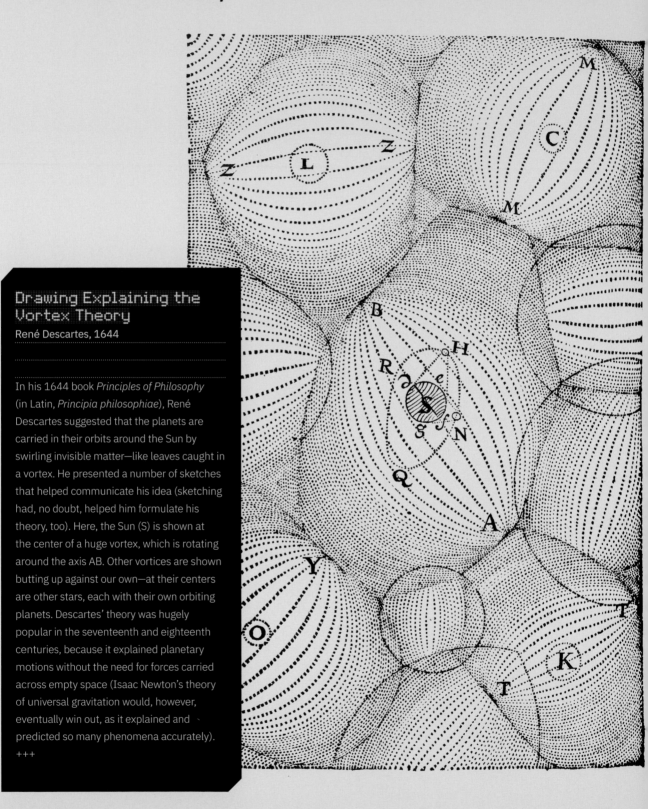

Drawing Explaining the Vortex Theory

René Descartes, 1644

In his 1644 book *Principles of Philosophy* (in Latin, *Principia philosophiae*), René Descartes suggested that the planets are carried in their orbits around the Sun by swirling invisible matter—like leaves caught in a vortex. He presented a number of sketches that helped communicate his idea (sketching had, no doubt, helped him formulate his theory, too). Here, the Sun (S) is shown at the center of a huge vortex, which is rotating around the axis AB. Other vortices are shown butting up against our own—at their centers are other stars, each with their own orbiting planets. Descartes' theory was hugely popular in the seventeenth and eighteenth centuries, because it explained planetary motions without the need for forces carried across empty space (Isaac Newton's theory of universal gravitation would, however, eventually win out, as it explained and predicted so many phenomena accurately).

+++

Giant Silk Moth on a Purple Coral Tree
Maria Sibylla Merian, 1705

The naturalist Maria Sibylla Merian became fascinated with insects and their life cycles in her early teens, and she dedicated her life to studying and documenting them. As a scientist, she made significant contributions to the field of entomology,[5] while her artistic abilities and her attention to detail enabled her to present her careful observations clearly. Many of her paintings were illustrative as well as representative. Here, for example, are several stages of the life cycle of the giant silk moth shown all at once—clearly not a straightforward still life. This picture was included in her book *Metamorphosis insectorum Surinamensium*,[6] which documented her 1699 scientific expedition to Suriname, during which she cataloged many species previously unknown to the scientific establishment. +++

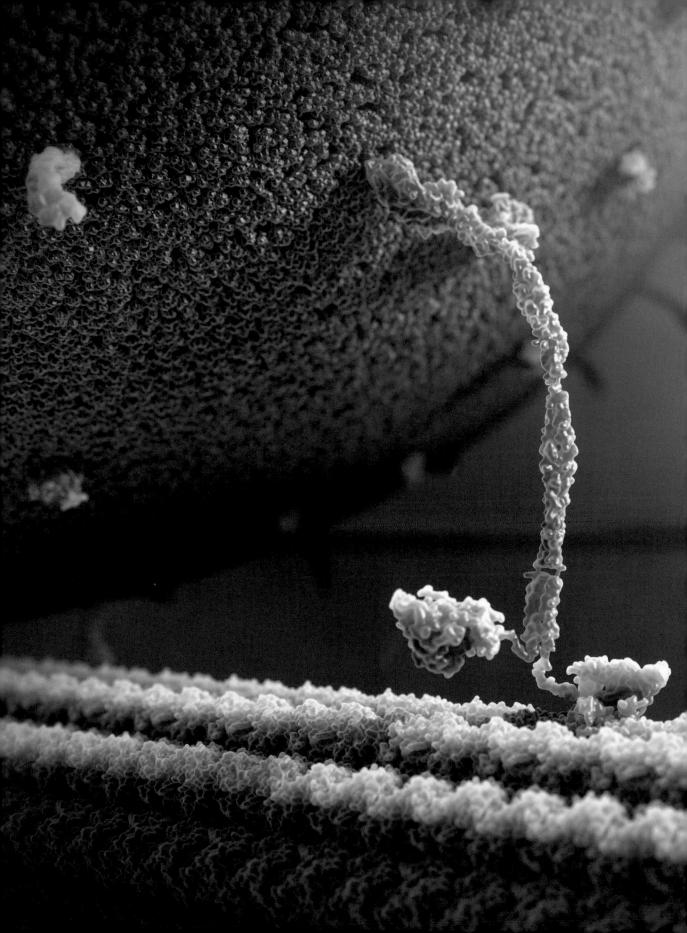

Artistic Representation of Kinesin Motor Protein Walking Along a Microtubule

Art of the Cell, date unknown

Inside every cell in every plant, fungus, and animal (including you), molecules of a protein called kinesin literally walk along molecular "wires" called microtubules, which form a crisscross framework. The kinesin molecules take around one hundred steps every second, transporting various molecules around the cell inside fatty membranes called vesicles. This remarkable process can never be captured photographically, but molecular biologists understand it well enough for artists to produce photorealistic images like this one—and even animations— to help explain it. Despite the fact that the kinesin, vesicle, and microtubule are faithfully represented down to molecular level in this image, this is still an artistic interpretation and an oversimplification of the busy internal world of the cell. +++

Painted Visualization of Seafloor

Heinrich Berann, ca. 1977

Here is the full version of the remarkable map of the seafloor painted by Heinrich Berann under the direction of geologists Marie Tharp and Bruce Heezen (see page 208). This map, along with other visualizations of seafloor bathymetry, helped cement the theory of plate tectonics, which had emerged in the 1960s. +++

Watercolor Cross Section of a Nerve
David S. Goodsell, 2020

David Goodsell is a professor of structural biology, and his beautiful and informative paintings bring together structural and molecular features of cells in ways that no microscope can do.[7] His representations of biology at the cellular level are anatomically correct—all the fats, proteins, and other biomolecules are represented, and in the right places (for clarity, he leaves out smaller molecules, such as water). The image shown here is of a cross section through a myelinated nerve. Myelin, represented by the yellow and orange layers that dominate the image, is a mixture of fats and proteins that protects the axons (outgoing signal channels) of certain neurones. Also shown is a microtubule (the blue circle; see also page 162 and pages 214–215) and several protein molecules that sit inside the neurone's cell membrane (the green arc). +++

Three-Dimensional Print of Blood Vessels

Peter Maloca, 2016

Another scientist who produces beautiful
works of art relating to their field of study
is Peter Maloca, associate professor of
ophthalmology. His images and sculptures
are informed by his expertise. This example
gives an impression of the vasculature (blood
vessels) that brings nutrients and oxygen to
the retina and the muscles around the pupil
of the eye (in this case, the eye of a miniature
pig). The sculpture was created by a 3D
printer, using a scan of the blood vessels
produced by computed tomography (CT). To
create the scan, the pig's blood was injected
with a contrast medium (a fluid that shows up
in the CT scanner). +++

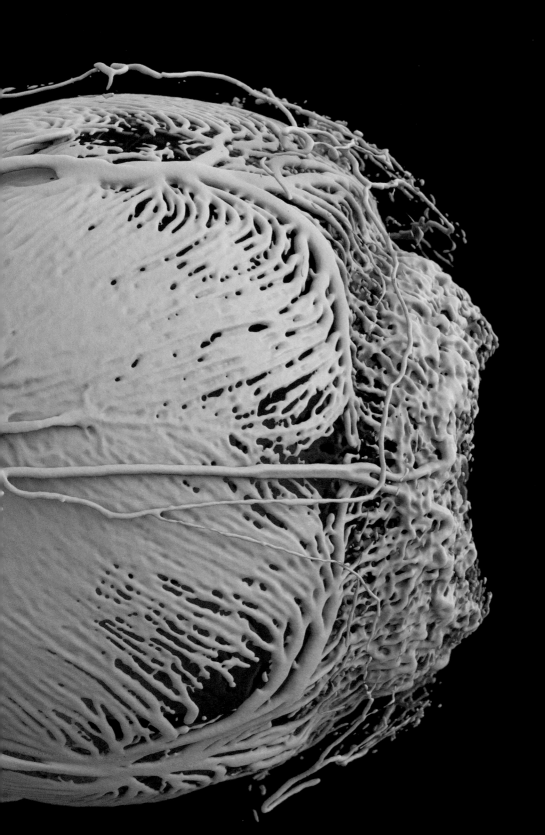

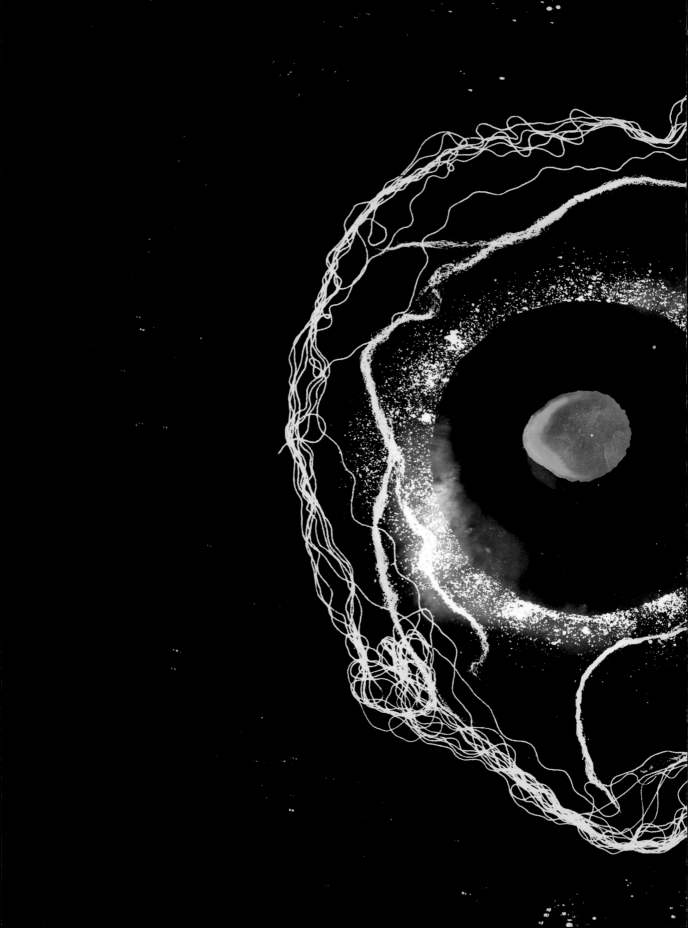

Heartbeat 1.1, Lenticular Print
Susan Aldworth, 2010

Susan Aldworth has a deep interest in the relationship between the brain and the mind, and the sense of self they create. She often collaborates with patients, doctors, scientists, and other health professionals, and has been active in the Art and Science movement since the 1990s—as a practitioner and lecturer. This image is part of a series of artworks about the heart, commissioned by a hospital in London. The series reflects not only the physiology of the heart, but also the cultural symbolism surrounding it—a perfect example of how the interaction of art and science can help bring science into culture, where it belongs. This is a two-dimensional representation of a lenticular (an image fronted by a system of vertical lenses). Moving past the image, the viewer sees different aspects of the image, reflecting the dynamic nature of the heart as a pump. +++

Optogenome—How do Chemicals Feel?
Marcus Lyon, 2011

Sometimes, art on a scientific theme is made by artists who have an interest in science. The pieces these artists produce are often more abstract and more emotive than something that is supposed to be illustrative or educational. This piece was created by artist Marcus Lyon, who was then artist in residence at AstraZeneca's Waltham, Massachusetts, oncology and infectious disease campus and the Medical Research Council's Centre for Developmental Neurobiology, at King's College, London. Lyon's interest in genetics was motivated in part by the death of his brother from an inherited disease. Like many artists and scientists, he is searching for "answers to the big questions" of the time. +++

"Life Tales," Digital Photograph Using Polarizing Filters

Ela Kurowska, 2014

After a successful career as a biochemist, Ela Kurowska turned to digital photography. She began experimenting with photoelasticity, a phenomenon in which certain substances take on a range of mesmerizing colors when positioned between two polarizing filters.

Photoelasticity is typically used by materials scientists to discover points of stress in design prototypes made of hard transparent plastic. Kurowska wanted to find a softer, more pliable material to use, and came across soft organic gels. Since 2013, she has been producing stunning images using the gels and their photoelasticity. Her work is informed, and driven, by her interest in the origins of life on Earth, and the pictures she creates resemble intricate living things photographed under a microscope. +++

Another one of the increasing number of artists who take science as their inspiration is Luke Jerram. This piece—part of Jerram's series Glass Microbiology—shows a virus called a T4 bacteriophage. Although it resembles something from science fiction, the shape of this virus is faithful to that of a real T4 bacteriophage, a virus that reproduces inside bacterial cells. However, it is also an aesthetically pleasing, abstracted piece of fine art. It has a presence that provokes emotion as well as curiosity— especially when the viewer becomes aware that it is modeled on a real biological entity.

+++

Paleoart

Piecing together the past

Planetary science, evolutionary biology, paleontology, oceanography, atmospheric chemistry, and geology . . . these are just some of the scientific disciplines involved in piecing together an idea of what the world was like before anyone was there to record it. Using a wide range of tools, techniques, and well-tested theories, as well as peer review and repeatable experiments, scientists in these fields have amassed a surprising volume of knowledge. They are extremely confident about many aspects of Earth's 4.64 billion year history—though, inevitably, many mysteries and uncertainties persist. Communicating the accumulated knowledge to a wide audience requires the imagination and skill of artists who understand enough of the science to create realistic artists' impressions. The art of reconstructing scenes or plants and animals from prehistoric times is called "paleoart."

Bringing back the dead

The first serious attempts at paleoart involved dinosaurs—and artists' impressions of these long-extinct animals remain popular. The scientific understanding of dinosaurs has evolved since dinosaur fossils were first studied scientifically, in the early nineteenth century. At first, they were terrifying lizards; later, lazy beasts whose extinction showed they were evolutionary failures; later still, during the dinosaur renaissance (a term coined by paleontologist Robert Bakker in the 1970s[8]), they became a mixture of large, slow herbivores and speedy, ferocious carnivores. And, only in the past twenty years, have paleontologists realized that a huge number of dinosaur species had feathers (see page 241). Paleoartists have had to keep up with all these changes (see Dinosaurs, Pterosaurs, and Birds page 238). Scientists and paleoartists follow similar paths in working out and portraying how other animals looked and behaved—including members of our own "tribe," the hominins (see pages 244 and 245).

The main sources of information about species that died out thousands or millions of years ago are, of course, fossils. Unfortunately, only a small proportion of individuals of any species became fossilized—and of those that did, the fleshy parts largely rotted away or were eaten soon after death. Anatomists and physiologists work with paleontologists, literally putting the flesh (and the muscles) on the bones. Today, digital scans of bones help that process, as does the constantly improving knowledge of the climate and environment in which the animals lived. All of this knowledge makes its way into paleoart, and from there, into the public consciousness—not only as images of dinosaurs, hominins, and other animals, but also plants and giant fungi (see page 234). Scientists even have a good idea of how our planet looked before life had begun—and that, too, makes for great paleoart (see opposite and overleaf).

Hadean Earth
Visualization
Simone Marchi, 2014

Geologists and planetary scientists have amassed vast knowledge and information about the history of our planet. We will never be able to go back in time or create another Earth, so the best way to communicate this knowledge is via artists' impressions. Skilled artists collaborate closely with scientists to create visualizations that are as accurate as possible—better still, perhaps, the skilled artist might also be one of the scientists. Planetary scientist Simone Marchi produced this visualization of Earth during the Hadean era, ca. four billion years ago, to accompany a project in which he and his colleagues estimated the rate of bombardment on the young Earth[9] (see also overleaf). Note the large craters (all trace of which has since been overwritten by later impacts and plate tectonics) and the melting of the crust caused by the impacts. +++

Hadean Earth Landscape
Simone Marchi and Dan Durda,
Southwest Research Institute,
date unknown

In this ground-based view of the Hadean era (see previous page), Simone Marchi and his colleague Dan Durda visualized the dramatic conditions that persisted on Earth during its first few hundred million years. Planetary scientists have investigated how the heat generated by large impacts can melt the rocks of the crust, causing the "outgassing" of volatile compounds such as water and carbon dioxide, which can then go on to form the planet's atmosphere.[10] Note how large the Moon looks in this view; our only natural satellite moves further away by nearly 4 centimeters (1.5 inches) each year, and was therefore much closer four billion years ago.

+++

Artist's Impression of a Late Silurian Landscape

Richard Jones, date unknown

By piecing together fossil finds over the past two hundred years, and by comparing those fossils with organisms alive today, palaeobiologists have a good idea how Earth's ancient landscapes would have looked. During the late Silurian period (around 430 million years ago), the sea was teeming with animals, but the only animals on land were small crawling insects and arachnids. There were, however, mosses and the first vascular plants (plants with vessels that carry water up from the soil). Shown here are *Cooksonia* (small, red, pod-like plants), the first known vascular plant, and *Baragwanathia*, a clubmoss that grew to 1 meter (3 feet) tall. The landscape is dominated by a fungus called *Prototaxites*, some of which grew to more than 25 meters (8 feet) tall and 1 meter (3 feet) in diameter.

+++

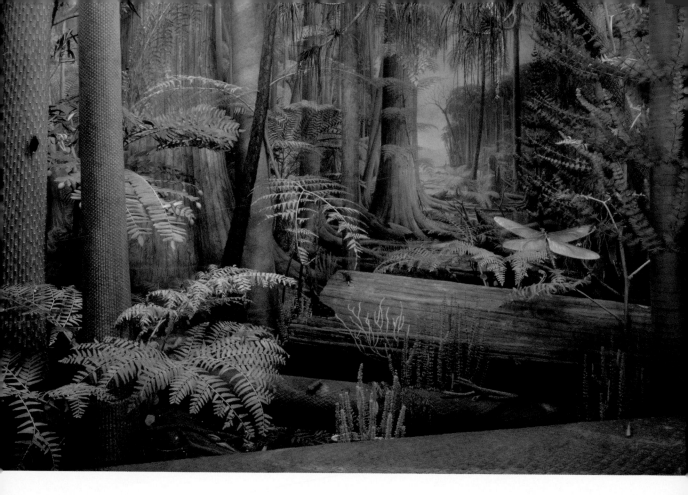

Diorama of a Carboniferous Forest
Field Museum, Chicago, 1929–1991

Dioramas provide scientists with a way of presenting scientific knowledge on a particular topic in an accessible and memorable way, in context. The diorama shown here was installed in the Field Museum in 1929 and updated several times before it was removed in 1991. It is based on the careful study of fossils from the Carboniferous period (359–299 million years ago). Dioramas became popular in the late nineteenth and early twentieth centuries, taking over from collections of curated finds with labels inside glass cases. Modern museum dioramas are often enhanced by computer animations, animatronic models, and interactive displays. +++

Artistic Reconstruction of a Woolly Mammoth

Roman Boltunov, 1805

In 1805, reindeer farmer Osip Šumakov sold a pair of woolly mammoth (*Mammuthus primigenius*) tusks to the merchant Roman Boltunov. He told Boltunov that the mammoth's carcass was intact, and was lying in the thawing ice of the Lena River Delta (in northern Siberia). Šumakov took Boltunov to the carcass, and Bultunov later drew this reconstruction of the animal, from memory, using measurements he took while visiting the animal's remains. The carcass was rotting and probably disfigured, so it is no surprise that Boltunov's drawing is not an accurate representation (to say the least)—but this was the first drawing of a woolly mammoth based on remains with flesh and skin on the bones. In 1806, the botanist Mikhail Adams took the carcass and the drawing to the Kunstkamera, in St. Petersburg (now the Peter the Great Museum of Anthropology and Ethnography). The original drawing is lost—this was a copy that was sent to the naturalist Johann Blumenbach, who wrote the caption at the bottom.[11] +++

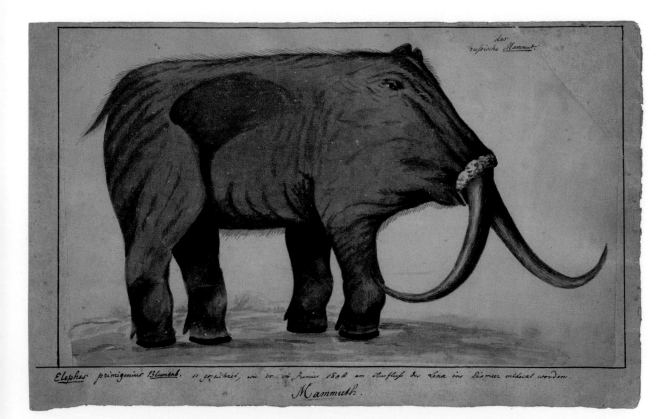

People have been finding bones of dinosaurs and other long-extinct animals for thousands of years, but until the nineteenth century, no one had any idea that they belonged to species that no longer exist. Before paleontology and natural history became subjects of serious study, many people believed fossils of extinct animals were bones of mythical creatures, including giant humans and flying monsters such as dragons. In the eighteenth and nineteenth centuries, opinion shifted, and people began attributing the bones to existing species that had simply not yet been discovered. One example of this was the pterosaur, a creature with wings and long slender arms and claws that was unlike any other animal known at the time.

The naturalist Cosimo Alessandro Collini was the first scientist to describe a pterosaur fossil, in 1784, and to ponder its origins. Collini thought the arms might have supported a membrane-like wing, similar to the wing of a bat. However, pterosaur fossils had only been found in coastal rocks, so he thought it must be a marine animal. And, since back then the idea that species come and go was unthinkable to most people, naturalists of the day supposed that Collini's find was simply rare or lived out at sea. In 1801, anatomist Georges Cuvier suggested that it was a flying reptile—in part because of the claws at the ends of its wings. In 1810, Cuvier proposed the name "ptéro-dactyl," meaning "winged finger." Today, *Pterodactylus* is considered an extinct genus (group of closely related species) within a larger group called Pterosauria—which were all indeed flying reptiles.

As the nineteenth century progressed, interest in fossil remains intensified—and scientists began to realize that fossils were the remains of extinct animals. In the 1820s, geologist Gideon Mantell found a tooth that resembled that of an iguana, only much larger; he realized that the iguana that owned it must have been huge. Mantell gave the fossil lizard the name *Iguanodon*, from the Greek for "iguana teeth." In 1841, paleontologist Richard Owen coined the term "dinosaur," meaning "terrible (or fearful) lizard." In the public imagination, pterosaurs—along with ichthyosaurs and plesiosaurs—are often considered as types of dinosaurs. This is perhaps because they were often portrayed alongside dinosaurs in early paleoart (including *Duria Antiquior*, opposite). In fact, they are all from separate lineages. But it was perhaps fortunate that pterosaurs were popularly considered flying dinosaurs, because it makes it easy to accept that the feathered, flying animals we know today—birds—

Duria Antiquior
Watercolor by Henry De La Beche, 1830
The full title of this painting is *Duria Antiquior (a more ancient Dorset)*. It was one of the first representations of extinct creatures in deep prehistory. Henry De La Beche was a geologist as well as an artist, and he painted the picture to represent some of the finds made by fossil hunters at the time—and particularly, those of the influential paleontologist Mary Anning, who lived in Dorset. England: pterosaurs (flying), ichthyosaurs (crocodile-shaped marine reptiles) and plesiosaurs (long-necked marine reptiles, one of which is being attacked by an ichthyosaur).

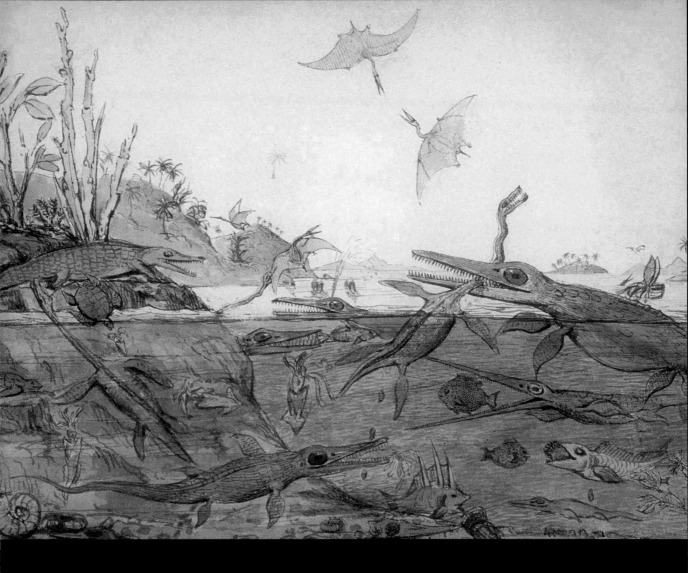

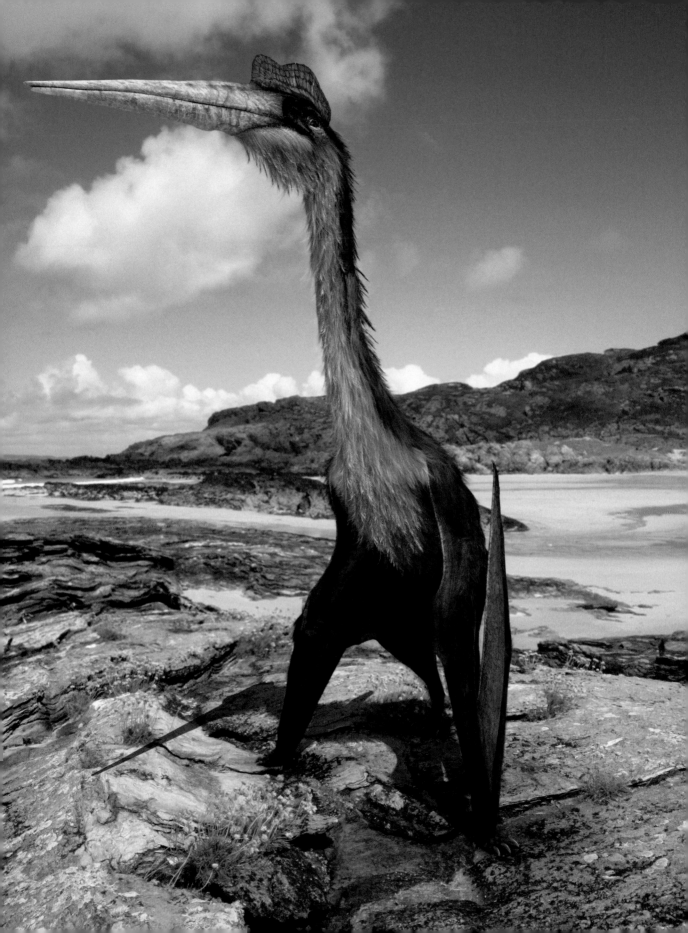

Reconstruction of
Quetzalcoatlus Northropi
Johnson Mortimer, 2016

Although *Quetzalcoatlus* is the name of a genus, there is only one known species, *Quetzalcoatlus northropi*. However, the genus is part of a larger group, a family, called Azhdarchidae, all of which were flying reptiles. These animals had huge skulls (even larger than the size of the skull in this artist's impression), with a large crest at the top. They were well adapted to walking around on all fours on land, but would have been able to soar high into the air. Their beak-like jaws would have been ideal for catching fish or feeding on already dead ones.

The first clue to the evolutionary link between dinosaurs and birds came with the discovery of fossils of *Archaeopteryx*, in the 1860s. This dinosaur had obvious birdlike features—it was typically about 30 centimeters (12 inches) tall and had winglike arms bearing feathers—but also had features of dinosaurs, including a long, lizardlike tail and claws at the ends of its arms. Through much of the twentieth century, the idea that birds are descended from dinosaurs dwindled, as naturalists found distinct differences in the anatomies of birds and dinosaurs. But it resurged as part of the "dinosaur renaissance" that began in the 1970s (see page 230). Paleontologists found more and more fossils of feathered dinosaurs, many of them more closely resembling birds than *Archaeopteryx* does—and all of them from the clade (large group of species) of dinosaurs called therapods. All of them shared important anatomical features with birds[12] — including not only feathers, but also light, "pneumatic" (air-filled) bones. The overwhelming consensus among modern paleontologists is that not all dinosaurs became extinct without any descendants during the mass extinction of sixty-six million years ago (the Cretaceous-Paleogene extinction event, K-Pg). The ones that survived had evolved feathers, perhaps largely as insulation—and the more than ten thousand species of birds alive today are their direct descendants.

It is important to note that while all birds are dinosaurs (descended from theropods), not all dinosaurs are direct ancestors of birds . . . and not all extinct flying reptiles were dinosaurs. Pterosaurs were not therapods, nor even dinosaurs—and certainly not birds. But they were flying reptiles, and they did live alongside dinosaurs, from the Triassic to the Late Cretaceous (220 to 66 million years ago). One of the most remarkable pterosaurs—and the largest-known flying animal so far discovered—is *Quetzalcoatlus*. The size of a giraffe, a *Quetzalcoatlus* had a wingspan of just over 10 meters (33 feet) as an adult. It existed in North America from about seventy-five million years ago until the K-Pg event. The first fossil of *Quetzalcoatlus* was discovered in 1975;[13] the name derives from the mythical Aztec feathered serpent deity Quetzacoatl. However, *Quetzalcoatlus* did not actually possess feathers (nor did any other pterosaurs)—but rather "pycnofibers." These dense, hairlike filaments were more similar to mammals' hair than birds' feathers.[14] Paleontologists are unsure as to the behavior of *Quetzalcoatlus*: its long, toothless, beak-like jaws share some characteristics with wading, scavenging birds such as storks.[15]

Artist's Impression of Tyrannosaurus

James Kuether, date unknown

Paleontologists began to recognize the close relationship between certain dinosaurs and birds in the late 1960s—but it is only in the twenty-first century that they have come to realize how many dinosaur species had feathers. Even *Tyrannosaurus*, long portrayed as a featherless dinosaur, had tufted feathers down its back and on the underside of its tail, as shown in this recent artist's impression (it was a therapod—see page 241). *Tyrannosaurus*' role in the food chain is also a matter of debate: there is evidence that it was as much a scavenger as an apex predator.[16] All of this new evidence is portrayed in this recent representation of *Tyrannosaurus*, during the late Cretaceous period (between 100 million and 66 million years ago) in what is now North America. In the background are two other dinosaur species: *Triceratops* and *Edmontosaurus*. +++

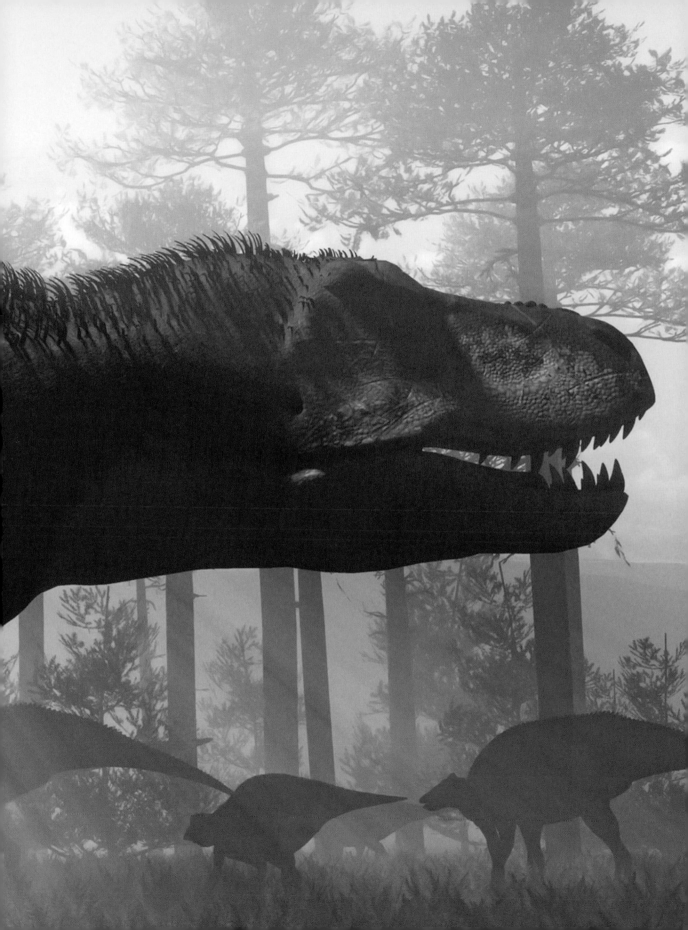

Reconstruction of Neanderthal

Hermann Schaaffhausen, 1888

The term "Neanderthal" derives from the Neandertal, a valley of the Düssel River in Germany. It was there, in 1856, that mine workers discovered fossilized human bones—the top of a skull, a pelvis, and some other long bones. Local schoolteacher Johann Fuhlrott realized that the bones did not belong to modern humans, and sent a cast of the skull, with its pronounced brow ridges, to anatomist and anthropologist Hermann Schaaffhausen. After studying the fossils, Fuhlrott and Schaaffhausen published an account of the find in 1857—and seven years later, geologist William King suggested the species be called *Homo neanderthalensis*. Schaaffhausen had artistic sketches made in the late 1850s to visualize how the Neanderthal's head might have looked; he updated the sketch several times before ending up with his final version, shown here.

+++

Three-Dimensional Reconstruction of Australopithecus sediba

Adrie and Alfons Kennis, Neanderthal Museum, Germany, date unknown

Identical twins Adrie and Alfons Kennis combine their two passions in their work: art and human evolution. They create lifelike models of prehistoric humans—although there is still much guesswork and a lack of consensus in just how accurate the models are.[17] The twins begin by 3D-printing the skeleton from detailed scans of bones. Next, they build up the muscles and main veins and arteries, and cover the resulting structure with layers of silicone. This sculpture is of *Australopithecus sediba*, which lived around two million years ago, in what is now South Africa. *Australopithecus* was a genus of great apes that arose around four million years ago and died out about one million years ago. The genus Homo, of which our own species *Homo sapiens* is a part, evolved directly from one or more members of *Australopithecus*.[10] +++

Space Art

Exploring space

Just as there is a name for artistic renditions of times past, so there is for artistic impressions of objects and scenes that we have never seen directly in deep space. It is called, predictably perhaps, astronomical art (if it features only astronomical objects) or, more generally, space art. People have imagined scenes in deep space for hundreds of years, but it is only in the last century or so that space art has had any sense of realism—encouraged and informed by the rapid advances in astronomy and astrophysics, and by the promise and realization of actually exploring space.

One of the first space artists, working in the early twentieth century, was keen amateur astronomer Thomas Simeon Scriven Bolton—normally known as Scriven Bolton. He strived to make his work as scientifically accurate as possible, often building models of the surface of the Moon or planets from plaster, and taking photographs of them, and afterward painting stars directly onto the prints.[19] Another space art pioneer was Lucien Rudaux, a professional astronomer, whose works were also accurate portrayals of scenes from the solar system. The first artist to create realistic representations of space exploration was Chesley Bonestell. He was not an astronomer or spaceflight engineer, but he worked hard to produce realistic images. Previously a special effects painter for the film industry, Bonestell produced paintings of rockets, space stations, and bases on the Moon and Mars that inspired a generation growing up in the first decades of the Space Age.[20]

Testable predictions

Apart from the subject matter, there is another difference between space art and paleoart. While we can never go back in time to compare works of paleoart with reality (unless we recreate extinct species, Jurassic Park-style), there are cases where the subjects of space art have been or may be imaged in real life. For example, Chesley Bonestell painted incredible close-up views of the rings of Saturn; similar views have since been captured as photographs, by space probes. Future telescopes may be able to resolve details on exoplanets (planets around stars outside our solar system—see Exoplanets, pages 252–255), or produce images of quasars so far away that they currently only appear as faint, fuzzy spots. Of course, some scenes will probably forever be impossible to see without artistic impressions. For example, it is hard to imagine that any person, however far in the future, will ever see an actual image of our own galaxy from the outside (see page 262).

Two Examples of Early Space Art

Lucien Rudaux, 1940s (top) and Max Meyer 1885 (bottom)

With some knowledge and understanding, artists can produce realistic scenes of a place without ever having been there. So it is with these two images. The top image is a view of planet Mars as it would appear from one of its moons. It combines aesthetic beauty with imagination, but is well informed, since its painter, Lucien Rudaux, was also a serious astronomer. The bottom image is an imagined close-up of the lunar crater Plato, with Earth visible in the sky. It was produced for astronomer Max Wilhelm Meyer, who was an early popularizer of science to the wider public. This particular image appeared in an astronomical theater he founded in Vienna, Austria. +++

Artist's Impression of the Moon's "Ruby Amphitheater"

New York Sun, 1835

Sometimes space artists' impressions can set out to mislead. In 1835, 134 years before people actually set foot on the Moon, the *New York Sun* newspaper published a series of six articles describing the discoveries supposedly made by the world-famous astronomer Sir John Herschel, and this detailed lithograph was one of the images that accompanied the story. Although Herschel was a real figure, the author of the articles, Dr. Andrew Grant, was fictional. The fantastic life-forms described by the fictitious Grant included furry, bat-like humanoids, two-legged beavers, and even one-horned goats.[21] The articles also described enormous amethyst crystals, wide rivers, carpets of dark red flowers and even beaches. Not only many readers, but also some scientists, were taken in, and the newspaper's circulation rocketed.

+++

Artist's Impression of 'Oumuamua

Martin Kornmesser, Luis Calçada, European Southern Observatory, 2017

In October 2017, astronomers using the University of Hawaii's Pan-STARRS1 telescope discovered an object moving through the solar system at an incredible 87 kilometers (54 miles) per second (313,200 kmh/194,400 mph). The interstellar object, labeled 1I/2017 U1 was nicknamed 'Oumuamua, Hawaiian for "scout." It was clear from 'Oumuamua's trajectory that it did not originate in our solar system—it was the first object ever detected that came from another star system. Careful observations at several facilities, including the European Southern Observatory's Very Large Telescope, hinted that 'Oumuamua is dark and elongated. This stunning representation captures those features beautifully. +++

Astronomers have long supposed that planets exist outside our solar system, in orbit around other stars. After a few erroneous or unconfirmed observations in the middle of the twentieth century, the first confirmed detection of an exoplanet came in 1992. Since then, astronomers have discovered many more: at the time of writing, the tally stands just short of five thousand. All the exoplanets so far detected lie within 3,000 light-years, which represents a small fraction of the size of our galaxy. Planets are almost certainly very common throughout our galaxy (which contains around a hundred billion stars), and there is no reason to expect that they are not just as common in other galaxies (and indeed, astronomers announced the tentative detection of an exoplanet in another galaxy for the first time, in 2021).[22] The sheer number of planets in the universe is dizzying, and there must be a planet of just about every kind imaginable – including, surely, some that harbor life.

Stars are extremely far away, so they only appear as points of light (although some of the very largest and closest do appear as tiny disks in powerful telescopes). Planets are much smaller still, and do not even shine with their own light. And so, astronomers have to use some cunning methods to detect exoplanets. The two most productive techniques to date are Doppler spectroscopy and transit photometry. The first of these relies upon the Doppler effect—the same phenomenon that causes the change in pitch of an ambulance siren as the ambulance moves toward and then away from you. When a planet is in orbit around a star, the gravitational interaction between the two makes the star "wobble," just as an athlete throwing the hammer wobbles slightly as they whirl the hammer around. The Doppler effect causes the frequency of the star's light to shift up and down as it wobbles—and from that shift, astronomers can work out the period and distance of the orbit, and the planet's mass. Examples of facilities that use this method are the High Accuracy Radial Velocity Planet Searcher (HARPS) at the La Silla Observatory in Chile and the High Resolution Echelle Spectrometer (HIRES) at the W.M. Keck Observatory in Hawaii. The second exoplanet detection method, transit photometry, relies on measurement of the light (photometry) from the star as a planet passes in front of it (transits). The regularity with which the star's light dims gives the orbital period (the time it takes for the planet to complete one complete orbit), while the amount the light dims gives an estimate of the planet's size. This is the method used by the Kepler space telescope (see pages 130–131).

Artist's Impression of TRAPPIST-1
ESO/N. Bartmann/spaceengine.org, 2017
In 2015, Belgian astronomers discovered three planets around a dim, ultracool red dwarf star with the inauspicious name 2MASS J23062928-0502285[23] (the star itself was discovered in 1999, as part of the Two Micron All Sky Survey, 2MASS). The discovery was made with the Transiting Planets and Planetesimals Small Telescope (TRAPPIST), a facility of the European Southern Observatory. Since then, astronomers have discovered a further four planets around the star. This artist's impression shows the view from the surface of one of the planets in the TRAPPIST-1 system. It features a view of the star from above the surface of one of its planets in the foreground, with another in transit across the star.

An Artist's Impression

Martin Kornmesser, European
Southern Observatory, 2016

Well-informed imagination
combined with artistic skill
produced this artist's impression
of a view from the surface of one
of the planets in the TRAPPIST-1
system. Two other planets are
visible, including one in transit
across the star's disk (this
painting was produced in 2016,
when only three of the planets
had been discovered). Note the
coexistence of solid and liquid
water —water vapor would also
be present in the atmosphere.
The planet is rocky, as are the
inner planets of most planetary
systems characterized so far
(including, of course, our own).
Elements present in the rocky
minerals, plus liquid water, plus
an atmosphere and the energy
from the star could just equal life.

Exoplanets are very numerous in our galaxy: estimates are typically around one hundred billion. Presumably, this is true in other galaxies, too—and there are at least one hundred billion of those. These facts suggest an inconceivable variety of sizes, compositions, orbital distances, and host star types. This is fertile ground for the imagination, and so for science fiction and artists' impressions. As an example, the seven planets of the TRAPPIST-1 system are all around the same size as Earth, suggesting they are rocky planets not dissimilar from our own. Around half of them are also all within the "zone of habitation"—in other words, at the right distance from the star for liquid water to exist on their surfaces. This zone is much closer to the star than our solar system's zone of habitation is to our Sun, simply because the star is much cooler. All seven planets are closer to their star than Mercury is to our Sun. The important thing is that the surface temperature is just right to make life viable there. The planets around TRAPPIST-1 are the best targets found so far for the search for life outside our solar system. The star itself is only a little more than one-tenth the diameter of our Sun, and burns its fuel of hydrogen and helium only slowly. This means it should have a very long life, giving stable conditions that could give life more of a chance to develop and take hold (although in some other respects, red dwarfs are not ideal for life-bearing planets).[24]

The star lies forty light-years away, so the likelihood of any future space probe or astronauts visiting it and capturing real images of its planets is extremely remote. But with the knowledge and understanding of the astrophysics behind the formation of planetary systems, of planetary physics, chemistry, and a host of other relevant areas of science, artists' impressions can be well-informed, convincing, and very intriguing. In the coming decades, improving technology—including the James Webb Space Telescope—will enable astronomers to work out the chemical composition of the atmosphere of planets like these.[25] This can only make the likelihood of discovering life elsewhere in the universe higher—and improving the accuracy of artists' impressions still further.

Mark A. Garlick, The Center for Astrophysics,
Harvard & Smithsonian, 2015

When a small- to medium-sized star reaches
the end of its life, it collapses to form a
very dense, hot object called a white dwarf.
In 2015, instruments aboard the Kepler
spacecraft detected a periodic dip in the
brightness of WD 1145+017, a white dwarf
about 570 light-years from Earth. This
brightness dip is caused by a planet or other
orbiting object passing in front of the star, and
is how Kepler discovered so many exoplanets
(see also, page 252). The shape of the light
curve was different from most, suggesting
that the orbiting object was surrounded
by a fuzzy halo of diffuse material—a
little like a comet. The observation tallied
with a hypothesis that explains why the
atmospheres of many white dwarfs are
"polluted" with elements such as calcium,
silicon, and magnesium.[26] This intriguing
artwork neatly sums up what is going on, and
realistically portrays a scene we will never
see for ourselves. +++

Artist's Impression of Gravitational Waves

LIGO/T. Pyle, 2016

Gravitational waves are disturbances in space-time, which travel outward, like ripples on a pond, from energetic astrophysical events, such as the merging of black holes. Their existence is a prediction of Albert Einstein's general theory of relativity, published in 1915. In 2016, researchers at the Laser Interferometry Gravitational-Wave Observatory (LIGO) announced their instruments had detected gravitational waves, twice, in 2015. The illustration shown here is an artist's impression of the second detection, which occurred in December 2015.[27] The waves LIGO detected were produced by the spiraling merger of two black holes, with masses fourteen and eight times the Sun's mass. The gravitational waves, traveling at the speed of light, took 1.3 billion years to reach Earth. The result of the merger was a single rotating black hole with twenty-one times the mass of the Sun —the "lost mass," equivalent to the mass of the Sun, is accounted for by the energy of the waves emitted by the event (according to Einstein's famous mass-energy equivalence, $E = mc^2$). +++

Artist's Impression of Quasar 3C 279

Martin Kornmesser, European Southern Observatory, 2012

Astronomers combined data from three radio telescopes to build up detailed knowledge of a distant quasar (see page 185), called 3C 279. The galaxy that is home to the quasar lies five billion light-years away, and the black hole at the quasar's center has a mass of about a billion Suns. Images constructed from the radio telescope data are very fuzzy, but enough is known about the quasar's structure, and about the physics behind it, to put together this picture of what it might actually look like. +++

Massive Plume on Betelgeuse

Luis Calçada, European Southern Observatory, 2009

Betelgeuse is a star in the constellation of Orion. It is a red supergiant star (see page 136) with a diameter nearly nine hundred times that of the Sun. In 2009, astronomers used the Very Large Telescope, in Chile, to produce the best images of Betelgeuse so far. The images showed a plume of gas almost as large as our entire solar system extending from the star's surface. Based on those images, and using knowledge of the physics behind supergiants, Luis Calçada produced this stunning artistic visualization. +++

Artist's Impression of the Milky Way Galaxy

NASA/JPL-Caltech/ESO/R. Hurt, 2013

Using ground-based and space telescopes, astronomers have cataloged the distances and speeds of hundreds of millions of stars, and the distribution of interstellar gas and dust in our galaxy, the Milky Way. These measurements show that the galaxy is rotating and has a dust-to-gas-to-stars ratio similar to other spiral and barred-spiral galaxies. There is a clear central bulge, as well—a feature of all spiral and barred-spiral galaxies. Our solar system lies in one of the spiral arms; when you gaze up on a clear dark night and see the fuzzy band, also called the Milky Way, you are looking toward the galaxy's central bulge. But seeing our galaxy in its entirety, from the outside, is something we will only ever visualize in artists' impressions like this one. +++

Endnotes

INTRODUCTION: THE IMPORTANCE OF SEEING

1 Excerpt from "A Comparison Between Poetry and Painting," from Leonardo da Vinci's undated manuscripts.

2 A. Brisbane, "Newspaper Copy That People Must Read." *Printers' Ink*, Volume LXXV, Number 3, p. 17. Decker Communications Inc., New York (1911). You can find the article by searching at www.hathitrust.org

3 M.C. Potter, B. Wyble, C.E. Hagmann, et al., "Detecting meaning in RSVP at 13 ms per picture." *Attention, Perception, & Psychophysics* 76, pp. 270–279 (2014). https://doi.org/10.3758/s13414-013-0605-z

4 Asifa Majid, Seán G. Roberts, Ludy Cilissen, Karen Emmorey, Brenda Nicodemus, Lucinda O'Grady, Bencie Woll, et al., "Differential Coding of Perception in the World's Languages." *Proceedings of the National Academy of Sciences* 115 (45): 11369 LP – 11376 (2018). https://doi.org/10.1073/pnas.1720419115

5 R. A. Barton, "Visual specialization and brain evolution in primates." *Proceedings of the Royal Society B: Biological Sciences*, 265(1409), 1933–1937 (1998). https://doi.org/10.1098/rspb.1998.0523

6 Lucy S. Petro et al., "Contributions of cortical feedback to sensory processing in primary visual cortex." *Frontiers in Psychology* vol. 5 1223 (6 Nov. 2014). doi:10.3389/fpsyg.2014.01223

7 Richard Buckminster Fuller, "Tunings," a recording made at his home in Sunset, Maine, on August 22, 1979.

CHAPTER 1: MAKING THE INVISIBLE VISIBLE

1 David C. Gooding, "From Phenomenology to Field Theory: Faraday's Visual Reasoning." *Perspectives on Science* 14 (1): 40–65 (2006). https://doi.org/10.1162/posc.2006.14.1.40

2 J.B. Jonas, U. Schneider, G.O. Naumann, "Count and density of human retinal photoreceptors." *Graefe's Archive for Clinical and Experimental Opthamology*; 230(6):505–10 (1992). doi: 10.1007/BF00181769. PMID: 1427131

3 S.S. Howards, "Antonie van Leeuwenhoek and the discovery of sperm." *Fertility & Sterility*; 67(1):16–7 (Jan 1997). doi: 10.1016/s0015-0282(97)81848-1. PMID: 8986676

4 J.D. Buddhue, "Meteoritic Dust" p. 102. *University of New Mexico Publications in Meteoritics 2*: Albuquerque, University of New Mexico Press (1950).

5 John M.C. Plane, "Cosmic dust in the earth's atmosphere." *Chemical Society Reviews* vol. 41,19 (2012): 6507-18. doi:10.1039/c2cs35132c

6 J. Warren, L. Watts, K. Thomas-Keprta, S. Wentworth, A. Dodson, and Michael E. Zolensky, "Cosmic dust catalog." Technical Report (1997).

7 Hope A. Ishii, John P. Bradley, Hans A. Bechtel, Donald E. Brownlee, Karen C. Bustillo, James Ciston, Jeffrey N. Cuzzi, Christine Floss, and David J. Joswiak, "Multiple Generations of Grain Aggregation in Different Environments Preceded Solar System Body Formation." *Proceedings of the National Academy of Sciences* 115 (26): 6608 LP – 6613 (2018). https://doi.org/10.1073/pnas.1720167115

8 J.R. Lemen, A.M. Title, D.J. Akin, et al.,"The Atmospheric Imaging Assembly (AIA) on the Solar Dynamics Observatory (SDO)." *Solar Physics* 275, 17–40 (2012). https://doi.org/10.1007/s11207-011-9776-8

9 Marina Venero Galanternik et al., "A novel perivascular cell population in the zebrafish brain." *eLife* vol. 6 e24369. (11 Apr. 2017). doi:10.7554/eLife.24369

10 B. Schuler, S. Fatayer, F. Mohn, et al., "Reversible Bergman cyclization by atomic manipulation." *Nature Chemisty* 8, 220–224 (2016). https://doi.org/10.1038/nchem.2438

11 F. Natterer, K. Yang, W. Paul, et al., "Reading and writing single-atom magnets." *Nature* 543, 226–228 (2017). https://doi.org/10.1038/nature21371

CHAPTER 2: DATA, INFORMATION, KNOWLEDGE

1 James R. Beniger and Dorothy L. Robyn, "Quantitative Graphics in Statistics: A Brief History." *The American Statistician* 32, no. 1 (1978): 1-11. Accessed August 23, 2021. doi:10.2307/2683467

2 E. Hubble, "A relation between distance and radial velocity among extra-galactic nebulae." *Proceedings of the National Academy of Sciences of the United States of America* 15(3):168–173 (1929).

3 Neta A. Bahcall, "Hubble's Law and the Expanding Universe." *Proceedings of the National Academy of Sciences of the United States of America* 112 (11): 3173 LP – 3175 (2015). https://doi.org/10.1073/pnas.1424299112

4 M. Kleiber, "Body size and metabolic rate." *Physiological Reviews* 27 (4): 511–41 (October 1947).

5 M.E. Mann, R. Bradley, and M. Hughes, "Northern Hemisphere Temperatures During the Past Millennium: Inferences, Uncertainties, and Limitations." *Geophysical Research Letters* 26: 759–762 (1999).

6 O. Rioul and M. Vetterli, "Wavelets and signal processing." *IEEE Signal Processing Magazine* vol. 8, no. 4, pp. 14–38 (Oct. 1991). doi: 10.1109/79.91217

7 F. Mazzocchi, "Could Big Data be the end of theory in science? A few remarks on the epistemology of data-driven science." *EMBO Reports* 16(10):1250–1255 (2015). doi:10.15252/embr.201541001

8 https://www.movebank.org

9 J. Shiers, "The worldwide LHC computing grid (worldwide LCG)." *Computer Physics Communications* 177(1-2):219 233 (2007).

10 J.W. Lichtman, H. Pfister, N. Shavit, "The big data challenges of connectomics. *Nature Neuroscience* 17(11):1448–1454 (2014). doi:10.1038/nn.3837

11 www.humanconnectomeproject.org

12 K. McDole et al., "In toto imaging and reconstruction of post-implantation mouse development at the single-cell level." (Published online October 11, 2018.) doi:10.1016/j.cell.2018.09.031

13 See, for example, A. Liew, "Understanding data, information, knowledge and their inter-relationships." *Journal of Knowledge Management Practice* 8(2), 1–16 (June 2007). ISSN 1705–9232

14 M. Mauri, T. Elli, G. Caviglia, G. Uboldi, and M. Azzi, "RAWGraphs: A Visualisation Platform to Create Open Outputs." In *Proceedings of the 12th Biannual Conference on Italian SIGCHI Chapter* (p. 28:1–28:5). New York, NY, USA: ACM (2017). https://doi.org/10.1145/3125571.3125585

15 M. Mauri, T. Elli, G. Caviglia, G. Uboldi, and M. Azzi, "RAWGraphs: A Visualisation Platform to Create Open Outputs." In *Proceedings of the 12th Biannual Conference on Italian SIGCHI Chapter* (p. 28:1–28:5). New York, NY, USA: ACM (2017). https://doi.org/10.1145/3125571.3125585

16 W. Van Panhuis, A. Cross, D. Burke, "Counts of Measles reported in UNITED STATES OF AMERICA: 1888–2002" (version 2.0, April 1, 2018): Project Tycho data release, DOI: 10.25337/T7/ptycho.v2.0/US.14189004

17 M. Krzywinski et al., "Circos: an Information Aesthetic for Comparative Genomics." *Genome Research* 19:1639–1645 (2009).

18 Jack Challoner, *Real Lives: John Snow*. London: A&C Black (2013).

19 William Smith, *A memoir to the map and delineation of the strata of England and Wales, with part of Scotland*. London, John Cary (1815).

20 R.D. Müller, M. Sdrolias, C. Gaina, and W.R. Roest, "Age, spreading rates and spreading symmetry of the world's ocean crust," *Geochemistry, Geophyisics, Geosystems* 9, Q04006 (2008). doi:10.1029/2007GC001743

21 www.showyourstripes.info

22 E. Bobek, B. Tversky, "Creating visual explanations improves learning." *Cognitive Research: Principles and Implications* 1(1):27 (2016). doi: 10.1186/s41235-016-0031-6. Epub 2016 Dec 7. PMID: 28180178; PMCID: PMC5256450.

23 In fact, Einstein wrote "the truth of a theory can never be proven. For one never knows if future experience will contradict its conclusion; and furthermore there are always other conceptual systems imaginable which might coordinate the very same facts." – from Albert Einstein, *The Collected Papers of Albert Einstein*, Volume 7, Document 28. Princeton University Press (2002).

24 Isaac Newton, *Opticks: or, A Treatise of the Reflexions, Refractions, Inflexions and Colours of Light*. London, Royal Society (1704).

25 Hüseyin Gazi Topdemir, "Kamal Al-Din Al-Farisi's Explanation of the Rainbow." *Humanity & Social Sciences Journal* 2 (1): 75–85 (2007). ISSN 1818-4960.

26 Sir John Ross, *Appendix to the Narrative of a Second Voyage in Search of the North-West Passage and of a Residence in the Arctic Regions During the Years 1829, 1830, 1831, 1832, 1833*. London, A.W. Wester (1835).

27 This version courtesy of the European Southern Observatory.

28 See, for example, Jack Challoner, *The Atom: A Visual Tour*. Cambridge, MA, MIT Press (2018).

29 Christiaan Huygens, *Traité de la lumière, où sont expliquées les causes de ce qui luy arrive dans la réflexion, et dans la réfraction, et particulièrement dans l'étrange réfraction du cristal d'Islande*, pp. 92–94. Leiden: Pierre van der Aa, (1690).

30 Daniel Bernoulli, *Hydrodynamica – sive de viribus et motibus fluidorum commentarii*, fig. 56. Strassburg: Johann Heinrich Decker (1738).

31 John Dalton, *A New System of Chemical Philosophy*, Plate 4. London, R. Bickerstaff (1808).

32 David Lindley, *Boltzmann's Atom: The Great Debate That Launched a Revolution in Physics*. New York, The Free Press (2001).

33 Alfred Korzybski, *Science and Sanity. An Introduction to Non-Aristotelian Systems and General Semantics*, pp. 747–761. The International Non-Aristotelian Library Publishing. Co. (1933).

34 www.evogeneao.com

35 See, for example, W.F. Doolittle, E. Bapteste, "Pattern pluralism and the Tree of Life hypothesis." *Proceedings of the National Academy of Sciences of the United States of America* 13;104(7):2043–9 (2007 Feb). doi: 10.1073/pnas.0610699104. Epub Jan 29, 2007. PMID: 17261804; PMCID: PMC1892968.

36 J. Wang, P. Youkharibache, D. Zhang, C.J. Lanczycki, R.C. Geer, T. Madej, L. Phan, M. Ward, S. Lu, G.H. Marchler, Y. Wang, S.H. Bryant, L.Y. Geer, A. Marchler-Bauer. iCn3D, a Web-based 3D Viewer for Sharing 1D/2D/3D Representations of Biomolecular Structures. *Bioinformatics* 1;36(1):131–135. (Epub June 20, 2019) doi: 10.1093/bioinformatics/btz502

CHAPTER 3: MATHEMATICAL MODELS AND SIMULATIONS

1 Galileo Galilei *Il Saggiatore*. Rome (1623).

2 Douglas W. MacDougal, *Newton's Gravity: An Introductory Guide to the Mechanics of the Universe*, Chapter 2. Netherlands: Springer New York (2012).

3 Isaac Newton, *Philosophiæ Naturalis Principia Mathematica*. London: *Jussu Societatis Regiae ac typis Iosephi Streater, prostat apud plures bibliopolas, anno MDCLXXXVII* [1687]

4 R.M. May, "Simple mathematical models with very complicated dynamics." *Nature*, 261(5560), 459–467 (1976). https://doi.org/10.1038/261459a0

5 P. Ieong, R.E. Amaro, and W.W. Li. "Molecular dynamics analysis of antibody recognition and escape by human H1N1 influenza hemagglutinin." *Biophysical Journal*, 108(11), 2704–2712 (2015). https://doi.org/10.1016/j.bpj.2015.04.025

6 D.B. Wells and A. Aksimentiev, "Mechanical properties of a complete microtubule revealed through molecular dynamics simulation." *Biophysical Journal*, 99(2), 629–637 (2010). https://doi.org/10.1016/j.bpj.2010.04.038

7 Roe D. R., Cheatham T.E. 3rd. "PTRAJ and CPPTRAJ: Software for Processing and Analysis of Molecular Dynamics Trajectory Data." *Journal of Chemical Theory and Computation*. 2013 Jul, 9 (7), 3084-3095. DOI: 10.1021/ct400341p. PMID: 26583988.

8 Malmi-Kakkada, A. N., Li, X., Samanta, H. S., Sinha, S. & Thirumalai, D., "Cell growth rate dictates the onset of glass to fluidlike transition and long time superdiffusion in an evolving cell colony." *Phys Rev*. X8, 021025 (2018).

9 C.W. Reynolds, "Flocks, Herds and Schools: A Distributed Behavioral Model." ACM Siggraph Computer Graphics, 21, 25–34 (1987). http://dx.doi.org/10.1145/37402.37406

10 R. Hinch, W.J.M. Probert, A. Nurtay, M. Kendall, C. Wymant, M. Hall, et al., "OpenABM-Covid19—An agent-based model for non-pharmaceutical interventions against COVID-19 including contact tracing." *PLoS Computational Biology* 17(7): e1009146 (2021). https://doi.org/10.1371/journal. pcbi.1009146

11 M. Kretzschmar, "Disease modeling for public health: added value, challenges, and institutional constraints." *Journal of Public Health Policy* 41, 39–51 (2020). https://doi. org/10.1057/s41271-019-00206-0

12 F. Samsel, J.M. Patchett, D.H. Rogers, K. Tsai, "Employing Color Theory to Visualize Volume-rendered Multivariate Ensembles of Asteroid Impact Simulations." Proceedings of the 35th Annual ACM Conference Extended Abstracts on Human Factors in Computing Systems (CHI EA '17) (2017).

13 For more information about fusion, and about the collaboration that led to these images, see "A deep dive into plasma," November 20, 2014, at the National Science Foundation website. https://www.nsf.gov/discoveries/disc_summ.jsp?cntn_id=133308&org=NSF

14 For more information and personnel details, see "Scientific Visualization of E3SM's Cryosphere Campaign Simulations," online at https://e3sm.org/scientific-visualization-of-e3sms-cryosphere-campaign-simulations/, August 2020.

15 See, for example, Eirik Endeve, Christian Cardall, Reuben Budiardja, Samuel Beck, Alborz Bejnood, and Anthony Mezzacappa, "Magnetic Field Evolution in Three-dimensional Simulations of the Stationary Accretion Shock Instability." (2011).

16 For more information and personnel details, see https://www.ppmstar.org

17 Christopher J. Conselice, Cui Yang, Asa F.L. Bluck, "The structures of distant galaxies − III. The merger history of over 20 000 massive galaxies at z < 1.2." *Monthly Notices of the Royal Astronomical Society*, Volume 394, Issue 4, pp. 1956–1972 (April 2009). https://doi.org/10.1111/j.1365-2966.2009.14396.x

18 Adapted from a NASA press release "Galaxy Collisions: Simulation vs Observations" (25 September 2015).

19 T. Di Matteo, V. Springel, and L. Hernquist. "Energy input from quasars regulates the growth and activity of black holes and their host galaxies." *Nature* 433, 604–607 (2005). https://doi.org/10.1038/nature03335

20 J. Wang, S. Bose, C.S. Frenk, et al., "Universal structure of dark matter haloes over a mass range of 20 orders of magnitude." *Nature* 585, 39–42 (2020). https://doi.org/10.1038/s41586-020-2642-9

21 J. Tao, W. Benger, K. Hu, E. Mathews, M. Ritter, P. Diener, C. Kaiser, H. Zhao, G. Allen, and Q. Chen, "An HPC framework for large scale simulations and visualizations of oil spill trajectories. Coastal Hazards." Selected Papers from EMI 2010 (2), 13–23 (2013). https://doi.org/10.1061/9780784412664.002

22 S. Zeller and D. Rogers, "Visualizing Science: How Color Determines What We See," *Eos Magazine*, May 21, 2020, https://eos.org/features/visualizing-science-how-color-determines-what-we-see

23 G. Abram, F. Samsel, M.R. Petersen, X. Asay-Davis, D. Comeau, and S.F. Price, "Antarctic Water Masses and Ice Shelves: Visualizing the Physics," in *IEEE Computer Graphics and Applications*, vol. 41, no. 1, 35–41, 1 Jan.–Feb. 2021, doi: 10.1109/MCG.2020.3044228

24 A. Blass, X. Zhu, R. Verzicco, D. Lohse, and R. Stevens, "Flow organization and heat transfer in turbulent wall sheared thermal convection." *Journal of Fluid Mechanics*, 897, A22 (2020). doi:10.1017/jfm.2020.378

25 J. Von Neumann, R. Charney, and J, Fjortoft, "Numerical Integration of the Barotropic Vorticity Equation." *Tellus: A Quarterly Journal of Geophysics*, Volume 2, Number 4 (1950).

26 H. Brix, D. Menemenlis, C. Hill, S. Dutkiewicz, O. Jahn, D. Wang, K. Bowman, and H. Zhang, "Using Green's Functions to initialize and adjust a global, eddying ocean biogeochemistry

general circulation model." *Ocean Modelling*, 95: 1–14 (November 2015).

CHAPTER 4: ART IN SCIENCE

1 J. H. Van 't Hoff, "Imagination in Science" [1878] (trans. by G. F. Springer). Molecular Biology Biochemistry and Biophysics. 1: 1–18 (1967).

2 David S. Goodsell, *The Machinery of Life*. Springer Science & Business Media (2009).

3 D.S. Goodsell, "Art as a tool for science." Nature Structural & Molecular Biology 28, 402–403 (2021). https://doi.org/10.1038/s41594-021-00587-5

4 Renati Des-Cartes (René Descartes). *Principia Philosophiæ*. Amstelodami, Apud Ludovicum Elzevirium (1644).

5 K. Etheridge, "Maria Sibylla Merian and the metamorphosis of natural history." *Endeavour*, 35(1), 16–22 (2011). https://doi.org/10.1016/j.endeavour.2010.10.002

6 Maria Sibylla Merian, *Metamorphosis insectorum Surinamensium*. Gerard Valck, Amsterdam (1705).

7 D. S. Goodsell, "Inside a living cell." *Trends in Biochemical Sciences*, 16(6), 203–206. (1991). https://doi.org/10.1016/0968-0004(91)90083-8

8 Robert T. Bakker, "DINOSAUR RENAISSANCE." *Scientific American* 232, no. 4: 58–79 (1975). http://www.jstor.org/stable/24949774.

9 S. Marchi, W. Bottke, L. Elkins-Tanton, et al., "Widespread mixing and burial of Earth's Hadean crust by asteroid impacts." *Nature* 511, 578–582 (2014). https://doi.org/10.1038/nature13539

10 See, for example, M.A. Thompson, M. Telus, L. Schaefer, et al., "Composition of terrestrial exoplanet atmospheres from meteorite outgassing experiments." *Nature Astronomy* 5, 575–585 (2021). https://doi.org/10.1038/s41550-021-01338-8

11 M. Reich et al., "Giants' bones and unicorn horns: ice age elephants offer 21st century insights." *Collections – Wisdom, Insight, Innovation* 8: 44–50 (2008).

12 J. Ostrom, "The Ancestry of Birds." *Nature* 242, 136 (1973). https://doi.org/10.1038/242136a0

13 D.A. Lawson, "Pterosaur from the latest Cretaceous of West Texas: discovery of the largest flying creature." *Science* 187:947–948 (1975).

14 D.M. Unwin and D.M. Martill, "No protofeathers on pterosaurs." *Nature Ecology & Evolution* 4, 1590–1591 (2020). https://doi.org/10.1038/s41559-020-01308-9

15 M.P. Witton and D. Naish, "A reappraisal of azhdarchid pterosaur functional morphology and paleoecology." *PloS One*, 3(5), e2271 (2008). https://doi.org/10.1371/journal.pone.0002271

16 See, for example, Cameron Pahl and Luis Ruedas, "Carnosaurs as Apex Scavengers: Agent-based simulations reveal possible vulture analogues in late Jurassic Dinosaurs." *Ecological Modelling*. 458. 109706. 10.1016/j.ecolmodel.2021.109706 (2021).

17 See, for example, Michael Balter, "Bringing Hominins Back to Life." *Science* 325 (5937): 136–39 (2009). https://doi.org/10.1126/science.325_136

18 A good, illustrated reference featuring sculptures by the Kennis twins, is: Alice Roberts, *Evolution: the Human Story*, 2nd edition. New York: DK (2018).

19 Clive Davenhall, "The Space Art of Scriven Bolton." eds. Nicholas Campion and Rolf Sinclair, *Culture and Cosmos*, Vol. 16 nos. 1 and 2, pp. 385–392 (2012).

20 Sidney Perkowitz, *Inspirational Realism: Chesley Bonestell and Astronomical Art*. (2013).

21 For more details, see István Kornél Vida, "The 'Great Moon Hoax' of 1835." *Hungarian Journal of English and American Studies* (HJEAS) 18, no. 1/2: 431–41 (2012). http://www.jstor.org/stable/43488485

22 R. Di Stefano, J. Berndtsson, R. Urquhart, et al., "A possible planet candidate in an external galaxy detected through X-ray transit." *Nature Astronomy* (2021).

23 M. Gillon, E. Jehin, S.M. Lederer, L. Delrez, J. de Wit, A. Burdanov, V. Van Grootel, A.J. Burgasser, A.H. Triaud, C. Opitom, B.O. Demory, D.K. Sahu, D. Bardalez Gagliuffi, P. Magain, and D. Queloz, "Temperate Earth-sized planets transiting a nearby ultracool dwarf star." *Nature*, 533(7602), 221–224 (2016). https://doi.org/10.1038/nature17448

24 See, for example, R. Barnes, K. Mullins, C. Goldblatt, V.S. Meadows, J.F. Kasting, and R. Heller, "Tidal Venuses: triggering a climate catastrophe via tidal heating." *Astrobiology*, 13(3), 225–250(2013). https://doi.org/10.1089/ast.2012.0851

25 J.K. Barstow and P.G.J. Irwin, "Habitable worlds with JWST: transit spectroscopy of the TRAPPIST-1 system?" *Monthly Notices of the Royal Astronomical Society*: Letters, Volume 461, Issue 1, 01, pp. L92–L96 (September 2016). https://doi.org/10.1093/mnrasl/slw109

26 A. Vanderburg, J. Johnson, S. Rappaport, et al., "A disintegrating minor planet transiting a white dwarf." *Nature* 526, 546–549 (2015). https://doi.org/10.1038/nature15527

27 B.P. Abbott, R. Abbott, R. Adhikari, S. Anderson, K. Arai, M. Araya, J. Barayoga, B. Barish, B. Berger, Garilynn Billingsley, Kent Blackburn, R. Bork, A. Brooks, S. Brunett, C. Cahillane, T. Callister, Cris Cepeda, P. Couvares, and Dennis Coyne, "GW151226: Observation of Gravitational Waves from a 22-Solar-Mass Binary Black Hole Coalescence." *Physical Review* Letters. 116 (2016).

Index

Image Credits

Every effort has been made to trace all copyright owners but if any have been inadvertently overlooked, the publishers would be pleased to make the necessary arrangements at the first opportunity.
Key: top = t; bottom = b; left = l; right = r; m = middle

7 Springer Medzin / Science Photo Library. **9** Wikipedia. **10** Royal Institution of Great Britain / Science Photo Library. **14** Science History Images / Alamy Stock Photo. **15** Wellcome Collection. **16** © The Royal Society. **17** Legado Cajal, Instituto Cajal (CSIC), Madrid. **18, 19** Library of Congress, Rare Book and Special Collection Divisions / Science Photo Library. **21** Wellcome Collection. **22-23** Flickr / Picturepest. **24-25** Royal Astronomical Society / Science Photo Library. **26-27** NASA, ESA, J. Dalcanton (University of Washington, USA), B. F. Williams (University of Washington, USA), L. C. Johnson (University of Washington, USA), the PHAT team, and R. Gendler. **28-29** NASA, ESA, G. Illingworth and D. Magee (University of California, Santa Cruz), K. Whitaker (University of Connecticut), R. Bouwens (Leiden University), P. Oesch (University of Geneva,) and the Hubble Legacy Field team. **30-31** NSO/NSF/AURA. **32-33** NASA/Johns Hopkins University Applied Physics Laboratory/Southwest Research Institute/Alex Parker. **34** Wellcome Collection. **35, 36-37** © Harold Edgerton/MIT, courtesy Palm Press, Inc. **38** Lowell Observatory Archives. **39** Photos courtesy of Louis H. Pedersen (1917) and Bruce F. Molina (2005), obtained from the Glacier Photograph Collection, Boulder, Colorado USA: National Snow and Ice Data Center/World Data Center for Glaciology. **40** © The Trustees of the Natural History Museum, London / Dr. Andrew R. Young. **41** NIAID. **42** Science History Images / Alamy Stock Photo. **43** C. S. Goldsmith and A. Balish. **45** Mauritius Images. **46** Flickr. **50-51** N.A. Sharp, NOAO/NSO/Kitt Peak FTS/AURA/NSF. **52-53** NASA. **55-56** ESA/Planck/C. North, www.chromoscope.net/planck. **58** Wikipedia. **59** Wellcome Collection. **60-61** RGB Ventures / SuperStock / Alamy Stock Photo. **62-63** NASA Earth Observatory image by Jesse Allen and Robert Simmon, using EO-1 ALI data from the NASA EO-1 team. Caption by Adam Voiland. **65** Wellcome Collection. **66** DR TORSTEN Wittman / Science Photo Library. **67** Sinclair Stammers / Science Photo Library. **68** National Institutes of Health / Science Photo Library. **69** Wikipedia. **71** Yon marsh Phototrix / Alamy Stock Photo. **72** Andrew Lambert Photography / Science Photo Library. **73** Prof. P. Fowler, University of Bristol / Science Photo Library. **74** Science Photo Library. **75** Stanford Linear Accelerator Center / Science Photo Library. **76** Matteo Omied / Alamy Stock Photo. **77** Nature Chemistry, DOI 10.1038/NCHEM.2438. **78** ORNL / Science Photo Library. **79** Stan Olswekski / IBM Research / Science Photo Library. **80** Courtesy of CERN. **85** King's College London Archives / Science Photo Library. **86m, 87t, 86-88b** Seismo Archives. **88-89** NCBI. **90-91** Wellcome Collection, Wikipedia. **92-93** NOAA Central Library Historical Collection. **94-95** Wellcome Collection. **96** NASA. **97** Image courtesy of the Edwin Hubble Papers, Huntington Library, San Marino, California. **98** Courtesy of Michael Mann. **99** Jack Challoner. **100-101** Aguasonic Acoustics / Science Photo Library. **104** Courtesy of CERN. **106** Thomas Schultz, University of Bonn, Germany. **107l** Patric Hagmann, Department of Radiology, Lausanne University Hospital (CHUV), Switzerland. **107r** Courtesy of the USC Laboratory of Neuro Imaging and Athinoula A. Martinos Center for Biomedical Imaging, Consortium of the Human Connectome Project, www.humanconnectomeproject.org. **108-109** NASA/NICER. **110-111** European Space Agency, Planck Collaboration. **112** NASA/JPL. **113, 114-115** Courtesy of Kate McDole, Ph.D. **117** Jack Challoner. **118-119** Wellcome Collection. **120-121** RAWGraphs / Project Tycho / (c) University of Pittsburgh. **122-123** Krzywinski, M. et al. Circos: An Information Aesthetic for Comparative Genomics. **124** Wellcome Collection. **125** Mary Evans / Natural History Museum. **126-127** NOAA Central Library Historical Collection. **128-129** Prof. Ed Hawkins, University of Reading and the National Centre for Atmospheric Science / www.ShowYourStripes.info. **130-131** Jason Rowe / Flickr. **133** Middle Tempel Library / Science Photo Library. **134-135** Wellcome Collection. **137** ESO. **139** Photo © Christie's Images / Bridgeman Images. **140** Jack Challoner. **142-143** Wikipedia. **144-145** © Len Eisenberg 2008, 2017 www.evogeneao.com. **146** © Science Museum / Science & Society Picture Library – All rights reserved. **147** A. Barrington Brown, © Gonville & Caius College / Science Photo Library. **149** NASA Ames. **150** Wikipedia. **155** NASA. **156** Paul Falstad. **157** Jack Challoner. **158-159** Jack Challoner. **160** Amaro Lab. **162-163** David B. Wells, and Aleksei Aksimentiev. **164-165** Guillermo Marin et al, Barcelona Supercomputer Center, 2012. **166** Dan Roe, University of Utah; Antonio Gomez and Anne Bowen, Texas Advanced Computing Center. **167** Abdul Malmi Kakkada (Dave Thirumalai's group – Department of Chemistry at UT Austin) Visualization: Anne Bowen, Texas Advanced Computing Center. **168-169** Wikipedia. **170** Craig Reynolds / 3313 Haskins Dr. / Belmont, CA 94002 / USA. **171** NCBI. **172-173** Francesca Samsel, David Honegger Rogers, John M. Patchett, Karen Tsai. **174-175** Wendell Horton and Lee Leonard, University of Texas at Austin; Greg Foss, Texas Advanced Computing Center. **176-177** Cryosphere-Ocean Visualization Project 14. **178** Flickr / US Department of Energy. **179** NASA. **180-181** The Laboratory for Computational Science & Engineering (LCSE). **182-183** NCSA, NASA, B. Robertson, L. Hernquist. **184** Max Planck Institute for Astrophysics. **186-187** NASA/J.F. Drake, M. Swisdak, M. Opher. **188-189** Sownak Bose. **191** Marcel Ritter, Jian Tao, Haihong Zhao, Louisiana State University Center for Computation and Technology. **192-193** Francesca Samsel, Texas Advanced Computing Center. **194** USGS. **195** NASA's Ames Research Center, Patrick Moran; NASA's Langley Research Center, Mehdi Khorrami; Exa Corporation, Ehab Fares. **196-197** Jordan B. Angel, NASA/Ames. **198-199** NASA/Marian Nemec and Michael Aftosmis. **200-201** Alexander Blass, Physics of Fluids Group, University of Twente, The Netherlands Xiaojue Zhu, Physics of Fluids Group, University of Twente, The Netherlands Jean Favre, Swiss National Supercomputing Center, Switzerland Roberto Verzicco, Physics of Fluids Group, University of Twente, The Netherlands Detlef Lohse, Physics of Fluids Group, University of Twente, The Netherlands Richard Stevens, Physics of Fluids Group, University of Twente, The Netherlands https://gfm.aps.org/meetings/dfd-2018/5b8e9e51b8ac31610362f17b. **203** Svenska Geografiska Föreningen. **205** NASA's Scientific Visualization Studio. **206-207** NASA. **208** Library of Congress Geography and Map Division Washington, D.C. 20540-4650 USA dcu. **211** © Science Museum / Science & Society Picture Library – All rights reserved. **212** Library of Congress Geography and Map Division Washington, D.C. 20540-4650 USA dcu. **213** Wikipedia. **214-215** John Liebler / Art of the Cell, www.artofthecell.com. **216-217** Library of Congress Geography and Map Division Washington, D.C. 20540-4650 USA dcu. **218-219** David Goodsell. **220-221** Wellcome Collection. **222-223** © Susan Aldworth. All Rights Reserved 2021 / Bridgeman Images. **224-225** Marcus Lyon. **226-227** Ela Kurowska, www.lightforms.ca. **228-229** Luke Jerram. **231, 232-233** Simone Marchi. **232-233, 234-235** Richard Jones / Science Photo Library. **236** Field Museum Library / Contributor. **237** Museum für Naturkunde, Berlin / MfN, HBSB, Zm B VIII 454. **239, 240** Wikipedia. **242** Wikipedia. **242-243** James Kuether / Science Photo Library. **245** Wikipedia / Neanderthal Museum. **247t** Wikipedia. **247b** Rijksmuseum. **248-249** Library of Congress Geography and Map Division Washington, D.C. 20540-4650 USA dcu. **250-251** ESO/M. Kornmesser. **253** ESO/N. Bartmann/spaceengine.org. **254-255** Scriven Bolton and Lucien Rudaux. **256-257** CfA/Mark A. Garlick / NASA. **258-259** LIGO/T. Pyle. **260** ESO/M. Kornmesser. **261** ESO/L. Calçada. **262-263** NASA/JPL-Caltech/ESO/R. Hurt.